Pilgrimage to the Museum

D1533965

Also by Stephen F. Auth
from Sophia Institute Press:

The Missionary of Wall Street:
From Managing Money
to Saving Souls on the Streets of New York

Pilgrimage
to the Museum

Man's Search for God
through Art and Time

By Stephen F. Auth

with Evelyn Moreno Auth
and Fr. Shawn Aaron, LC

SOPHIA INSTITUTE PRESS
Manchester, New Hampshire

Copyright © 2022 by Stephen F. Auth, Evelyn Moreno Auth, and Fr. Shawn Aaron, LLC

Printed in the United States of America. All rights reserved.

Cover design by Updatefordesign Studio.

On the cover: (center) photo by Zalfa Imani / Unsplash; (top row) Claude Monet, *Rouen Cathedral: The Portal (Sunlight)*; Antonello da Messina, *Virgin Annunciate*; Jean-Baptiste Joseph Pater, *The Fair at Bezons*; Salvador Dalí, *Crucifixion (Corpus Hypercubus)*; Pablo Picasso, *Still Life with a Bottle of Rum*; (bottom row) Duccio di Buoninsegna, *Madonna and Child*; Pablo Picasso, *The Blind Man's Meal*; Rembrandt van Rijn, *Aristotle with a Bust of Homer*; El Greco, *View of Toledo*. See credits on page viii.

All interior images not otherwise credited are from the Metropolitan Museum of Art, which has kindly donated them to the public domain. See other image credits on page viii.

Unless otherwise noted, biblical references in this book are taken from the Catholic Edition of the Revised Standard Version of the Bible, copyright 1965, 1966 by the Division of Christian Education of the National Council of the Churches of Christ in the United States of America. Used by permission. All rights reserved.

No part of this book may be reproduced, stored in a retrieval system, or transmitted in any form, or by any means, electronic, mechanical, photocopying, or otherwise, without the prior written permission of the publisher, except by a reviewer, who may quote brief passages in a review.

Sophia Institute Press
Box 5284, Manchester, NH 03108
1-800-888-9344
www.SophiaInstitute.com

Sophia Institute Press is a registered trademark of Sophia Institute.

paperback ISBN 978-1-64413-716-1

ebook ISBN 978-1-64413-717-8

Library of Congress Control Number: 2022933865

First printing

*For the souls of the artists of the last five thousand years
who are referenced in the pages that follow.
Thank you for leading me closer to the mystery of God.*

God has made everything appropriate to its time, but has put the timeless into their hearts so they cannot find out, from beginning to end, the work which God has done.

—Ecclesiastes 3:11

Contents

Image Credits

Giuseppe Sanmartino, *The Dead Christ*, Capella Sansevero, Naples, Italy; John Heseltine/Alamy Stock Photo.

Monet, Claude (1840-1926), *Rouen Cathedral: The Portal (in Sun)*, 1894. Oil on canvas, 39 1/4 x 25 7/8 in. (99.7 x 65.7 cm). Theodore M. Davis Collection, Bequest of Theodore M. Davis, 1915 (30.95.250). The Metropolitan Museum of Art/New York, NY/USA. Image copyright © The Metropolitan Museum of Art. Image source: Art Resource, NY.

Pablo Picasso, *The Actor* (2D6CMWM), Peter Barritt/Alamy Stock Photo.

Picasso, Pablo (1881-1973) © ARS, NY. *The Blind Man's Meal*, 1903. Oil on canvas. H. 37 1/2, W. 37 1/4 inches (95.3 x 94.6 cm). The Metropolitan Museum of Art, Purchase, Mr. and Mrs. Ira Haupt Gift, 1950 (50.188). The Metropolitan Museum of Art/New York, NY/USA. Image copyright © The Metropolitan Museum of Art. Image source: Art Resource, NY.

Pablo Picasso, *Les Demoiselles d'Avignon* (M062HC), Peter Barritt/Alamy Stock Photo.

Picasso, Pablo (1881-1973) © ARS, NY. *Still Life with a Bottle of Rum*, 1911. Oil on canvas, 24 1/8 x 19 7/8in. (61.3 x 50.5 cm). Jacques and Natasha Gelman Collection, 1998 (1999.363.63). Photo: Lynton Gardiner. The Metropolitan Museum of Art/New York, NY/USA. Image copyright © The Metropolitan Museum of Art. Image source: Art Resource, NY.

Jackson Pollock, *Autumn Rhythm* (R21FWF), Alan Wylie/Alamy Stock Photo.

Hopper, Edward (1882-1967) © ARS, NY. *From Williamsburg Bridge*, 1928. Oil on canvas, H. 29, W. 43 inches (73.7 x 109.2 cm.). George A. Hearn Fund, 1937 (37.44). The Metropolitan Museum of Art/New York, NY/USA. Image copyright © The Metropolitan Museum of Art. Image source: Art Resource, NY.

Mark Rothko, *No. 3* (2D90YK8), Peter Barritt/Alamy Stock Photo.

Cadmus, Paul (1904-1999) © ARS, NY. *The Seven Deadly Sins: Anger*, 1947. Egg tempera on Masonite. 24 × 12 in. (61 × 30.5 cm). Gift of Lincoln Kirstein, 1993 (1993.87.4). The Metropolitan Museum of Art/New York, NY/USA. Image copyright © The Metropolitan Museum of Art. Image source: Art Resource, NY. © 2022 Estate of Paul Cadmus/Artists Rights Society (ARS), NY.

Cadmus, Paul (1904-1999) © ARS, NY. *The Seven Deadly Sins: Gluttony*, 1949. Egg tempera on cardboard. 24 × 11 3/4 in. (61 × 29.8 cm). Gift of Lincoln Kirstein, 1993 (1993.87.7). The Metropolitan Museum of Art/New York, NY/USA. Image copyright © The Metropolitan Museum of Art. Image source: Art Resource, NY. © 2022 Estate of Paul Cadmus/Artists Rights Society (ARS), NY.

Salvador Dalí, *Crucifixion* (D9C1AC), World History Archive/Alamy Stock Photo.

Pilgrimage to the Museum

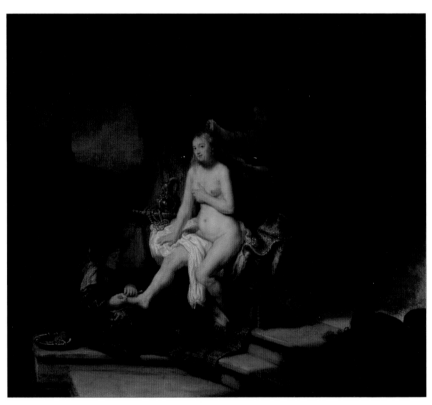

Rembrandt van Rijn, *The Toilet of Bathsheba*, 1643

1

A Light Comes On

September 2009. The Met. We're stopped before a small Rembrandt painting called *The Toilet of Bathsheba,* and I'm listening to the volunteer docent explain it.

She's doing a good job. She reminds us that this Bathsheba belongs to Rembrandt's "Oriental period," when he became fascinated with the exotic world of the Far East as the Dutch traders of the rising metropolis of Amsterdam brought back tales and riches from far-off lands. The brushstrokes are classically middle-period Rembrandt, when he gave up the almost photographic accuracy of his early work and began to loosen and broaden his brushwork to create more artistic impressions.

Bathsheba, the docent tells us, stands out as one of only a very few nudes painted by the great artist in the very Protestant Dutch Republic of the 1600s. Somewhat scandalously for the art establishment of the time, his representation of the nude Bathsheba was not an idealized female form, like the ones painted during the Renaissance, but rather, a real woman whom perhaps the artist knew; he even painted the mark of her garter on her right leg.

Pilgrimage to the Museum

The docent is careful to point out for us that David is also in this picture, the shadowy figure up on the castle turret in the far upper left corner of the canvas.

Everything she says is delivered cleanly and precisely. It's all entirely accurate. Objective. Neutral. Almost scientific. That fits well with my own prejudices. My classical training at one of the country's great universities has left me instinctively of the mind that art can and should be studied in an almost scientific context.

Still, as the docent whisks the group forward to Rembrandt's nearby self-portraits, I find myself lagging behind, reflecting.

Beneath the rich surface of this canvas, something is stirring. Something dark.

—«««•»»»—

All these years later, I remember every detail of that moment. The museum's volunteer thorough though somewhat clinical assessment rang true for me according to what I remembered from the undergraduate art-history classes I had squeezed into my years at Princeton University whenever I could. Though I was not an art-history major, my heart and my head have been in the grip of the mysteries and beauty of Western art ever since.

As my global-investment work took me all over the world, for the next forty-some-odd years, I found myself continually studying and learning about art at virtually all the great art museums of the world. (Just as I did at Princeton, I squeezed those visits into many a hectic business trip that had other objectives for sure.) And when I got back home, I always had the Met.

I often took these little tours in the Met. Some years earlier, my wife, Evelyn, and I had begun giving our own tours through the Metropolitan Museum of Art's collections, usually to our out-of-town guests who were eager to visit the museum and see its highlights. We'd grown to love and cherish this jewel of the Big Apple, with its encyclopedic collection of art from virtually every period and culture of human history. So whenever I had a free hour or two, I'd show up at the Met to see if I could learn a little more.

In spite of the religious content of so much of the art, though, I hadn't connected much of it with religion. In the years since I had left college as an "indifferent agnostic," I had slowly been coming back to the Catholic Faith of my childhood. Like all such spiritual journeys, it had its ups and downs, but by now, I was deep into an inner awakening of my relationship with God.

Even so, I still largely had God in my Sunday-morning box. When I thought about art, God seemed to have little place in the narrative.

Now, in front of this mysteriously rich painting by one of the greatest artists of all time, I sensed something very different. The more I looked at it, the more it seemed that talk of Rembrandt's Oriental period and his broadening brushstrokes was a distraction, unimportant—a ripple on the surface of a much deeper lake.

Then, with a crack of thunder, I saw it.

The Toilet of Bathsheba was not about the nude Bathsheba.

In fact, the figure at the center of the canvas wasn't meant to portray the flesh-and-blood Bathsheba at all.

Rather, I was looking at the image of Bathsheba through David's eyes as he stared out from the ramparts of his castle—what my priest friend always calls the dangerous "second look."

The Toilet of Bathsheba was Rembrandt's take on David's fall and redemption, or perhaps his own. Or, perhaps closer to the mark, my own.

This painting's real title should be "The Slippery Slope of Sin."

But to figure this out, we'd have to go back in time, to the beginning—to ancient Egypt at least. And we'd have to dig deeper spiritually: deeper into the spiritual context of Rembrandt's Dutch Reformed Republic of Amsterdam, deeper into the artist's soul, and deeper into mine.

And—gulp!—we'd have to bring up the tricky matter of God.

—⟨⟨⟨◆⟩⟩⟩—

That evening, I rushed home to Evelyn, bursting with renewed enthusiasm, tinged as always with a bit of anxiety.

"Sweetheart! I just had a breakthrough!"

"What now, honey?"

I suppose this wasn't the first time I had told her that I had had a breakthrough.

"We've been doing the tour of the Met all wrong!" I told her. "We're only scratching the surface here. The paintings we're showing are all connected!"

I hadn't expressed that very well. "Sure, they're all classics," she said. "But, Steve, the styles and subject matters are so different."

"On the surface, that's true. But in the end, they're all about the same thing."

"Just one thing, Steve? Really? You and your theories! What's that one thing?"

"Man's search for God. Or maybe our search for God."

I was afraid I might have sounded trite or stupid. But after a pause, Evelyn smiled.

"Well now, for once, I agree with you. But if we do this, we're going to need a priest. We're going to need Fr. Shawn."

Fr. Shawn Aaron is a gentle, introspective, holy man whom Evelyn and I have grown to know and love through our relationship with Regnum Christi. Although he is no art expert, he has an uncanny ability to unpack the spiritual wiring of humanity. He is the "priest friend" whose advice I had just remembered while in front of *Bathsheba*. A perfect complement to our little band. Before long, he had enlisted.

-⦉⦉◆⦊⦊-

Now, as we approached our informal tour from a new perspective, more and more previously random-seeming elements and artistic dead ends began to fit together in ways we had never seen before. We looked at paintings we used to think were unimportant or by lesser artists, and now they suddenly seemed pivotal to the narrative. An intellectual dam had broken.

As the pieces came together, they formed a story that rang true. We would find a motif in one century and see it recur later in others. The narrative resonated across time, even as the great artists themselves came and went with the centuries.

We're still on that journey.

Come along with us. I think you'll see the same things we saw. We're going to take a quick tour through the entire history of Western art. Not that I'm ambitious or anything.

And we're going to do it right here, in New York.

Because I grew up in metropolitan New York, the Met is the one place I go when I want to lead people through the whole history of Western art. There are a few great museums in the world

where you might be able to do this kind of tour—the Louvre and the British Museum come to mind. But I don't think there's anywhere else on Earth where you could find such an encyclopedic collection of art in the Western tradition, from the first stirrings to the present moment. I have a New Yorker's prejudices, of course, but for me, the Met is it.

So we'll tell our story of Western art mainly in the Met, with only a few diversions to examine other works that are too pivotal to the narrative to overlook. But the Met is really just incidental. We're not looking for one particular collection of art. We're looking for God.

That's why we won't be looking only at paintings and sculptures. We'll be looking into our own souls too. There's a longing for God that lies buried deep in your soul, and in mine, and this quick run through art history will put us in touch with it.

Oh, and about "The Slippery Slope of Sin" by Rembrandt: we'll get there. But first we have to jet back in time a few thousand years to ancient Egypt.

2

Men as Gods

Ancient Egypt

How you are fallen from heaven,
O Day Star, son of Dawn!
How you are cut down to the ground,
you who laid the nations low!
You said in your heart,
"I will ascend to heaven;
above the stars of God
I will set my throne on high;
I will sit on the mount of assembly
in the far north;
I will ascend above the heights of the clouds,
I will make myself like the Most High."

—Isaiah 14:12-14

When you walk into the Great Hall at the entrance to the Metropolitan Museum of Art, you find yourself in a Roman palace—arches, domes, Ionic columns. That entrance tells a story. The whole tradition of Western art is here—in a building from the 1800s that would have been in style 1,800 years before that.

But we're going to go much further back than ancient Rome. We're going to turn right from the main lobby and walk between the towering, fluted columns. Suddenly we'll have left New York and even Rome far behind us and traveled back more than four millennia to ancient Egypt.

—⟪⟨◆⟩⟫—

Old Kingdom, Egypt, mid-twenty-fourth century BC. By the middle of the second millennium BC, a rich civilization had developed along the Nile River on its long passage through the arid land of Egypt to the Mediterranean Sea. Advancements in irrigation and agriculture began to produce a surplus of food. These break-throughs, in turn, allowed for the development of urban cultures that could focus on industry and trade and could exchange their more advanced wares for the food they needed in Egypt's great cities.

As Egypt's civilization grew richer and more advanced, Egyptians had time and energy to focus on existential questions.

What is the meaning of life?

Where am I heading next?

And ultimately, *Who is God?*

Egyptian art and architecture, harnessed to the goals of its royal patrons, was almost entirely focused on these questions—on the Egyptian view of the afterlife.

Remember that the Egyptians didn't have the benefit of the great revelations God Himself made to the Hebrews and then to the Christians. Those came later. The Egyptians had to rely on their own instincts and desires in their search.

What did they come up with? Well, I like to describe it as "a U-Haul following a hearse"—the kind of U-Haul most priests will tell you you'll never see.

A U-Haul Following a Hearse

Saqqara, Egypt, ca. 2350 BC. Perneb, a wealthy member of the pharaoh's court in the Fifth Dynasty, had a comfortable life. He lived in Memphis, the ancient capital, and he was one of the upper crust. Life along the Nile—if you weren't one of the thousands of slaves working there—was pretty good: food, drink, and entertainment aplenty.

The Egyptians, Perneb included, almost uniquely among the people of the ancient world at this time, hoped to take this good life with them into eternity.

Much of their surviving art, in fact, is found in their tombs.

Egyptian tombs were built partly to honor and memorialize the dead but also to serve as a staging ground to the eternal—at least, that is, for the fortunate few who could afford a structure (called a mastaba) of the kind that Perneb would build in the great burial ground of Saqqara. It wasn't as big as the pharaohs' pyramids, but a mastaba was a substantial house-like structure that contained everything a man of Perneb's stature would need in the afterlife.

What would he have thought if he had known his whole tomb would end up in an art museum in a land he had never heard of?

Step into the inner burial chamber of the Tomb of Perneb. The wealthy Perneb had it built to house his mummy, and his relatives and servants were to bring food and entertainment offerings, his favorite things, for his use in the afterlife. He believed—or hoped, at least—that he would emerge from his mummy wrappings and go through that sealed stone door in the picture for a big eternal party.

Of course, the family couldn't be expected to visit the entombed Perneb forever (they would eventually die, unfortunately without a similar life raft to the eternal). So Perneb and the design team had a plan B. We can see it here in the relief paintings on the walls of this inner chamber.

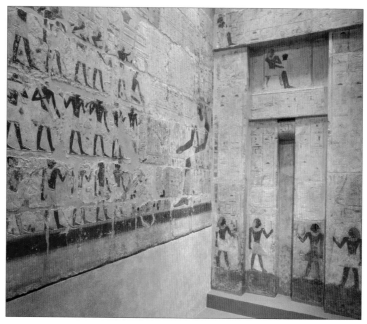

Relief detail from the Tomb of Perneb,
Old Kingdom, Egypt, 2381–2323 BC

Lined up like planes coming into LaGuardia Airport, Perneb's various servants and attendants carry everything he could possibly need, and then some, for an eternal blast for the ages. You name it, you got it! It's the U-Haul following the hearse!

Spend a few moments taking in the detail and complexity of this composition. The figures are two-dimensional and a bit unreal, suggesting that the souls they represent are distant, existing in a nonearthly world. Yet, despite their lack of weight, they are in some ways full of life, color, and energy. One carries a cluster of blue grapes; another, an ancient guitar; a third, a tempting vessel of wine; a fourth, a roasted pheasant. Just about every potential article of pleasure old Perneb would want.

What's most fascinating about Perneb's tomb is that "plan B" seems to have included him as well: he is pictured here in silhouette, seated. In fact, just to be sure he makes it, he's pictured thrice—once on either side of the entrance to the burial chamber and once above it. "Seated" is important in an Egyptian context; when Egyptian artists showed someone in this posture, it indicated that he was, in fact, a god himself. To emphasize the point, the artists also made these god-like images of Perneb larger than life, or at least significantly larger than the little people carrying his favorite toys to him—as if to say, "Perneb is a god here; you are not." Or, in my perhaps oversimplified summary of Egyptian spirituality, "man as God."

Now, you might be smiling at Perneb's pridefulness in presuming to be able to make himself a god. After all, instead of ending up in eternity, he found himself here at the Met.

But remember, we're in Egypt at the time before God revealed Himself even to the Hebrews, so this is what theologians call "pre-revelation theology." Perneb and the Egyptians at this stage didn't have the benefit of the great Hebrew prophets. Certainly they didn't have the graces and the insights into the eternal that God's Son Himself offered; those would not come until two and a half millennia later.

Yet still, in their hearts, they were clearly longing for, seeking, a relationship with their Creator, seeking eternity. That's a start to the spiritual journey. That's a beginning. You have to be a seeker before you become a follower.

So when you're through giggling over poor old Perneb and his foibles, ask yourself this question: *When in your own life have you tried to make yourself God? Done your will, not His?*

Maybe there's a little of Perneb in all of us.

Maybe that's what Original Sin is.

Or, as Eugene Boylan put it in *This Tremendous Lover*, "Other sins evade God, so to speak. Pride opposes him."

Well, then, let's roll it forward a few hundred years, to about the time of the Jewish exile in Egypt, and the reign of one of its most famous women Pharaohs, Hatshepsut.

And don't fret too much about poor Perneb. We'll be running into him again … and again … and again.

The Woman Who Would Be King—and God

Deir el-Bahari, Valley of the Kings, Thebes, Egypt, fifteenth century BC. Historians divide Egyptian history into three "kingdoms," and our friend Perneb was in the Old Kingdom. Now we've skipped right over the Middle Kingdom and landed in the New Kingdom.

By this time, Egypt had grown to the height of its influence in the ancient world. With trade routes stretching from western Asia south to the middle of the African continent and by sea to the Aegean Islands, its Nile-based culture and economy was thriving.

Amid this affluence, Hatshepsut, principal wife of her stepbrother King Thutmose II, found herself queen regent when Thutmose passed to the afterlife and her young stepson Thutmose III inherited the throne.

We can presume that the noble-born Hatshepsut was accustomed to the complexities of Egyptian court life. One step at a time, she consolidated power and eventually came to rule as pharaoh, under the throne name of Maatkare.

When Thutmose III came of age, she kept him safely at a distance by commanding him to lead the army southeast on a maritime expedition to conquer the land of Punt on the Red Sea. Meanwhile, Egypt flourished under her rule. Today's historians consider her one of the most effective of all the pharaohs.

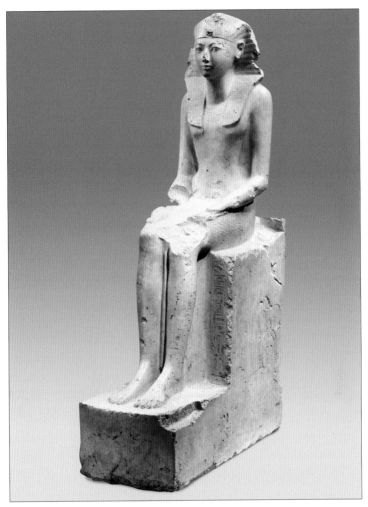

Seated statue of Hatshepsut, New Kingdom, Dynasty 18,
Egypt, ca. 1479–1458 BC

Hatshepsut, of course, had more than just her contemporary
successes on her mind. Like all the great Egyptian leaders, she was
determined to build a mortuary temple suitable for the ages to

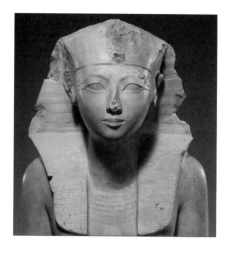

herald her entrance into the afterlife and eternal greatness. The Temple of Hatshepsut, dedicated to the divine queen along with the god Amun, fit this bill.

From a spiritual perspective, what strikes me most about this beautifully crafted statue of Hatshepsut is its stillness and the nearly lifelike way in which the sculptor has serenely but very obviously revealed the pharaoh's often-hidden gender. Unlike most Egyptian statuary, which, like the afterlife it was meant to depict, is often distant and two-dimensional, this remarkable piece has three-dimensional form and substance—and, yes, almost a feminine sensuality. Hatshepsut's mysterious and beautiful face calls out to us across the ages: "I may be in Heaven, but I'm still here too." The form of her very delicate and beautiful body shines through the light fabric of the classical shendyt-kilt worn by the male rulers of the day, which ironically looks very much like a modern-day skirt worn more often today by women. Within that skirt, above which the figure is bare, the sculptor was given freedom to celebrate the beauty of Hatshepsut's female form, here on Earth even more so than in the afterlife to which she aspired. It was almost as if,

through this intimate life-size statue, presumably in one of the temple's inner chambers, Hatshepsut had the confidence and boldness to proclaim, "Here I am, seated on the throne as divine ruler! Take that, Egypt!"

Sadly, pride always seems to go before the fall. After a successful twenty-year reign, Hatshepsut died, and Thutmose III finally ascended his throne. One of his first acts was to attempt to blot out all memory of Hatshepsut and to cheat her of the eternity she longed for by destroying the dozens of statues of her around the temple, including this beautiful image we're examining. After smashing her statues, his men buried the fragments in a deep pit near the main temple complex. After 3,500 years, archaeologists found her and brought her back in pieces to New York, London, and elsewhere, where they carefully reconstructed her. In this way, at least, she lives on. But not before spending a few millennia in a dark pit.

If even Hatshepsut, with all her worldly accomplishments, all her confidence expressed so boldly in this beautiful work from ancient Egypt, all her wealth and power—if even Hatshepsut could fall, what of us? "Cancel culture" may have started in ancient Egypt, but it has recurred intermittently in the centuries since—right up to the present day.

It's not just individuals who fall. Civilizations collapse, too. Shortly after Hatshepsut's death, the Hebrews would come to Egypt and ultimately escape, led by Moses. While other great dynasties would follow, and even surpass, Hatshepsut's 18th dynasty, within a few hundred years the long decline of Egypt would begin.

As the technology of shipbuilding evolved, ever more efficient and reliable water-based transport led to the emergence of new civilizations in the Mediterranean world. One of these had a luckier situation than the rest—positioned in the very heart of the sea.

The great Greek civilization was coming, and with it, an entirely new way of thinking about the world beyond our own—and the gods who controlled it.

So that's our next stop: ancient Greece. Whereas the Egyptians tried to make men into gods, the Greeks would make their gods into men.

3

God as Men

The Rise of the Greeks

For all men who were ignorant of God were foolish by nature; and they were unable from the good things that are seen to know him who exists, nor did they recognize the craftsman while paying heed to his works; but they supposed that either fire or wind or swift air, or the circle of the stars, or turbulent water, or the luminaries of heaven were the gods that rule the world.

If through delight in the beauty of these things men assumed them to be gods, let them know how much better than these is their Lord, for the author of beauty created them. And if men were amazed at their power and working, let them perceive from them how much more powerful is he who formed them. For from the greatness and beauty of created things comes a corresponding perception of their Creator.

Yet these men are little to be blamed, for perhaps they go astray while seeking God and desiring to find him. For as they live among his works they keep searching, and they trust in what they see, because the things that are seen are beautiful. Yet again, not even they are to be excused; for if they had the power to know so much that they could investigate the world, how did they fail to find sooner the Lord of these things?

—Wisdom 13:1–9

Attica, ancient Greece, ca. 590 BC. Egypt is still the powerhouse on the Nile, but it's not the only empire in town. New powers rise in the Middle East: Assyria, Babylonia, and eventually Persia.

Each culture barters what it has most of—food and papyrus from Egypt, spices from Asia, and so on. But who will haul all those goods from here to there?

-≪≪◆≫≫-

At first, the Phoenicians, operating from the well-placed Levant coast of the Eastern Mediterranean, monopolized the trade. They had developed an early form of ships with wooden hulls and multideck oars that could sail the rough Mediterranean waters or be rowed through them far more safely and quickly than the river-based, flat-bottomed hulls of the Egyptian fleet. The Phoenicians were traders, not statesmen or empire builders, and they usually found themselves working for whichever large, land-based army had most recently conquered the others.

But the Phoenicians eventually had serious competition.

One people was better placed than any other to dominate the Mediterranean trade, a people centered within the sea itself: the Greeks. From the Egyptians they learned a lot about civilization. From the Phoenicians they learned shipbuilding, trading skills, and the alphabet. They seem to have come up with their own very effective ways of organizing a state. And they added one last ingredient: the invention of the Greek coin. The Greeks invented money.

"Have money, will travel." Coinage gave the Greeks a distinct advantage in trade: their ships were no longer forced to carry all the various goods desired by every single port of call on their trading routes. Now they could carry just the ones needed for the next port of call. With all these advantages, plus a geographical layout that

made it difficult and costly to conquer them, the Greeks began to take over even as the Egyptians were falling away.

And that brings us to the Kouros.

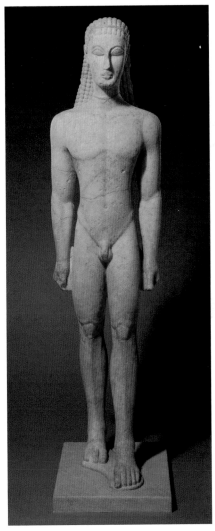

Kouros, Attica, 590–580 BC

A Perfect Man Is Born

The *Kouros* is standing here near the entrance to the Greco-Roman wing, which is right where he belongs. He marks the point of transition in the art world from Egypt to Greece.

This magnificent statue is one of the earliest of its kind from Attica, the area around Athens. Right here we can see art taking a new direction—a direction guided by the Greeks' spiritual beliefs. Like the art of the Egyptians, this statue is associated with death: it was discovered by the Met's archaeologists in an ancient graveyard outside Athens. But we've come a long way from Egypt.

At first glance, we can see many of the same things in the *Kouros* that we've seen already in Egyptian art: the stiff, almost surreal pose; the highly decorative hairpiece on top of his head; the nearly abstract way in which the youth's musculature is crafted; the still, steady, almost serene, visage of the youth, looking back perhaps from the afterlife.

But look closer for a moment. There's something quite different here, quite new.

The *Kouros* is nude. Not a stitch of clothing. Not even a papyrus kilt.

And something else. He's standing free of the stone.

It's almost as if he is *here*, not *there*. In fact, he's walking toward us. He's alive.

And not just alive. Confident. Strong. "Six-pack abs." Perfect.

"Come on!" you might be saying. "No one looks that good! Not even a Hollywood movie star!"

And that's the point. No one does, at least no human does. Indeed, the Kouros is not a human. He's a god. Perfect.

And men (and women), in fact, don't *make* themselves gods. The best of them *are*, in effect, gods. That is why the Greeks celebrate the beauty of their bodies—and even compete nude at their

Olympic games. And that is why all the Greek gods are described in the form of men and women, not as supernatural figures living in a shadowy, ethereal, far-off space. They are here, with us.

Or perhaps, as the Greeks might have thought about it, "They *are* us. They are men."

Perfection Achieved, for a Moment:
The Classical Age of Athens

Athens, Greece, 450–430 BC. Within 150 years of their sudden appearance as a mercantile power, the Greek city-states, led by the city of Athens, had risen to unprecedented prosperity in the ancient world. After a surprise victory at Salamis over the mighty Persian navy early in the fifth century BC, the Greeks, and Athens above all, seemed unstoppable. Their art evolved as quickly as everything else, patronized by Greek wealth and power.

As talent was drawn to Athens from around the ancient world, a competition of sorts evolved. Artists began signing their work, and they studied and practiced to outdistance their rivals.

First among these was the great classical Greek artist Polykleitos. Here we see his *Diadoumenos*—an athlete crowned with the victor's *diadem* (that ribbon around his hair). The Met is fortunate indeed to have this beautifully restored first-century-AD copy of the now-lost bronze fifth-century-BC original. (By the time the copy was made, another greater power—Rome—would have risen in the Mediterranean, and its wealthy merchant class often commissioned copies of Greek statuary to adorn their villas.)

Diadoumenos's relation to his Kouros ancestor of just 150 years before should be clear. Celebrating his perfect body, he is nude as before. And his musculature is even more perfect, perhaps drawn from a human model but more likely the artist's perfect image of a human model. And like the Kouros, he is free of the stone, even

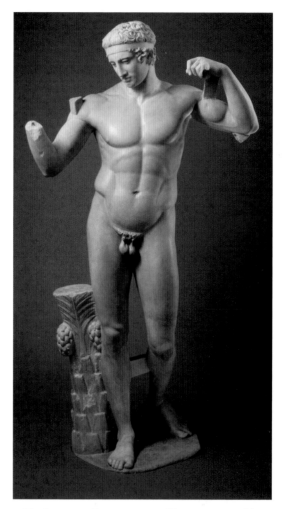

Diadoumenos, Roman copy of bronze original by
Polykleitos from the mid-fifth century BC, AD 69–96

more so. He is very much here, very present. You might find it
hard to resist squeezing his calf to see if it actually flexes. (But do
resist. They have some big security guards at the Met.)

But there is something more here—something deeper, more compelling. Like the *Kouros*, this god-man is confident. Sure of himself. And, underscoring the artist's point, that confidence is almost casual, maybe a little arrogant. He is looking into the future, and he almost seems to see victory. He is poised firmly on his two feet but, unlike his forebear, is not glued to the floor. In his controlled forward twist, what art historians call classical *contrapposto*, Diadoumenos seems both still *and* about to advance forward at the same time.

He is a young man of both virtue and profound physical capability. He is perfect. He is a god on Earth. Who needs Heaven when Heaven is here already?

The mood of the moment is captured almost perfectly by the Greek philosopher Plato:

> But if it were given to man to gaze on beauty's very self—unsullied, unalloyed, and freed from the mortal taint that haunts the frailer loveliness of flesh and blood—if, I say, it were given to man to see the heavenly beauty face to face, would you call his, she asked me, an unenviable life, whose eyes had been opened to the vision, and who had gazed upon it in true contemplation until it had become his own forever?[1]

By the way, this Greek celebration of gods as men, or perfection on earth, was not limited to men, though male athletes and warriors drew much of the artists' attention. Many statues of the Greeks' "perfect woman," Aphrodite, the goddess of love, also survive (again through Roman copies). This statue, attributed to another of the great Greek sculptors of the age, Kallimachos, presents this image

[1] *Symposium* 211e, trans. Michael Joyce, 1935.

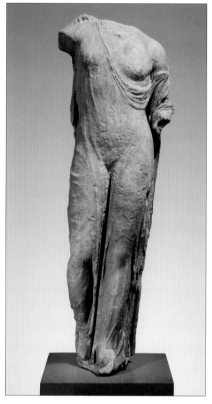

Attributed to Kallimachos, marble statue of Aphrodite,
called the "Venus Genetrix," first-century-AD Roman
copy of Greek original, fifth century BC

of the perfect woman. Let's pause a moment before her, to whom
the Met refers by her Latin name, "Venus Genetrix."

Not only does Kallimachos's Aphrodite seem to be the perfect
woman. As we gaze at the fragment here of her beautiful form
beneath the thin gauze of her toga, we ask, "Was Kallimachos
the perfect sculptor?" His rendition of the goddess is so alluring,
so present before us, it seems as if the sculptor has chiseled her

elegant body completely and then draped a thin veil over her. But of course he didn't. He sculpted her from the outside in. And she's a wonder to behold:

Beauty! Terrible Beauty! A deathless Goddess—so she strikes our eyes![2]

The Greek civilization, arguably, was the leading civilization of its day, and many of its greatest achievements would influence the entire course of Western civilization. The Greeks came up with new political forms, such as democracy, that changed the history of government. Their refined sense of art and beauty set the standards for the rest of the history of art. Their achievements in theater, philosophy, astronomy, and mathematics would forever change the course of human history.

All these great achievements came out of a search for God, for their Creator, who they reasoned was discoverable through logic and reason and who is, in fact, present among us—in fact, *was* us. At least, was the best of us—the most virtuous, the most athletic, the most politically skilled. Who is God? Why, *I* am!

This answer to the age-old question gave them a confidence and daring to conquer the ancient world through the person of their most famous student, a Macedonian named Alexander.

One of my favorite warnings to my investment teams is to be wary of overconfidence bred from success—"Humility at the highs!" We're all guilty of losing our humility just when we need it most, and it's likely that the touch of arrogance we sensed in

[2] Homer, *Iliad*, bk. 3, lines 190-191, trans. Robert Fagles (New York: Penguin, 1990), 134-135.

Diadoumenos crept into the Athenians more broadly as they reached the peak of their power. Their overstepping led to the bloody, thirty-year Peloponnesian War. That war ended in the sack of Athens by Sparta in 404 BC, just twenty years or so after Polykleitos sculpted the *Diadoumenos*. With the two great powers among the Greek cities weakened, Alexander's father, Philip, conquered all of Greece. Then Alexander conquered the world.

But, of course, Alexander died young, and his flash-in-the-pan empire died with him. After him, another Mediterranean power began rising to the west, and man's search for God would take a terrible wrong turn. The godless time of the Romans was coming.

But before heading into the Roman abyss, let us linger just a moment longer here, with Aphrodite. As we gaze on this beautiful image of ancient Greece, we ponder just how close the Greeks came to finding God, finding the perfect being that no man could fully look in the face.

Still, it's time to move on. We have twenty-five hundred years of searching in front of us. And don't worry too much about Aphrodite. She'll be back, and so will Alexander—courtesy of two of the greatest artists of all time, Peter Paul Rubens and Rembrandt van Rijn. First though, to borrow a phrase, all roads lead to Rome.

4

No God but Me

Rome

As it was in the days of Noah, so will it be in the days of the Son
of man. They ate, they drank, they married, they were given in
marriage, until the day when Noah entered the ark, and the flood
came and destroyed them all. Likewise as it was in the days of
Lot—they ate, they drank, they bought, they sold, they planted,
they built, but on the day when Lot went out from Sodom fire
and brimstone rained from heaven and destroyed them all.

—Luke 17:26-29

We've found our way to one of what I call the twelve hidden rooms of the Met. You have to know where to look for them, but they are worth seeking out. This one in particular is a gem; it's a little piece of the ancient Roman Empire preserved for us by a cataclysmic disaster.

The Night before the End: Pompeii

Pompeii, Italy, 79 BC. On the night Vesuvius blew, the wealthy family of Fannius Synistor presumably went to bed, perhaps in this room, happy and satisfied with their life. I often wonder about them. I wonder whether they had had a chance to meet St. Paul.

He may have stopped in Pompeii on his first journey to Rome, as a prisoner on a ship sent from Jerusalem. That would have been just a few years earlier. Had they converted to Christ?

We don't know, but it seems unlikely. Some evidence has surfaced of a Christian presence in Pompeii at the time of its destruction,[3] but few, if any, Christian artifacts were unearthed in this sumptuous villa.

No, this room speaks of an entirely different focus and outlook on life—one that seems more classically pre-Christian Roman.

Roman society adapted for its own religion many gods and deities from the Mediterranean world it conquered, and common Roman daily practice included ritual activity associated with one or more of those gods. In this respect, most historians refer to the Romans as a culture that was profoundly "religious." Unlike the Egyptian theology that had come before, or the Christian movement that began with Christ's death and Resurrection in a backwater city of the empire, however, Roman worship largely focused on placating gods that might, for mere sport, disrupt daily plans and activities. So Roman religious practices were focused more on preserving the things of this world, rather than transporting adherents to the next, the eternal. The focus was on the here and now, and to the extent that gods entered the picture, it seems largely to fit into what we would call superstition rather than belief.

This extended the Greek idea of "men as gods" to its ultimate conclusion, "men as men," with God not really in the picture. Said differently, "there is no god but Caesar" loosely translated to, "there is no God at all."

You can hear this spirituality of the here and now speaking through the art on the walls. One striking contrast with Egyptian

[3] See *The Postil Magazine*, March 1, 2018, and also Bruce W. Longenecker, "The Crosses of Pompeii."

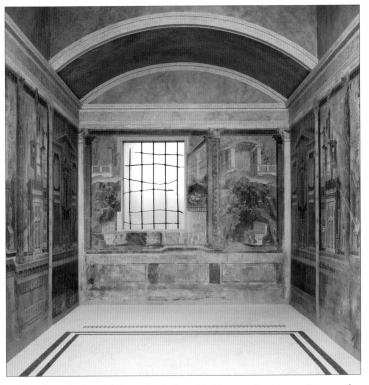

Cubiculum (bedroom) from the Villa of P. Fannius Synistor at Boscoreale, ca. 50–40 BC, buried in the eruption of Mount Vesuvius, AD 79

art that most visitors instantly grasp here is the realistic, three-dimensional nature of the painting, representing a living landscape.

In fact, it doesn't just represent a landscape. It's trying to create the illusion that the bedroom is *in* a landscape. The side walls are portrayed as three-dimensional porticos, with shadowing from the light source at the center (that window you see is the only real window the room had). Through the open porticos, the vista opens to an enchanting, three-dimensional outdoor garden that invites us to enter and visit.

Pilgrimage to the Museum

What a change from the burial chamber of Perneb, painted 2,300 years earlier, with its two-dimensional, almost abstract figures clearly somewhere up in the heavens—and certainly not here in the present! Interestingly, in this bedroom from Pompeii, the only reference at all to something beyond the here and now is the little grotesque faces peering down from above the fake porticos on the room's side walls. What do they mean? Frankly, I don't know. But my guess is that the artist included these superstitious and somewhat mysterious figures not as a form of reverence but simply as a realistic detail that would add to the illusion of a true portico to a garden. Roman architecture at this time commonly included gargoyles like this both for warding off evil spirits and for channeling rainwater off the roof.

It's sad to think about, isn't it? This wealthy family went to bed one night happy, maybe even drunk, with the pleasures of their very wealthy lifestyle as portrayed in their illusionistic bedroom here—and then never arose the next morning. Or worse, arose to a living nightmare and died running to escape it.

"Too bad they didn't listen to St. Paul!" our inner judge snickers.

Then we pause a moment and think about our own lives.

When have *I* been just like Fannius Synistor?

When have I focused too much on the pleasures of the here and now and gotten so distracted by the illusion of comfort in material things that I lost focus on the eternal?

Gulp.

Buried Alive

Cairo, Egypt, AD 160. Roman culture's spiritual emphasis on the here and now, rather than on the eternal or the perfect, really jumps out at you when you examine their images of people. Unlike the two-dimensional abstract figures in ancient Egyptian art, the people in Roman art are three-dimensional solid figures. And

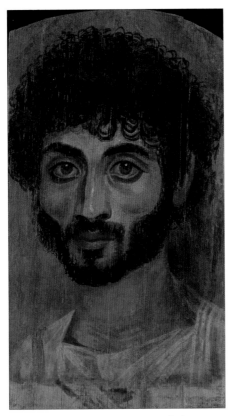

Portrait of a Thin-Faced Bearded Man,
Egypt, Roman Period, AD 160–180

they are real-life representational portraits, not idealized forms, as in ancient Greek art. They depict life in the present, showing little focus at all on something greater, something eternal.

This contrast becomes almost ironic in Egypt during Roman occupation. Rome took over the remnants of the old Egyptian kingdom in the very early days of the Roman Empire. By the time of this remarkably preserved portrait, two hundred years later, Egypt,

culturally, was Roman. Incredibly, this image, painted nearly two thousand years ago, continues to evoke the real-life person this young man must have been. His thin cheeks and high cheekbones suggest that he might have lived life moderately. His well-trimmed beard and curly hair suggest someone who cared about his appearance. He looks out on the viewer with his dark, curious eyes, as if to say, "Hello, who are you? My name is Max." There's just one problem. He's dead.

This young man's portrait was painted on his mummified body. So even as the ancient Egyptian burial practice continued among the wealthy right up to this day in AD 160, the art on the mummy had become Roman—a portrait of the man as he was.

Far from an abstraction of the man as he might now be in the afterlife.

Eternal? Did someone mention eternal? What's that?

A World of Worries on His Mind

Rome, AD 251. The incredibly intact, larger-than-life (eight feet high!) bronze statue of the emperor Trebonianus Gallus is a major treasure of the Met, one of the few bronze statues of this period that survived intact to this day. (It did so by getting itself buried in the mud of the Tiber for sixteen hundred years.) It captures both Roman and Greek spirituality in one fell swoop.

The body of the emperor shown here is nude, strong, and musclebound, idealized in the Greek tradition. (Art historians believe it references the famous Greek statue of Alexander by Lysippos.)

But the head is far from idealized. Rather, it is a portrait of the emperor. We can tell this almost immediately by its imperfection: it's smaller than the body—this apparently was the case in real life. The visage is not handsome, as a Greek god's face would have been. Images on coins minted during Gallus's reign depict the same face we see here on his statue. Yes, this is a real-life portrait,

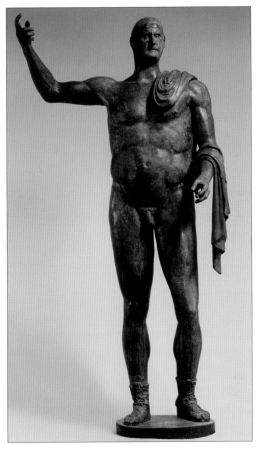

Bronze statue of the emperor
Trebonianus Gallus, AD 251–253

not an idealized form. This is meant to portray the emperor here, not "there."

Gallus's reign as emperor was short and unmemorable. He ascended the throne when the previous emperor was killed in a battle with the Goths in 251; rumors circulated thereafter that Gallus had colluded with the Goths to help them win. Gallus was

made emperor by acclamation of his troops in what was, in effect, a military coup; he died, along with his surviving son, two years later when those same troops abandoned him.

What strikes me most deeply about this statue of Trebonianus Gallus is that face of his. His brow is creased, as if to say, "Hey! I've got the worries of the whole world on my mind! Give me a break!" And worries he had, for sure. In godless Rome, it was "live by the sword, die by the sword"—literally. The only person Trebonianus Gallus could trust was Trebonianus Gallus; and ultimately, that wasn't enough to save his skin.

Trebonianus Gallus was as close as you get to being on top of the world, and what he found there was not happy, joyful, peaceful, or fulfilling.

It was cold, empty, and alone.

He had no God.

No one had his back.

But curiously, almost right next to the statue of one of Rome's most godless emperors hangs the bust of its most godly one. We'll turn to him now.

Europe Pivots toward Eternity: Constantine

Constantinople, AD 325. In the seventy-five years following the death of Trebonianus Gallus, the Roman Empire was almost always at war. One weak, unmemorable emperor followed another. The Germanic tribes to the north took advantage of the chaos to raid across the weakly defended border. The economy spiraled downward.

Every so often, the emperor of the moment would decide to persecute the Christians. They refused to worship the emperor as divine! Everything must be their fault.

Amid this tumult, a giant of a man rose to power. Marching on Rome, he had a vision of a cross in the sky. Adopting that

sign as his own, he faced the much larger army of his chief rival, Maxentius, in the spring of 312—and defeated him. Constantine entered Rome, victor and Christian, under the banner of the cross.

Constantine reunited the far-flung reaches of the empire under one rule and, at the same time, moved the empire's capital to a new city on the very edge of Europe—in what is now Istanbul. It had been the little town of Byzantium, but Constantine built it into a great imperial capital. During the Middle Ages, this great city on the Bosporus would bear his name: Constantinople.

By the time Constantine became emperor, the nascent "Way" —that is, "Christianity"—had grown from a small collection of fishermen distraught after Jesus' Crucifixion to an empire-wide phenomenon. Some historians suggest that, by now, Christians made up the single largest religious group in the population. This growth occurred despite routine persecution, most recently under Diocletian, just before Constantine came to power. Diocletian's was the most gruesome of all the persecutions, with thousands of Christians martyred for their Faith.

Still, the Christians kept coming, conquering hearts and minds with a new, very different message: that we are all sons and daughters of a loving God, that He sent His Son to save us, and that if we follow His Way by loving God and loving our neighbor, we can reach eternal life in Heaven. This hopeful, joyful, confident message conquered the empire.

Constantine himself devoted the rest of his long life to the Christian God and, by most accounts, lived as a devout Christian even as he led the revival and rebuilding of the old empire from its new capital, Constantinople.

Constantine's colossal bust, a full thirty-seven inches in height and originally attached to what must have been a colossal full-body statue, was erected in Rome early in the new emperor's reign,

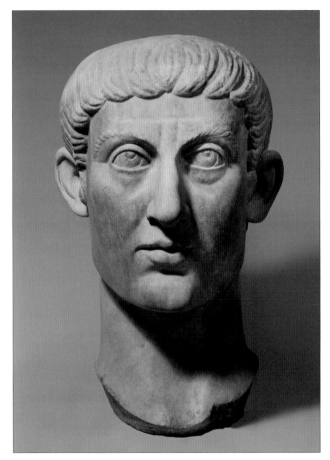

Marble portrait head of the
emperor Constantine I, AD 325–370

probably before he moved the capital east. It hangs, quite helpfully
for our purposes, on the wall just to Trebonianus Gallus's left and
stands in stark contrast to the earlier work. Whereas Gallus's face
is creased in worry and concern about the world and his role in
it, Constantine projects calm serenity and confidence.

Now, Constantine had at least as many problems to deal with as Trebonianus Gallus did—not least the quarrels among the Christians themselves that would lead him to call the Council of Nicaea, which gave us our Nicene Creed. Yet Constantine looks like a man firmly in charge, looking ahead.

In fact, his gaze seems to be transfixed not on us but on something else, something outside our space.

Could it be that cross he saw in the sky before the battle for Rome?

Think about the difference between these two men, Trebonianus Gallus and Constantine. What role did God play in each of their lives? What role does God play in mine?

Constantine seems the more admirable for sure, but isn't there a little of both of them inside me?

After all, don't I share Gallus's penchant for ignoring God's agenda and pursuing my own? And when I do, don't I also find my forehead creased with worry?

When have I gone out the door in the morning with the face of Trebonianus Gallus rather than the face of Constantine?

How often have I left God out of my equation and decided to go it alone?

On the other hand, there were times when I followed God's will, not mine. In those cases, despite the challenges, the outcomes were so much better!

Constantine. Get me more of that guy! That's the face I want!

Placed as he is on the very threshold of history, Constantine seems to be looking out at something else as well: to a new age, which historians used to call the "Dark Ages." They were tough years, to be sure, for political and economic stability and for the advancement

of learning and recording of history. The Middle Ages in Europe, however, were also rich in spirituality anchored by Christianity. This new religious orientation, very different from the Egyptians' "men as gods," the Greeks' "God as men," and the Romans' "there is no God," was at once more confident, more joyful, more loving, and more hopeful. Indeed, from a spiritual context, you could call the Middle Ages not dark at all. In some respects, they could be called the "Light Ages."

And to find them, we're going down into the depths of the museum.

You Are God, I Am Not

The Middle Ages

Turn to me and be saved, all the ends of the earth!
For I am God, and there is no other.

—Isaiah 45:22

The area we will now visit is not the most popular part of the museum. We have to go back from the Great Hall and then under the Grand Staircase until we find ourselves in a kind of stone cavern that was literally buried inside the Met for more than a hundred years before being recently opened and transformed to a small gallery under the main staircase.[4]

It's strange that we have to go under a staircase to be lifted up to Heaven.

Lifted up to Heaven

Palestine, Byzantine Empire, AD 620. Although the western half of the Roman Empire would fall to the various Germanic invasions

[4] Often this is true. When this book was published, this little Ascension had been picked out for a temporary exhibit of late-antique art.

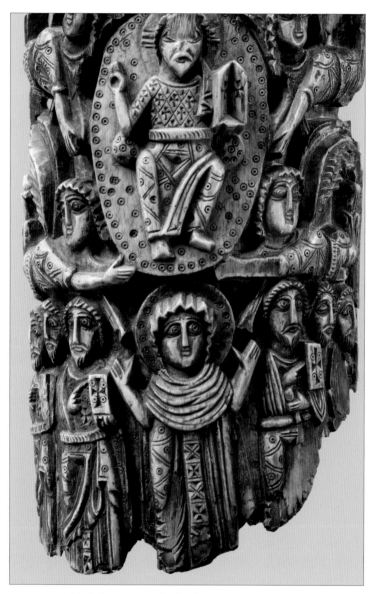

Tusk fragment with the Ascension, Byzantine,
720–970 (radiocarbon date)

of the fifth century, the eastern half would carry on for nearly a thousand years more, based in the great capital city that Constantine had built for it, Constantinople. Modern historians call it the Byzantine Empire, but the Byzantines never used that term; they always called themselves Romans.

In this eastern empire, a new style of art would evolve, very clearly distinct from its Roman roots.

In fact, Byzantine art, with its spiritual focus on the afterlife and the eternal, not the present, had more in common with ancient Egypt than with ancient Rome. Whereas Roman art sought to represent a three-dimensional, lifelike illusion of the present, the art of the early Christians and Byzantines deliberately departed from this art form toward a more abstract and two-dimensional design. While the Egyptians used this form to display their own expected life in the eternal as gods themselves, the Christian artists adapted the Egyptian formula to create spiritual works rooted in post-revelation theology.

Virtually all the surviving art from this period, created within a deeply Christian culture, focuses on the afterlife—and, in particular, on Christ and the saints. Most of these pieces were designed as devotional tools, to bring the viewer into the spiritual realm on the right footing. This foundational premise is probably best summarized by the first meditation in the spiritual exercises of St. Ignatius: "You are God, I am not."

One of the oldest examples of this early Christian art at the Met is this ivory tusk fragment from the Levant, the eastern Mediterranean. According to the Met, carbon dating suggests that it was created somewhere between 720 and 970, after the conquest of the Levant by the Islamic Kingdom in the 630s. At this time, there were still a lot of cultural crosscurrents between the earlier Byzantine and later Islamic cultures, though this remnant is entirely Byzantine in its spiritual conception and perhaps may have

been carved even earlier, prior to the conquest. But whether it was carved while the area was still under Byzantine control or was carved secretly under Islamic rule, the tusk is spiritually Byzantine.

I've heard casual viewers of early Christian art describe it as "childish." It looks as if it were carved by an amateur, they say. I think this prejudice is akin to concluding that the works of Jackson Pollock and other American abstract expressionists (don't worry, we'll get there eventually!) are also childish and reproducible by any six-year-old with a can of paint and a canvas. But if we learn to think like a Byzantine Christian, this art can still lift us up to Heaven for a moment, as it was intended to do.

In this aged, worn, partial fragment, representing the resurrected Christ, the apostles and Mary look up from the mountaintop to Jesus ascending to His throne. They speak to us with reassuring words of love and peace. All the figures are depicted in a two-dimensional, otherworldly space, transplanting us from our present physical world to a world of the spirit. In this abstract realm, the ascended Jesus is very much present, alive, and, as always, teaching and leading us.

This Byzantine artifact gives us a good chance to do a mental reset. We've been in the very physical world of Greece and Rome. Now we're entering a much more spiritual realm. We're in a world that has been fundamentally changed by the Resurrection.

Contemplate that fact of history for a moment. Without it, Jesus would be just another interesting historical figure, a prophet martyred at the hands of the Romans in AD 33. The Resurrection changes all that. The Resurrection allows us to see Jesus as He truly is, the beloved Son of God, reigning forever over Heaven and Earth. And it makes us, through Him, who we are: sons and daughters of God, so beloved and cherished that God Himself would come down to earth to save us from ourselves.

So ask yourself this: Do I have as much faith in the Resurrection as the artist who carved this tusk, perhaps in the last days of the Byzantine Levant, on the eve of the Islamic conquest?

As a Christian, do I radiate the same confident joy and serenity as Mary and the apostles do in this little image?

It's something to reflect on as we walk a few steps to consider an even tinier work of art from the middle of the Middle Ages. We're staying in Constantinople, but we're moving forward several centuries.

Adoring Christ in Heaven

Constantinople, 1100. Constantine had chosen his capital city well. The Bosporus is the only way for a ship to pass between the Black Sea and the Mediterranean—and it's a very narrow strait. It's also the traditional line between Europe and Asia. Constantinople was the gateway between the continents.

With the Asian-European trade that passed through its gates, Constantinople would grow to become one of the most affluent cities in all of Europe. Islamic forces from North Africa and the Middle East would gradually whittle away at the empire's outer reaches, but Constantinople held strong. And its art stayed true to its spiritual emphasis. Although its arts would grow increasingly elaborate and expensive to create, the spirituality of its art would remain consistent with the early form represented by the Ascension fragment we just spent time with.

Here, in a little nook off the main Medieval Art Gallery (shaped, by the way, like a medieval Romanesque cathedral), one of these Byzantine treasures of the Met is on display in a small glass case: "Medallion of Christ from an Icon Frame." It's not even a complete work of art we're looking at here: it's a small piece of the border from a work of art that's now lost.

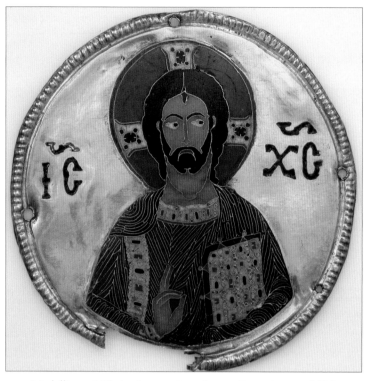

Medallion of Christ from an icon frame, Byzantine, ca. 1100

There are several of these little medallions on display here. They were originally arranged around a larger icon in the center, probably of the archangel Gabriel.

The Met's arrangement of the nine medallions it has (the remaining three are missing) gives us a sense of the overall spiritual effect this richly decorated icon must have conveyed, with a plethora of messages and teachings crammed into the overall miniature frame. The one we're looking at is barely two inches across, but since it's Christ Himself, it's appropriately at the top in the center. His outstretched hand seems to be assuring us that we should "be

not afraid." Christ is flanked, formulaically, by His Mother, Mary, on His right and St. John the Baptist on His left; these two are pleading our case with Him while He, in turn, pleads it before the Father. Beneath this spiritual triad is a virtual "dream team" of saints looking up to Christ on our behalf: Sts. Peter and Paul; the evangelists, Matthew, Mark, Luke, and John; and supporting the group in the center at the bottom, St. George.

With a gold backdrop and a multicolored glass glaze, delineated with the finest of gold lines to keep the glass colors from blending into one another, this set of medallions must have been extraordinarily costly to produce. Each color of glaze—some colors made of ground precious stones—would have been individually fired before the next could be meticulously applied.

These were, in every sense of the term, sacred objects.

Byzantine icons follow an instantly recognizable formula that reflects Byzantine spirituality. The gold backdrop suggests the heavenly realm the subject inhabits. The two-dimensional figure seems disembodied and otherworldly, and the symbolism is rich. It brings us in prayer and supplication into the presence of God, who inhabits an incomprehensible spiritual realm that we are not part of yet but hope to be soon.

We are here, in the present. God is up there, in a mysterious, otherworldly place called Heaven.

Then, Fr. Shawn points out, there's the matter of the halo. This is why it's useful to have a priest come with us on our tour.

The halo is not just on Christ. It's on all of the other saints and apostles in the composition. What's that about?

"The halo of Christ," say Fr. Shawn, "symbolizes His divinity as the God-Man. The fact that the other men and women in the composition also bear His halo symbolizes their sharing with Him, and through Him, a place in Heaven."

So it means these people in the other medallions are with Christ right now?

"That's right," Fr. Shawn tells us. "All the people we see here are not just historical figures. They're all present-day figures, alive and well, albeit in a spiritual realm, not in a worldly one. Christ's divinity, His eternal life in Heaven, is shared with all of us who, like the saints before us, take up our crosses and follow Him."

Our world has grown much more sophisticated and complex since the time of the Byzantines. Scientific advancements have opened new horizons and a richer understanding of the universe around us. Yet, as we stand before this little icon fragment, somehow a stillness overcomes us. A sense of place, of truth—a sense that, somehow, I *do* fit into a plan. And that plan includes me in something far bigger than the present limitations of life here on earth.

In the glimmer of this miniature icon from what historians used to call a "darker" era, I am enlightened.

I know my place again.

And I can see the path home. Through Him.

That's a beginning.

And now you might wonder why I'm reaching into my pocket for my phone. Well, it's because this is one of those places where I have to cheat a little.

Turin, Italy, twenty-first century. Before you run to the Met to see the Shroud of Turin, let me assure you that it isn't there. And no, we're not going to weigh in here on the mystery of the Shroud. Whole treatises have been offered on it.

But I can't help briefly showing you the image of the face on the Shroud. Look at it next to the image of Christ on the medallion. The picture on my phone is bigger than the medallion!

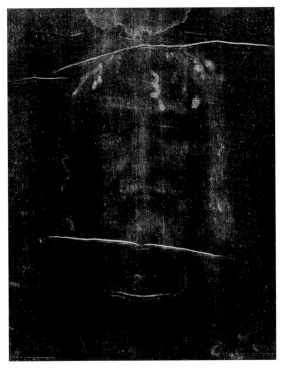

Image on the Shroud of Turin, Turin, Italy
image courtesy of Wikimedia Commons

The thing I want you to notice is how closely the face on the Shroud resembles the face on the Met's little icon. Notice such features as the rounded, bushy eyebrows, the mid-length beard, and, of course, that handsome long, thin nose.

If the Shroud of Turin really is an artifact of the Resurrection, how did it end up in Turin? One hypothesis is that it was moved from Jerusalem, just prior to the Roman destruction of that city in AD 70, to Edessa, where it became known as the "Edessa image." Later, it seems to have been moved to the Byzantine capital of Constantinople, where it remained until the city's sacking by

the French in the Fourth Crusade in 1204. From there, it could have traveled to France with the French King Louis VIII and eventually to Turin.

Byzantine documents make occasional references to something they call the "Mandylion" or "Four-Fold," and some scholars believe there is evidence on the Shroud of its having been folded in this way for what would have been several centuries. They theorize that the Byzantine "Mandylion" was folded in four, revealing only the face of Christ on the Shroud, in order to avoid displaying Jesus' naked body.[5] I'll confess that after listening to all the evidence, I believe that the Shroud is not a forgery and that the image on it is Christ's. And if so, it is likely that the Shroud would have been viewed occasionally in the Byzantine court and could have at least been the remote inspiration for the images of Christ typically seen in Byzantine icons.

If so, He is definitely God, and we are most definitely not.

Now it's time to move from the East to the West, from the very edge of Asia to the heart of Italy. Fortunately, it's not much of a journey in the Met. We'll find that the Byzantine style has followed us. In fact, we could say that the Byzantine style will turn out to be the foundation of Western European art.

An Icon for the Ages

Lucca, Italy, area of Byzantine influence, 1230. In the mid-500s, the Eastern Roman Empire reconquered much of Italy, and for centuries after that, the Byzantines kept a foothold there. Although

[5] John Long, "The Shroud of Turin's Earlier History, Part One — To Edessa," Associates for Biblical Research, March 14, 2013, https://biblearchaeology.org/the-shroud-of-turin-list/2284-the-shroud-of-turins-earlier-history-part-one-to-edessa.

the Byzantines lost control of their lands in the Italian peninsula during the eighth to tenth centuries, they continued to exert a strong influence on the area well into the later Middle Ages. In fact, Byzantine cultural influence on Italy increased in the thirteenth century, following the sack of Constantinople in 1204 by the armies of the Fourth Crusade. That was the pillage that *might* have brought back the Shroud of Turin. But whether or not the trophies won included the Shroud, the Crusaders certainly brought many of Constantinople's artistic treasures, including its famous icon paintings —

Here Evelyn breaks in. "Or, Steve, in the vocabulary of Orthodox Byzantium, icon 'writings.'

"Byzantine icon painters were generally deeply spiritual souls, even mystics. Many were probably monks. They didn't view their icons as objects of art that they had created. Rather, they viewed them as works of the Holy Spirit. Indeed, before attempting a new icon, the icon painter would often fast and pray for forty days and forty nights, to commune with the Holy Spirit. He then painted, or 'wrote,' what he had been inspired to do."

Constantinople's icon masterpieces flooded into northern Italy just as the deeply religious Middle Ages of Western Europe were in full swing. They influenced medieval artists everywhere, especially in northern Italy, and certainly in the area of Lucca, where Berlinghiero executed this shimmering example of a Byzantine icon, transporting us to another world.

Evelyn has made a special study of this painting. She can point out that the icon shares with our earlier medallion of Christ many stylistic techniques to suggest we are in Heaven here, not on Earth: the abstract, two-dimensional figures, the halos on the subjects, and the gold-leaf backdrop. Not Peoria, to be sure. Or Lucca, for that matter.

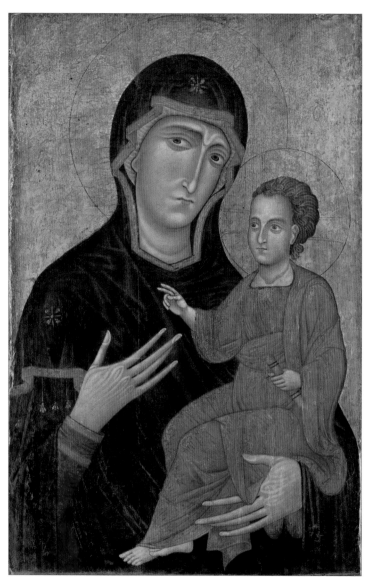

Berlinghiero, *Madonna and Child*, possibly 1230s

Here, Berlinghiero has adopted for his subject matter the very popular Hodegetria, or "one who shows the way." Mary is that "one," gently holding—no, *displaying*—her young Son for us to see. The long, gentle, almost abstract digits of her right hand are pointing to Him, alerting us to where we need to fix our gaze. Her ears are enlarged, to suggest that we keep our own ears wide open, to hear His Word—which, by the way, He carries tucked away in that scroll in His left hand. Her lips are small and sealed, advising quiet—as if she's saying, "Listen, don't talk. It's the only way to hear His gentle voice telling you what to do."

Look closer at the Christ Child. "Why, He's not a baby at all!" No, He's not. And that's the point. In this image of the Hodegetria, He's already teaching us, as He looks out from His seat on her arm, gesturing "Peace be with you" with His right hand.

The more Evelyn looks into this painting, the more she stirs up in the details. It is rich with medieval symbols and allegories that point to the heavens. The stars on the Virgin's head and shoulder, for instance, stand for her virginity before and during the birth of Christ. The third star, which stands for her virginity ever after, is hidden by the Child Himself, but Berlinghiero's audience would have known it was there.

We are now firmly in another world. A spiritual one.

Time to visit Heaven.

But first I'm going to take you into the studios of a cable news network, which you might think is kind of in the opposite direction.

Heaven on Earth in an Abbey Chapel

Fox Business Studios, New York, Tuesday morning, April 15, 2019. On a dark Tuesday morning during Holy Week, I received a call at five o'clock from Fox Business. "Steve, you're scheduled to be on

later this morning. Can you get here at six o'clock instead? Maria would like to talk to you about your new book, *The Missionary of Wall Street*, and the fire at Notre Dame."

The great cathedral had caught fire the night before, and it was still burning.

The analysis all night long from the scientific and archaeological community had been pretty banal, in my view. There was careful review, for sure, of the damage to the great cathedral's stone structure, the overheated mortar holding together its skeleton, the unprotected wooden roof, and, of course, its magnificent flying buttresses.

But all of this left me a little cold. It was scientifically correct, but frankly, it missed the point, from a practicing Catholic's perspective.

"I'll be right over."

I hopped in a cab and was soon engaged in one of the most unusual market interviews I had ever had. We did get to the markets, eventually. But not before we discussed what was really going on here.

"You see, Maria, for a Catholic, a church is where Christ comes to us, physically, in the Sacrifice of the Mass. In the Middle Ages, they were keenly aware of this. They built those flying buttresses not for their own sake, but for God's. They were designed to take the weight of all that stone off the walls themselves, so that the walls could be glass. And not just glass but stained glass that glimmered across the space within it. This is the closest we get to Heaven on Earth. For many Catholics around the world, watching Notre Dame go up in flames last night was like watching Heaven burn."

This brings us to our next destination at the Met.

We have a little piece of Notre Dame de Paris right here—which means that we have a little piece of Heaven. Well, not *exactly* Notre Dame—and not *exactly* Heaven. But it's a piece of St. Louis IX's Sainte-Chapelle, a small medieval chapel from the same neighborhood in Paris. We have two of its stained-glass windows in front of us now.

Saint-Germain-des-Prés Abbey Chapel, Paris, France, thirteenth century.
The abbey chapel of Saint-Germain-de-Prés sits just a few blocks
across the Seine from Notre Dame and was first built in the sixth
century to house a relic of St. Vincent of Saragossa. The church was
burned, looted, and rebuilt multiple times over its storied career and
still stands in the sixth arrondissement of Paris. Many of its original
stained-glass windows have been lost, with just fragments scattered
around museums in the United States and in Britain. The Met has
this one, along with a few others at its special medieval wing in
the Cloisters, uptown. The stained-glass windows we are standing
before now were constructed in the thirteenth century, not long
after Berlinghiero completed his icon of the Madonna and Child.

Thoughtfully, the Met has placed these backlit windows on a
wall within the dark, Romanesque-style cathedral gallery in which
other important elements of its medieval collection are housed.
With this placement, we can almost transport ourselves back in
time to the great Gothic chapel in which this window once hung.

So imagine yourself in Paris of the 1200s. All around us, light
shimmers through the multicolored glass of these tall, fragile
windows that soar to the heavens. Beyond the spectacular visual
fireworks, every window is designed to tell us a story, to educate
us. Most of the stories are from Sacred Scripture. Since most of
us at this time can't read, this is our catechism class.

The window we are studying tells us part of a story not from the
Gospels but from one of the early followers of Christ, St. Vincent,
who was martyred for his Faith. Here we see only half of the story;
the rest is on a panel that used to be next to this one and is now
at the Walters Museum in Baltimore.

The story of St. Vincent is set during the great Diocletian per-
secution of 300 to 304, just a decade before Constantine. It's now
the waning days of the godless empire; our old friend Trebonianus

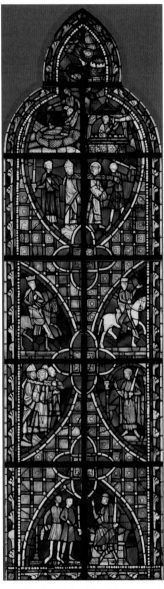

Scenes from the legend of St. Vincent of Saragossa
and the history of his relics, ca. 1245–1247

Gallus has been dead for fifty years. Barbarians are increasingly at the gate, and the Roman economy has tanked. The emperor Diocletian attempts to control what must have been a runaway inflationary impulse, instituting price controls. When that doesn't work, he turns to an old standby: "Round up the Christians and execute them!" Easier said than done. Some estimate that there may have been more than a million Christians practicing their Faith in the empire at this time.

In the scene before us, reading from left to right and bottom to top, we see first the governor Dacian commissioning his soldiers to arrest the bishop of Saragossa. In the scene just above it, the bishop of Saragossa and his deacon, Vincent, are called before Dacian to explain their refusal to acknowledge the emperor as a god. Instantly we notice who has the halo of sainthood here; it's not the bishop—it's Vincent, the deacon.

There's a lesson right away! The call to holiness, to sainthood, is not limited to the clergy; we are *all* called to be saints.

The bishop, perhaps to his good fortune, has a speech impediment, so St. Vincent does the talking.

The middle panels might confuse a visitor from the twenty-first century, but here in the thirteenth, we have the context to understand that they're telling a related story, showing how King Louis VIII gave a relic of St. Vincent to the abbey in 1215. That's why St. Vincent's story is on these windows, so the middle panels give us the context that any Parisian of the 1200s will understand.

Now back to our regularly scheduled story of St. Vincent, already in progress. Dacian doesn't like what he hears, so he has both Vincent and the bishop led off to the dungeons, where gruesome tortures await them. The paired adjacent window—which we don't have here—shows some of the worst that St. Vincent endured: the rack, the floor of broken pottery shards, and then back to the

rack for another round. Try as he might, the governor can't break Vincent, who stoically, even joyfully, bears all that the governor's torturers can dish out.

As Vincent endures, much to the governor's consternation, the ranks of the Christians keep growing. Finally, Dacian allows a visit by Vincent's friends to his cell, where they lay him in a linen bed; the Lord takes him at this moment, and Dacian is denied further sport.

Hoping to end all further veneration and even knowledge of the deacon, Dacian has Vincent's body attached to a millstone and cast into the sea; this is shown in the upper panel of the window at the Walters. In the upper panel of our window here at the Met, we can see an angel releasing the body from its millstone, so that it can float safely back to land and the Church, while taking Vincent's soul up to Heaven and eternal peace.

As the light streams through the story of St. Vincent of Saragossa, we begin to feel as if we're part of the story. We see history from Heaven's point of view. We're in Heaven ourselves—only for a moment, perhaps, but a moment we'll never forget.

One of the great ironies, or maybe truths, of the St. Vincent story partly explains how this panel came to be here at the Met. Like the Christians under Diocletian, stained-glass windows themselves were the subject of a great persecution of the Church during the mob rule of the Reign of Terror in the early 1790s in Paris. The good monks, seeing the end coming, quickly took down from their chapel's walls the precious stained-glass windows within whose light they had offered the Sacrifice of the Mass. The windows were buried safely in a farmyard outside the city and were unearthed years later; the monks had long since disappeared, swallowed up in the holocaust of the Terror. The chapel's many panels were divided up and sold to private bidders, one of whom brought this

window back to New York. Here, hopefully, the windows will be protected for generations to come. They serve as a silent reminder of what happens to our humanity, our spirituality, when the terror of the mob rules.

Now back to Italy. Wonderful things are just beginning to happen there.

6

God Comes into the World

The Proto-Renaissance

*"Behold, a virgin shall conceive and bear a son, and his name
shall be called Emmanuel" (which means, God with us).*

—Matthew 1:23

Tuscany, Italy, 1300. As the Middle Ages advanced in learning and
trade, and particularly following the "best-selling" book on the
Far East produced by Marco Polo on his return from the court of
Genghis Kahn in 1300, the vision of the medieval world began to
broaden and to open. Florence, situated in the Arno River valley
along the main land route from Venice to Rome, developed into
a relatively open economy for trade and finance, bringing wealth
and power to the city-state. Just as in Athens centuries before, that
wealth and power brought the development of the arts.

The confluence of wealth, art, the opening of the mind, and,
of course, a deeply religious cultural milieu began to push art in
a new direction, one based more on Earth than in the world of
the spirit.

Two artists, in particular, crashed upon the medieval scene
with an almost revolutionary style that would forever change the
course of art, ushering in what art historians now call the "proto-
Renaissance." These two men were Giotto di Bondone of Florence

and Duccio di Buoninsegna of nearby Siena. And, in part, thanks to the Met's longest-tenured director, Philippe de Montebello, we have rare examples of both proto-Renaissance greats here in New York.

Art Begins Its Quest to Paint the Soul

Siena, Italy, 1300. By 1300, the economy of greater Tuscany was booming, and Siena was no exception. The great Siena Cathedral had just been finished, and plans to build one several times larger, using the current cathedral as the transept, were already in the making. One of the artists engaged by the city to provide the religious paintings for the great church was Duccio. But before he would complete his famous Maestà altarpiece in 1312, he produced a smaller devotional painting meant for a private viewer in prayer. The little painting—a mere eleven by eighteen inches—changed Western art forever.

Thanks to Montebello, who purchased it for the Met in 2004 for the controversial price of forty-five million dollars, it is available for viewing here in New York City. (For the full backstory of this purchase, see Montebello's book with Martin Gayford, *Rendezvous with Art.*)

To many casual visitors, this Madonna and Child, at first glance, looks similar to the Byzantine icon paintings, familiar to us from the Berlinghiero, on whose spiritual and artistic heritage it draws. Key elements of the Byzantine formula remain very much intact, including the gold backdrop signifying Heaven and the pose of Mary, cradling the Baby Jesus in her arms, her eyes firmly focused on Him, our God.

But look again. Something very different is happening here.

Notice the balustrade along the bottom of the painting. It is not part of the frame. Duccio painted it as if to invite us to look in on this scene through the window of an inn in Bethlehem, not in Heaven—as if it is *here*, on Earth.

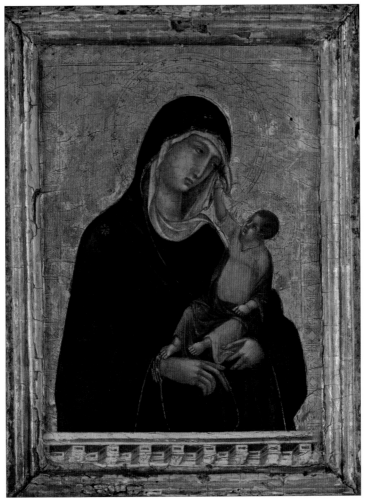

Duccio di Buoninsegna, *Madonna and Child*, 1300

Then look more carefully at the interplay between Mary and
Jesus. In her eyes you can see not just her symbolic focus on our
Lord and Savior, but her inner thoughts as a mother, contemplat-
ing the future as told to her through the angels, the shepherds,

the magi, and the prophets she had met, keeping "all these things, pondering them in her heart" (Luke 2:19). There is melancholy there, worry, concern, sadness, and resignation: her *fiat*—be it so—to God to stay the course, to fulfill her mission.

Then consider the Christ Child. Here is no distant symbol of the eternal God but rather, an extraordinarily empathetic, caring Person here on Earth, present. Sensing His Mother's pain, He reaches up with His tiny arm to console her, as if to say, "It's all right, Mom. You're doing the right thing. It's all going to be fine. This is all part of my Father's plan. I'm here to save you, and to save all of humanity."

In this one small painting, in this one gentle interplay between Mother and Son, Duccio changed everything. Art would no longer be about portraying to the Christian believer the abstract world of the spirit above. It would now pursue a more difficult, more challenging mission. In the world of a flat canvas and a painter's brush, it would now undertake to portray the life within, the very soul of man himself.

The Emmanuel Moment: God Becomes Man

Florence, Italy, 1300. Although the hilltop town of Siena was in the orbit of, and the occasional rival of, the rising metropolis of Florence, Florence was better situated along the River Arno to lead the economic and cultural charge into Europe's "Reawakening." As interest in the arts expanded, there rose a school of artists competing with one another, as well as supporting one another, that would bring religious art once and for all back to planet Earth and out of the spiritual heavens.

Chief in this movement was Giotto di Bondone, Florence's art champion and answer to Siena's Duccio.

Giotto's most famous works are his fresco cycles in the Scrovegni Chapel in Padua and the upper church of the Basilica di San Francesco in Assisi. The Met's collection includes one of the rare Giotto

paintings that are not frescoed into the walls of great churches, and it hangs here just opposite Duccio's masterpiece. It is called *The Adoration of the Magi.*

Although not a monumental work like Giotto's great fresco cycles, this panel from a larger altarpiece (we don't know where it was originally installed) is a good example of the revolution in European art that historians credit to Giotto. This revolution was as much a spiritual awakening as it was a stylistic one, and as usual, these two forces are inseparable.

Giotto di Bondone, *The Adoration of the Magi,* ca. 1320

Giotto has retained a touch of the Byzantine gold backdrop of Heaven in the skies above the manger, from which the angels emerge. But the rest of the scene is—in one of the first instances since the Roman era—firmly rooted in the world as we know it. Mary rests in a manger that is three-dimensional, with the figures in the foreground brought further into our space through the careful use of perspective. Importantly, all the figures are sculpted and shaded to give them Giotto's classic sense of weight and life, with the three kings and Joseph firmly grounded in a crude landscape. These are real people whom Giotto is painting here, inviting us into a real event that occurred here on Earth.

To give his figures even more humanity, he borrows from Duccio by adding some human drama to the scene. The lead king kneels before the one true King, placing his own earthly crown on the ground. It seems as if he has spontaneously been inspired to hold the Christ Child himself, reaching out and taking Him up from His humble crib, while Joseph and Mary look on with a bit of anxiety, if not alarm. "Careful there, your majesty! Have you ever held a baby before? This one is extremely precious! Right now, goal number one is to keep Him safe so He can complete His mission to save the world!"

In this one small panel, Giotto has given art a new mission. No longer would art confine itself to the two-dimensional, spiritual realm of Heaven. Henceforth, the goal would be to bring art back to Earth. From here on, the art world would be completely changed. The Lord our God had come to Earth and become man. This was as far from the Egyptian conception of "men as gods" as it was from the Romans' "there is no God" and the Middle Ages' "God above." It is closer, perhaps, to the Greek idea of gods disguised as men.

But in its combination of humanity, solidity, and clear religious narrative, this *Adoration of the Magi* is, in fact, entirely new. With

this small painting, Giotto is shouting from the rooftops across the ages, "God has become man!"

This is art's Emmanuel moment.

And now we move from two of the most famous paintings in the history of art to one that you probably haven't heard of.

But Evelyn insists, and I've learned it's a good idea to listen to her.

New York, 2010. In one of our early revised tours of the Met following my breakthrough in front of Rembrandt's *Toilet of Bathsheba*, my dear bride, Evelyn, began tugging at my shirtsleeve urgently as we were whisking through the Medieval Art section on our way to the Renaissance.

"Steve! Steve! Stop here. I think this painting would be a good one to include in our new tour!"

It was Lorenzo Monaco's *The Intercession of Christ and the Virgin*, hanging quietly behind the wall that visitors pass every day on their hurried way to the Lehman Wing—or, at Christmastime, to the great Met Christmas tree that stands at the far end of this cavernous Romanesque-style "cathedral."

I wasn't impressed. "Sweetheart, please! Lorenzo Monaco was not one of the top ten Renaissance artists, and we need to keep this focused on the many masterpieces in this incredible museum. It's a spiritual-highlights tour designed for a single three-hour visit, and we don't have to dabble with lesser works."

"Okay, Steve, but I really think we should consider this."

And that was that.

Except that it wasn't.

About a week later, I returned to the museum on my own and gave the painting a second look. This time, I began to see what Evelyn had seen.

I hesitantly added it to our tour, and as we studied and meditated on it further over the years that followed, it grew richer and richer for us—though I think Evelyn perceived where this was heading all along.

It now stands at the very fulcrum of our tour, balancing two worlds at either end of the seesaw. Three thousand years earlier stand the Egyptians—or, one could say, "us"—approaching the spiritual world with a pridefulness that gets in the way of a relationship with our Creator. On the other end sit the moderns—"us" again—reducing art and spirituality to a relativism dependent on our independent views and "consciences," with God and eternity again falling out of the equation.

Right in the middle stands Lorenzo Monaco.

Everyone in His Place

Florence, Italy, 1400. By the beginning of the 1400s, the European art world was in a state of flux. Following the Great Plague of the mid-1300s—which, by some estimates, killed up to 60 percent of Europe's population—Europe was in rebuilding mode. With renewed urgency, artists were struggling to reconcile the ongoing spiritual popularity of late Gothic art (called "International Gothic" by modern historians) and the budding new realism introduced by Duccio and Giotto.

Lorenzo Monaco—"Lawrence the Monk"—was, in some ways, born to address this need for synthesis: he grew up in Duccio's Siena and worked virtually his entire artistic career in Giotto's Florence.

On one level, *The Intercession* appears to be a typical late-Gothic work. The main figures of Jesus, Mary, and God the Father, though having a modicum of earthly weight to them, are clothed in largely abstract, almost decorative fabric. They are placed within

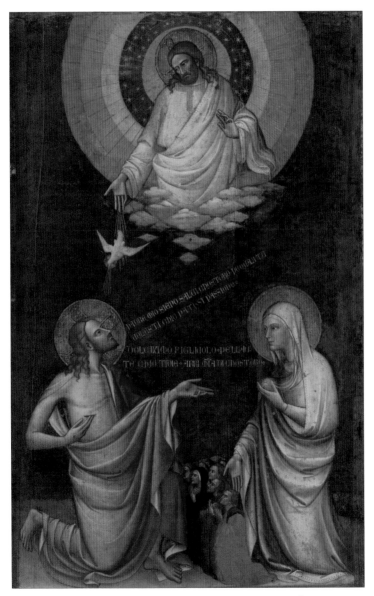

Piero di Giovanni, called "Lorenzo Monaco,"
The Intercession of Christ and the Virgin, before 1402

an ultramarine-blue backdrop, which, at the time, would have been a far more expensive version of the more typical Byzantine gold backdrop, signifying Heaven. (This blue pigment was made by grinding down the rare semiprecious stone lapis lazuli.) We can assume by the liberal use of blue here that this painting was commissioned by a wealthy Florentine patron whose family had, a short generation earlier, survived the Great Plague. The overall effect conveyed by these three oversize figures (*The Intercession* is huge, standing almost eight feet tall) is that they float somewhere in the heavens above, in the world of the spirit.

At the same time, the gestures and dialogue (helpfully scripted in Italian by the artist on the canvas itself) speak perfectly to the mission of each figure within the arc of salvation history.

Mary, the Theotokos, the "Mother of God," is pleading for the penitents: "Dearest Son, because of the milk that I gave you, have mercy on them."[6] She reminds Jesus of her sacrifice for Him — in the fashion of many mothers everywhere — even holding out her breast to Him.

We remember that, at the wedding feast at Cana, Jesus was reluctant to turn down a request from His Mother (see John 2:1-12). Here He looks upward to His Father, pointing to the five wounds of His Passion and pleading, "My Father, let those be saved for whom You wished me to suffer the Passion."

The Father returns Jesus' love and mercy through Him to the sinners, in the form of the Holy Spirit, pictured here as a dove.

In this single, carefully constructed composition, Lorenzo has painted a lasting image of Christian theology, with God the Father, God the Son, and God the Holy Spirit, united by love for each other and for us. Mary is with them in Heaven yet apart from the Holy Trinity. She herself is on her knees, begging to her

[6] These translations come from the Met's catalogue.

Son, Jesus, to seek the Father's forgiveness for us sinners here on Earth. And as we know from the Wedding at Cana, Jesus can't say no to His Mother—"the Gate of Heaven."

This brings us to the penitents.

Though at first we can almost miss them, dwarfed as they are by the larger-than-life spiritual figures who dominate the canvas, on second glance we spy them, crouching together, kneeling humbly before Christ, with Mary gently urging them forward toward her Son. "Go ahead," she seems to say. "Don't be afraid. He'll forgive you if you only ask."

As we stand before this masterpiece created at the turn of the century of the Black Death, we slowly begin to notice something unusual. The artistic style of how the sinners are rendered here is completely different from the style of the larger figures. Not only are the penitents physically much smaller, but they are also shaded and weighted, three-dimensional, painted in the style of Giotto and the coming Renaissance! And what's more, their faces are not idealized abstracts symbolizing a God above; they are individualized, with special little features that suggests that these figures are portraits of real people. But who? There is only one possible conclusion, considering the expense of this painting. The sinners are the patrons, the family who commissioned *The Intercession.*

This is for art the antithesis of the Tomb of Perneb. In his tomb, Perneb the patron had the artist paint him bigger than life, as a god in the afterlife to be adored and waited upon by scores of "little people," just as he was on Earth. A good eternal life if you can get it!

But in this Lorenzo painting, hanging on an almost hidden wall of one of the greatest museums in the world, we have a very different conception of man's place in the world. Across time, these wealthy yet fervent penitents seem to be warning us: "We may have

great wealth, but like everyone else, we won't be taking it with us. And like everyone else, we are sinners who stand humbly before our God, begging forgiveness, pleading for His mercy."

In this single, complex yet simple masterpiece, Lorenzo Monaco has everyone in his proper place. And he used the two styles of painting available to him to do it. One, abstract and in Heaven, drew from the "Light Ages," which were now receding. The other, placed firmly on Earth with great physicality and humanity, pointed to the age of the Renaissance that was now upon us.

As we stand before this perfect synthesis in Christian art, Evelyn asks us all to join her in reciting the Hail Mary:

> *Hail Mary*
> *full of grace,*
> *the Lord is with thee.*
> *Blessed art though among women,*
> *and blessed is the fruit of thy womb, Jesus.*
> *Holy Mary,*
> *Mother of God,*
> *pray for us sinners,*
> *now and at the hour of our death.*
> *Amen.*

Thank you, Evelyn, for helping me to see.

At the Foot of the Cross

Florence, Italy, early 1400s. By the early 1400s, Florence had emerged as a hotbed of economic and artistic activity, and many of the early Renaissance greats—Donatello, Ghiberti, Masaccio, and others—were drawn there. The Medici family, by now the leading financiers of the day, were headed by their patriarch, Cosimo. The Medicis dominated the scene of civic, economic, and political

life in Florence and, by extension, all of Tuscany. Their influence extended even to Rome.

A young, aesthetic Dominican monk, Fra Giovanni da Fiesole, who had joined the monastery at nearby Fiesole as a manuscript illuminator, would eventually be drawn to Florence to paint his famous frescoes on the walls of the San Marco convent. Despite his growing fame, he led an austere, reformed monastic lifestyle. He seemed so spiritually inspired in his painting that many Florentines simply referred to him as "Fra Angelico," the angelic friar. He was eventually beatified by the Catholic Church.

Fra Angelico is the last of our proto-Renaissance painters. His long career actually bridges that period and the full-blown Renaissance that he helped create with his magnificent murals at San Marco. Michelangelo is said to have been inspired by him as he set off to paint the Sistine Chapel ceiling.

The Fra Angelico that the Met has is from earlier, when his style was still evolving, transitioning from the late Gothic world of the spirit to the new Renaissance world of God on Earth. Just a small tempera-on-wood panel, nineteen by twenty-five inches, this little gem is so atypical of Fra Angelico's later monumental style that visitors familiar with the San Marco monastery often don't recognize the artist. Ironic. It's his only work that he signed. If you look closely, you can see "Fra Giovanni" inscribed on the leather strap of the horse on the right side of the scene. "Fra Giovanni," or "Brother John," is, of course, what he called himself before being declared "the angelic monk."

Like the Lorenzo Monaco we just reflected on, this image at first appears comfortably Byzantine or Gothic, with its heavenly gold backdrop covering nearly half the space and all of the background. But here, twenty years after *The Intercession*, all the figures are painted in solid three-dimensionality. They are physically present

with us here on Earth. And not just anywhere on Earth: this is Calvary, the sacred ground where Jesus poured out His life to redeem the world. Paradoxically, in death, He triumphed.

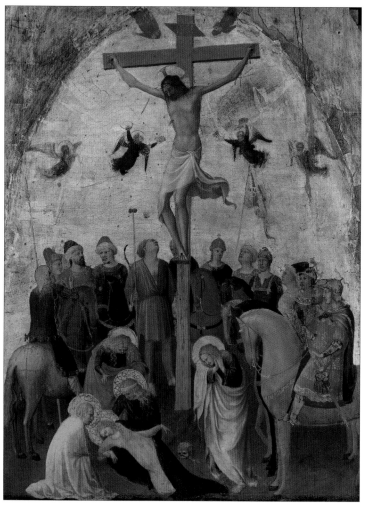

Guido di Pietro, known as Fra Giovanni,
later "Fra Angelico," *The Crucifixion*, 1420–1423

How vividly and dramatically Fra Angelico depicts this scene! Jesus has just breathed His last, attended to from the heavens above by the angels hovering over Him and on the earth below by the five followers who, according to John's Gospel, stood with Him until the end: "his mother, and his mother's sister, Mary the wife of Clopas, and Mary Magdalene" and "the disciple whom he loved" (John 19:25-26). A Roman soldier who had formed part of His torture crew now looks up adoringly, newly converted by the water and blood flowing over him out of Jesus' pierced side. Other soldiers and casual passersby look on, with different levels of understanding of what has just happened.

Then our eyes are drawn to the action down below, at the foot of the Cross. The Virgin Mother, who has witnessed her Son's Passion to the end, has finally collapsed in grief. She's caught by John, whom Jesus had appointed as her guardian just minutes before. His final drops of blood trickle down the Cross to the little group, consecrating them. A skull sits there as well, a symbol of death, of course, but also of Jesus' conquering of death, the Resurrection about to come.

The emotion of this piece, the tremendous grief of Mary as she experiences the gruesome death of her Son, is sometimes frankly overwhelming. What can I say? What can anyone say?

The only thing that seems appropriate is this hymn from the 1200s:

> *At the Cross her station keeping,*
> *Stood the mournful Mother weeping,*
> *Close to Jesus to the last.*
>
> *Through her heart, His sorrow sharing,*
> *All His bitter anguish bearing,*
> *Now at length the sword had passed....*

Pilgrimage to the Museum

For the sins of His own nation
Saw Him hang in desolation
Till His spirit forth He sent.

O sweet Mother! font of love,
Touch my spirit from above,
Make my heart with yours accord.

Make me feel as you have felt;
Make my soul to glow and melt
With the love of Christ, my Lord.

—Stabat Mater Dolorosa

Creation through the Eyes of the Creator

The High Renaissance

You, therefore, must be perfect, as your heavenly Father is perfect.

—Matthew 5:48

Florence, Italy, ca. 1485. Put yourself in a world of infinite possibilities.

It's the late 1400s, and Florence, under the Medici clan, is a thriving commercial and financial center—and the center of the European art world. A new sense of the larger world is in the air: new lands are being discovered. In fact, they say that Botticelli—we'll meet him in a moment—has Amerigo Vespucci, the famous explorer, for a patron. Meanwhile, books are everywhere, because some clever German invented a way to print hundreds of copies of the same book. With all this printing comes a new interest in the learning of classical Greece and Rome, and that touches off a new era of scientific progress.

It seems as though there's nothing we humans can't accomplish if we put our minds to it. And that's especially true in the art world.

At this time, artists are using the scientific principles of precise mathematical perspective to create lifelike architectural surroundings for their religious scenes. They keep the medieval focus on

the spiritual, but they're always trying to outdo one another in depicting saints and angels as perfect, idealized versions of humans. It's as if they're determined to paint *us* through the eyes of God, in His image and likeness, as the perfect beings He wanted us to be.

Long ago, one of my college professors told me a story about two of the most famous artists of the Renaissance. It may be apocryphal, but it's a good story, and it really captures the new mood in the art world. Michelangelo was working on the Sistine Chapel ceiling, and one morning, after he had worked all night, he passed Raphael (who was working in the same building) on his way out.

"Why, Michelangelo," said Raphael, "you look like God Himself coming out of the Sistine Chapel after your night's work!"

"Humph!" said Michelangelo. "I'm not God, but I did just finish His portrait."

The Perfect *Fiat*

This is the time art historians call the High Renaissance. And one of the most famous early examples of the High Renaissance style is here in front of us now. It's Botticelli's magnificent little devotional painting called simply *The Annunciation*.

The precisely controlled mathematical perspective in this painting, the confident three-dimensional architectural space, and the very formal, practiced way the angel and Mary bow to each other all add up to give the viewer a feeling that, while they are entering a real space, it is somehow a perfect space too.

Evelyn has meditated long on this small painting, and her eyes see little details that a cursory glance can miss. Mary's innocence and virginity, her perfect state, are emphasized by the pillars separating her from the angel, who dares not pass through them to enter the Virgin's private chamber. The lush garden, which

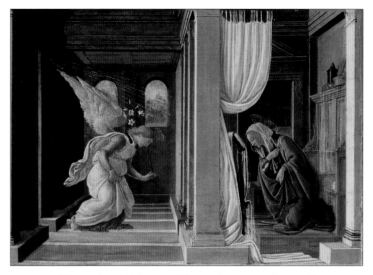

Allessandro di Mariano Filipepi, known as Botticelli,
The Annunciation, ca. 1485-1492

we spy through the window in the background, suggests both
Mary's fertility and her purity. Mary herself bows both humbly
and willingly before this messenger of the Lord, placing herself
into his hands despite the difficulties this mission entailed. The
Holy Spirit Himself is present, as He descends on her in the form
of the rays of light entering her bedchamber as she gives her *fiat*—
"be it so"—to God.

The Annunciation to Mary happened two thousand years
ago, and this painting obviously sets the scene in far too rich
and "modern" surroundings for that time. But it expresses the
spiritual reality. This was the perfect moment in creation—God's
answer to the failure in the Garden of Eden. We can almost hear
the angel's miraculous yet reassuring message: "Do not be afraid,
Mary" (Luke 1:30). The perfect messenger, the perfectly improved
Eve, the perfect yes to the will of God, the perfect Incarnation of

the new, perfect Adam, God's only Son: it would be hard to get better than this.

God Makes a Perfect Lemonade out of an Imperfect Lemon

Florence, Italy, 1456. About a decade after Botticelli was born, a competitor and colleague of his came into the world as a lemon, of sorts. His name was Filippino Lippi.

Filippino's father, Filippo Lippi, was a Florentine monk who had a vocation to paint and eventually developed into an established painter of Florence during the rise of the Renaissance in the early 1400s.

Although he lived outside the monastery, Filippo remained theoretically bound by his vows as a friar. But like many of us, he had his soft spots. You might say he had a whole lot of soft spots: he was known throughout town for his somewhat wild lifestyle. Patrons such as the Medicis would literally lock him in his room in order to extract their commissions out of him, but he'd often sneak out at night by climbing out of a window using a rope of sheets. During the work on one such commission, a painting of the Virgin Mother for a convent, he ran off with a beautiful novice of the convent, seduced her, and with her produced a son: Filippino. Quite the scandal in its day!

Then, surprisingly, the young Filippino would grow up with his father's tutelage to become one of the greatest painters of the Italian Renaissance. A lesson for all of us. Jesus' Church is run by imperfect humans—and some really imperfect ones who have done horrible things. The rest of the Church is peopled by good souls like us who have our own spiritual flaws. Yet sometimes, out of the bad things we do, the Lord finds a way to make a perfect lemonade, sometimes years later. And here's the lemonade right in front of us now: the younger Lippi's *Madonna and Child*.

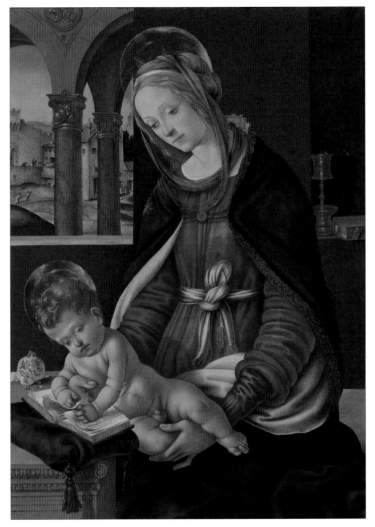

Filippino Lippi, *Madonna and Child*, ca. 1483–1484

When this painting was restored to its place in the European painting galleries in 2010, after years of careful cleaning and restoration, it created a frenzy in all of New York, with everyone

eager to see "the blue Madonna." "Blue" because Mary's cloak here, which—from veneer overpainting and centuries of being in candlelit rooms—had previously faded to a dark, almost black robe, had reemerged into the light in all its shimmering brilliance. The liberal use of the highly valuable lapis pigment (a ground semiprecious stone we last saw—unrestored—in Lorenzo Monaco's *Intercession of Christ and the Virgin*) in the painting is a tribute both to the majesty of Mary and to the wealth of the patron who commissioned this work.

Its subject: the perfect mother-son relationship. Mary gently cradles the Christ Child in a moment of domestic bliss, looking down fondly on her beautiful baby boy. She has the beginning of a gentle smile on her lips, and her brow, for once, is not creased with the reflection on the future that usually burdens her in other depictions.

Jesus, for His part, is the perfect kid—not moody or screaming for food, but rather, already hard at work, paging through the Torah and boning up on Scripture. Even here, He's preparing for His mission.

The precise lines and perfect imagery in this painting create the right visual expression of this peaceful domestic scene. Sometimes a painting invites us just to stand still in front of it in silence and prayer, and this is one of those paintings.

So often, we focus on Christ's divinity and on the super holiness of His Mother, Mary. Other times, we focus on Christ's great teachings and miracles or on His Passion and death. Rarely do we consider Him in a happy scene like this, being just a boy with a mother, like us.

Of course, we know it won't always be so. Even Lippi reminds us of our Lord's coming Passion and death with the open pomegranate on Jesus' right. "A common reference to Christ's Passion,"

pipes in Fr. Shawn. But Lippi does this gently, helping us to linger for a moment on the joy of the present scene.

We have a struggle ahead of us. Our search for God will deepen and at times run aground. So let's just cherish this brief moment in front of Lippi's glass of refreshing lemonade. The calm before the storm. Then it's on to our next painting, which isn't strictly here.

The Perfect Yes, Sicilian Style

I first saw this next painting at the Met, but it was here for just a few months in 2005. Now we can look at it only on screen. Evelyn, who's our enforcer on this tour, says I may include only three images that can be viewed only on screen, and then I've used up my dispensation.

So this work is one of them: the *Virgin Annunciate*, by Antonello da Messina. In the art world, some people call it the "Catholic Mona Lisa." I consider it one of the greatest works of art in the history of man's search for God. The artist came from a place that was far from the center of the Italian Renaissance—but maybe that's part of what makes this painting stand out.

Palermo, Sicily, late 1400s. Renaissance Sicily was a melting pot. Although the locals spoke an Italian dialect, this strategic island in the heart of the Mediterranean often found itself a pawn in the great geopolitics of the age. It was conquered and reconquered and traded and kicked around. Until just before 1100, a Muslim emirate of Sicily ruled much of the island. The Byzantine Empire tried to reconquer it with the help of Norman mercenaries, but the Normans ended up taking it over for themselves and setting up their own kingdom, which passed into the hands of a German dynasty and then a Spanish one.

By the time of Antonello da Messina's birth in midcentury, Sicily was no longer an independent kingdom but a protectorate of the prince of Aragon. When Spanish Castile and Aragon united in midcentury to drive out the remnants of the Islamic caliphate in southern Spain, Sicily found itself fully under Spanish rule. As a result, the small but flourishing art culture in Palermo, though Italian, was heavily influenced by its Spanish overlords, themselves oriented more toward the art of the northern Renaissance than the Renaissance in Florence and Tuscany.

Like the Florentine art of the period, this northern art sought to see the world through the eyes of God. But the northern painters' focus seemed to be more on painting ideal spiritual beings even as those beings inhabited very human, not idealized, bodies. And importantly, they painted in oils on canvas or wood, not frescoes, giving them the flexibility to produce works of great depth and color.

Antonello da Messina towered above the rest of the artists who emerged from this Spanish-Italian world in the late 1400s. Interestingly, this "Catholic Mona Lisa" was painted at nearly the same time as Leonardo's famous woman of mystery that hangs today at the Louvre.

So when the *Virgin Annunciate* traveled out of Palermo for only the second time in its five-hundred-year history, visiting her at the Met was a must. Evelyn and I and our fourteen-year-old younger son, Michael, jumped into the car one Saturday morning and headed to the Met.

I met more than the usual teenage resistance to that objective, despite the fact that I had sprinkled in several teenager-friendly activities throughout the day as a deal sweetener. Michael was a good kid, but somehow we got into a spat over this, so neither of us was in a very good mood when we finally made it to the gallery where the *Virgin Annunciate* hung.

Those bad feelings ended at that moment. All of us were transfixed.

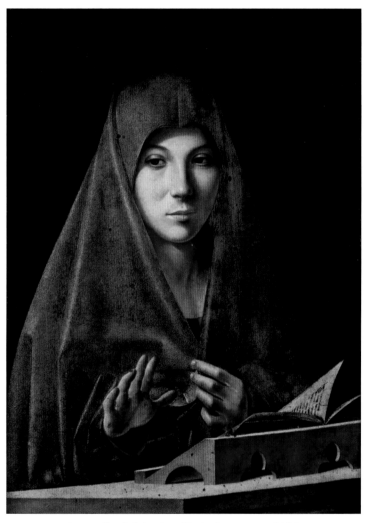

Antonello da Messina, *Virgin Annunciate*, 1476,
Palazzo Abatellis, Palermo, Sicily, special exhibition
at the Metropolitan Museum of Art, 2005

There is so much going on in this simple painting of a single simple girl that every time I've studied it, I've seen more.

As we enter the scene, we see a young woman, alone—in the dark. There is no architectural setting around her. The area behind her is simply black darkness. A quiet pervades the scene.

We assume this is Mary, perhaps in the solitude of her private chamber. Before her lies an open book, perhaps the Psalms; it seems she has been reading them here in her room. She is at prayer, preparing her heart. Had Mary not been prepared, if her heart was not already open through study and meditation on God's Word, would she have recognized the voice of the angel? Would *my* heart be prepared enough to see an angel from God if he entered *my* room?

Speaking of the angel, where is he? We know he's there—the sudden wind from his entrance on the scene is blowing the pages of the book. But we can't see him. In this almost revolutionary gesture (there is no Annunciation scene that I know of that does not include the image of the angel), Antonello has created for us the ambiguity of this whole situation as Mary experienced it. "Is the angel really there, or am I imagining him?"

Then we see Mary clasping her shawl together with her left hand, protecting her modesty. After all, she is a young, beautiful Jewish virgin and has probably never been alone in her room with a stranger, much less someone with wings. Her first human instinct is to protect her purity. Would that have been mine?

The angel begins to speak his message. Alarming, at best. But Mary doesn't shut him up. Instead, she focuses on him and on what he's saying. She holds out her right hand, considering, discerning. We almost see her belief in the veracity of this strange message rising as her right hand begins to curl, to accept the word. Do I listen enough in prayer to God? Do I give Him a chance to tell me what He wants? Or do I interrupt with my own ideas and move on?

Then I see those lips. Pursed. Firm. Concerned, yet determined. Mary has been asked to take on a spiritual job that at best seems well above her pay grade. To the outside eye, it's likely to lead to a quick stoning and death for having gotten herself pregnant before consummating her marriage to Joseph, particularly if he should denounce her publicly. Yet she believes. She takes on the mission. She says yes.

And then the eyes. These are not the far-off eyes of a youth who's heading out to "live her dream," to "do her thing." There is focus. Determination. Love. Obedience. Perseverance.

This is a mission with long odds for success. A small girl, alone, taking on a mission of great danger and risk. Her betrothed husband might very well disown her, scandalized. The village would then likely try to stone her. The King will want the child killed, for sure. And if he doesn't get the boy, the Romans will. The only escape hatch is a dangerous five-hundred-mile trip across an arid, lawless desert wasteland. Mission impossible.

But look at that face again.

I'm putting my money on the girl.

The Perfect Queen

Convent of Sant'Antonio, Perugia, Italy, on the way from Urbino to Florence, 1504. By the beginning of the 1500s, the "High Renaissance" style had begun to emerge. Art increasingly focused on more beautiful, ideal images portrayed through the eyes of our Creator. As artists looked for perfection, ever more simplified, uncluttered, and tightly organized compositions became the order of the day.

The two most prominent leaders of this movement, Leonardo da Vinci and Michelangelo, were based in the center of the European art world, the bustling city of Florence. At age twenty-one,

a brilliant young artist from Urbino, Raffaello Sanzio—known in English as Raphael—traveled to Florence to study the works of da Vinci and Michelangelo. On the way, he painted the *Madonna and Child Enthroned with Saints* for the Franciscan sisters at Sant'Antonio. The life-size panel hangs at the Met and is one of the few works by any of these three great masters to be found in a public museum outside of Rome or Paris.

The Met has thoughtfully placed a small bench right in front of this silent masterwork. We'll take the hint and sit here for a while, reflecting on this idealized scene full of allegory and extra meanings. The stillness of it, the solidity, and the perfect linear perspective almost draw us in magnetically as we rest before it.

The main, triangular grouping at dead center is our focus, of course. Mary is seated on her heavenly throne, which Raphael has positioned very solidly on the ground, here in Tuscany. The controlled majesty of her face matches that of the Infant Jesus, calmly sharing her throne and blessing young John the Baptist at Mary's feet. John, also calm, bows in adoration before his Lord and the Queen Mother. Like everyone else in this painting, the two boys present the ideal images of the perfect children, the well-behaved little rascals we all dream we could have! Helpfully, Raphael has clothed them both in modern dress, presumably at the behest of the modest nuns for whom nudity of any kind would have presented a problem.

Sts. Peter and Paul stand firmly guarding the throne to Mary's right and left, respectively. The two female saints in the painting, which must have inspired the many nuns who prayed near it, are possibly Catherine of Alexandria and Lucy, early Christian martyrs who bravely stood up for the Faith, and for their virginity, in the face of the Roman authorities. Like Sts. Peter and Paul, they died gruesome deaths for the Lord. Each attends to Mary.

Raffaello Sanzio, known as Raphael,
Madonna and Child Enthroned with Saints, ca. 1504

Interestingly, Raphael imagines the Madonna enthroned firmly on Earth, depicted in the expansive landscape that fades into the background beyond the tightly organized grouping of figures. Then,

above the group, we find God the Father. Painted in the more linear style of the 1400s, which was now rapidly receding, the Father seems clearly to be blessing Mary from His throne in Heaven, above. Raphael thus gives us the Madonna Enthroned as Queen of Heaven and Earth—the ideal Mother, of both Jesus and His Church.

This painting seems so ideal and so beautiful that it can almost put you to sleep. Perfection can be boring, to a certain extent.

But I think there's more here than just perfection. This painting is one of Fr. Shawn's favorites at the Met—not just for its beauty, but for its meditative power. Standing before it for a long time, he is drawn into its perfect stillness, its moment in time between Heaven and Earth, and and is put right in front of that throne. There, he can imagine himself in the company of this glorious, haloed group. He can become, for a moment, a saint.

The Perfect Host

Brussels, Netherlands, 1520. Brussels is still at this time within the greater area known as "the Netherlands," which would later be broken up during Europe's religious wars into Catholic Belgium and Protestant Netherlands. Like Sicily, the town of Brussels is home to the "Flemish" or "Netherlandish" school of art, sometimes called the "Northern Renaissance" style. (It has more of a claim to "Northern Renaissance" than Sicily, being actually in the north!) Still, thriving commercial melting pot that Brussels is, the art of Italy is a major influence as well.

Not long before 1520, Raphael sent his cartoons ("cartoons" in the art world means "sketches" or "designs") to Brussels for the Sistine Chapel tapestries the pope had commissioned from him in 1515. There, Brussels' highly skilled weavers would produce some of the finest and richest tapestries ever made, before or since.

Designed by Bernard van Orley, *The Last Supper*, Netherlands, 1520

Shortly after, the Duke of Alba commissioned Bernard van Orley to produce this tapestry of the Last Supper. It is one of two representations of the Last Supper at the Met.

We're not in Italy anymore. We can see it right away in the style. The tapestry—so rich, detailed, and three-dimensional that it seems to be a painting—is far busier and more decorated than anything the austere work of the High Renaissance Italian painters produced.

But spiritually, there is something very special going on here. And importantly, there is even someone here without a halo, who is for me the "perfect host."

Jesus has just finished the Last Supper with His apostles. In a Catholic context, that supper was the first consecration of bread and wine, transubstantiated into Jesus' Body and Blood. Jesus has just made a startling announcement: "One of you will betray me." The apostles instantly turn to one another to ask, "Is it you? Is it I?" The betrayer, Judas, is seen in the lower right of the frame, holding the money bag that he was in charge of—or perhaps the bag of silver he has already been given for agreeing to turn over his Lord in the approaching darkness. John, perhaps at the urging of St. Peter (who seems to be signaling him from the lower left), is cozied up on Jesus' chest, coaxing Jesus to tell him who the betrayer will be.

Of course, there is another betrayer in the room: St. Peter, in the lower left, symmetrically balanced in the scene against Judas on the far side. Peter, too, will betray Christ by denying Him three times that very night.

But van Orley highlights an important distinction between them. While Judas has already turned to go, leaving the light of Christ forever and slipping into the darkness outside, Peter remains in place, eyes focused on his Lord, heart in the right place. We know this will matter in the end. Peter, focused on Jesus, can find his way back to the Lord's mercy. He will become the father of the Church. He will get his halo. Judas ends his life in suicide rather than seeking forgiveness.

As we place ourselves in this scene, most of us usually dismiss Judas as a weak traitor and Peter and the other disciples as "us."

Let's think again. When in my life have I betrayed the Lord—done what was in my interests, not His?

All of us sin. That's the human condition. To be Peters, not Judases, the test is *not* whether we betray Christ. Both did. The key is that, when we inevitably do, which of these two men models our next step?

Are we too proud to return, to seek forgiveness? That's the path of Judas, to eternal pain and sorrow, the path of darkness.

Or do we keep our eyes focused on Jesus? Do our hearts turn back to Him? Do we have the humility to seek His forgiveness? That's Peter's way. It leads to Heaven.

After several visits to this tapestry, one of our guests asked me a question about something I had never noticed. Why are there fourteen characters in this scene? Shouldn't there be thirteen — Jesus and the twelve apostles?

Carefully, I counted the figures. Fourteen.

Then I saw him.

The perfect host. The anti-Perneb.

He's the figure in the foreground, serving the apostles and Jesus. Besides Judas, he is the only figure without a halo, which is reserved

for persons acknowledged by the Church as saints. But who is he? Unlike the apostles, he's dressed in fine clothing and wearing fancy sandals. So he's not a servant. He's wealthy.

Think back to the story in the Bible. When Jesus was preparing to celebrate the Passover, He sent two of His disciples to Jerusalem ahead of Him, telling them that the master of a certain house would show them "a large upper

room furnished and ready" (see Mark 14:12–16). Someone Jesus knew in Jerusalem was rich enough to have a dining room big enough for thirteen guests—and all the plates and utensils they'd need for a holiday dinner.

That must be our fourteenth man in this tapestry—the unnamed owner of the home whose Upper Room served as the place of gathering for this Last Supper—as well as a safe harbor for the apostles in the scary days after Christ's Crucifixion.

Evelyn and I have been to that Upper Room in Jerusalem, or at least to what the local tradition holds was the Upper Room. The house it is in is quite large. It would have been owned by a wealthy member of the Jewish community at that time, presumably an early convert to Christ.

And there's something else here. Unlike the faces of the apostles, which are universal and almost iconic (who couldn't pick out St. Peter here, for instance, or St. John?), this man's face appears real, a portrait. It's a long face, with a thin nose and finely groomed beard. Could it be the duke himself—the patron of the painting?

My only conclusion is that it must be! This is the man who commissioned van Orley to paint the cartoon for the tapestry! He asked to be painted into the scene, not as the king or as God, as our old friend Perneb would have done, but rather, in the humblest of roles, as the one waiting on the apostles and Christ.

Sometimes as I consider this, I ask myself quietly: if *I* had commissioned this painting, would I have been humble enough to have myself painted as the lowest of the group? Might I not have at least angled to be shown as one of the apostles, if not St. Peter himself?

Despite all the improvements in style, in wealth, in theological thinking, and in art since the Middle Ages, it seems to me

that the artists of the Renaissance and their patrons still had it right.

You are God, and I am not.

–⟪⟨◦⟩⟫–

Soon after Raphael arrived in Florence, both he and Michelangelo, along with many other Florentine artists, were called to Rome by Pope Alexander VI—they were later called by Popes Julius II and Leo X as well—to help them rebuild the papal city in the image of God. The competition among these talented artists to produce the perfect image through the eyes of God led to new heights, including, of course, Michelangelo's groundbreaking Sistine Chapel ceiling and Raphael's loggia next door in the papal apartments.

But like the intense period of classical Greece that emerged in Athens during the last decades of the fourth century BC, the weight of the whole exercise cast the seeds of its own collapse. Perhaps it's that old human arrogance problem again.

Desperate to raise funds to support the rebuilding, Pope Leo began to sell indulgences throughout Europe, a scandalous corruption in the eyes of many. For a German monk in the town of Wittenberg, this was the final straw. That monk's name was Martin Luther, and in 1517, he broke from the Church.

Within a few short years, Europe began to tear itself apart. By 1524, mutinous German troops of the Holy Roman Emperor Charles V (a Catholic, no less) invaded and sacked Rome. The pope was forced to flee, humbled. Rome was wrecked. Leonardo died in Paris in 1519, Raphael in Rome the next year. Though Michelangelo would live on to an old age with many powerful works still ahead, the old magic was gone. In a flash, the perfect idealized world of the Renaissance was over. Reality had set in. And reality is always less than ideal. It is also a lot more dramatic.

But before we go there, to the Baroque, we first need to take a short detour to a deeply religious artist who found his own way through the morass. That artist's name was Doménikos Theotokópoulos. But because he was a Greek in Spain, we know him today simply as "El Greco."

A Spiritual Synthesis for All Times

El Greco, Mannerism, and Spiritual Rebirth

*But I say, walk by the Spirit, and do not gratify the desires
of the flesh. For the desires of the flesh are against the
Spirit, and the desires of the Spirit are against the flesh; for
these are opposed to each other, to prevent you from doing
what you would. But if you are led by the Spirit you are
not under the law.... But the fruit of the Spirit is love,
joy, peace, patience, kindness, goodness, faithfulness....
If we live by the Spirit, let us also walk by the Spirit.*

—Galatians 5:16–18, 22, 25

Heraklion, Crete, Venetian Protectorate, mid-1500s. Our young Greek
artist—the one who will be known to history as El Greco—is grow-
ing up in something of a cultural melting pot. Crete right now is
under the protection of the powerful Venetians. When the Turks
finally took Constantinople in 1453, ending forever the era of the
Christian Byzantine Empire, many of the Byzantine icon painters
("writers of the Holy Spirit," they called themselves) took their
art and their religious mysticism to Crete. At the same time, the
Italian Renaissance was flourishing, and now, by the mid-1500s,

the influence of Italian masters such as Titian, Veronese, and Tintoretto is exerting a powerful force.

Within this "artistic gumbo soup" (a term I picked up from the Greek embassy's special exposition on El Greco in New York many years ago), the young genius Doménikos is developing a unique style. Somehow, it blends Byzantine mysticism and spirituality with many of the naturalistic techniques of Renaissance Italy, such as three-dimensional perspective, sculpted (sort of) figures, and rich Venetian oil paints and colors. Art historians call this style Mannerism. In some ways, it's a synthesis of many of the artistic trends that preceded Doménikos—and even those that were to come after him. More on that "after him" part later, when we arrive at Picasso.

At any rate, Crete was a very interesting place to grow up as an artist. But of course, if you had real talent, you'd eventually end up in Italy.

An Evil Spirit Is Driven Out

Venice, Italy, 1570. Our young Greek artist Doménikos Theotokópoulos has been studying art in the studio of the great Venetian Renaissance master Titian for at least half a dozen years by now.

Venice is still a major trading center between the Mediterranean world and the Far East, though new sea routes to the Far East have been opened up by the Portuguese, the Spanish, and the Dutch on the western coast of Europe. Religious wars rage in Europe between Protestants and Catholics, and the Catholic Counter-Reformation has been launched, designed to reform the Church from within while assertively challenging the spread of Protestantism in the West. Italy remains firmly Catholic, and the young artist from Crete has been experimenting with his own style there.

My guess is that *Christ Healing the Blind* is one such experiment, as it was never finished. El Greco would take it with him to Spain when he left for the court of King Philip II seven years later.

Although many artists had painted this scene more dramatically than El Greco does here, and others would paint it more dramatically later, none of them would ever capture the deeper spiritual insights that El Greco portrayed in this very early work. It has taken Evelyn and me years to see them, and we're still not sure we've seen them all—yet.

Warning: this is an unfinished work, so what follows is more than my usual share of conjecture, and some historians would probably flat-out disagree with it. Call this the interpretation from a missionary's perspective.

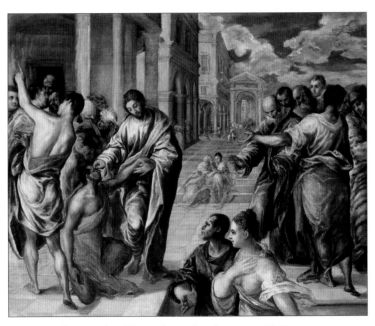

Doménikos Theotokópoulos, known as El Greco,
Christ Healing the Blind, 1570

At one level, El Greco does a passable job portraying the physical healing that is described in John 9. The blind man, alone among the bustling crowd, kneels before Jesus, begging Jesus to heal him. Jesus gently touches the man, and as He does, the formerly blind man looks up at Him with eyes that see.

The various other players on the scene in John's Gospel are also present here. The disciples, as witnesses, look on intently from the right side of the canvas. The parents may be the couple in the foreground. And the less interested group to the left are probably meant to portray the nonbelieving Jews and the Pharisees.

In the back, on the way along which Christ has just come, two ethereal figures, half finished, sit deep in conversation, presumably so self-absorbed that they missed Christ as He passed by them.

But El Greco seems to have more in mind here than a surface reading of John's Gospel story.

Notice first the different reactions of each group.

The apostles are clearly engaged as witnesses, and certainly without their testimony later, we would not have known about this miraculous event. In some cases, their individual personalities shine through. The older, bearded figure at the far left of the group must be St. Peter; always the man of action, he seems to be trying physically to help Jesus manage this difficult cure.

I'm still trying to figure out who each of the other apostles is, but one I am sure of. In the upper right of the group, one apostle seems to look on the scene and witness it differently. He looks on almost lovingly, transfixed by his Lord and by what is happening. He also is young and not bearded. This is most certainly John, whose Gospel of Love, as some call it, is where this event is recorded.

(If you doubt this assertion, wait until you take a close look at the figure of John in *The Opening of the Fifth Seal*, painted by El Greco nearly forty years later. It's the very same image of John that El Greco seems to have had in his head for this "beloved apostle.")

The parents of the blind man in the foreground also seem to be reacting to the scene as John describes them: thrilled that their son has been cured but a little skeptical, or maybe a little fearful of the consequences, knowing that this could lead to trouble with the Pharisees. They will eventually wash their hands of the scene and refuse to corroborate it or deny that it happened (John 9:20-22).

The group I find most fascinating, though, is the group immediately to Jesus' right. These seem to be some combination of everyday folks and perhaps some Pharisees as well, distracted by something else occurring off the canvas—something that, in retrospect, is much less important, but they pay more attention to it than they do to Jesus. Maybe it's some trade deal or perhaps just another banal conversation. I often wonder about these people. Many had been calling for a sign from Jesus, but just at the moment they would have seen one, they were distracted by noise, by things of the world. Tragic.

As I gaze on this last group, I ask myself, "How often have *I* missed a sign from Christ because I was distracted with something that seemed important at the time but was of no lasting consequence—even trivial?"

These psychological portraits by El Greco are all painted in a sweeping, almost ethereal style that broke conclusively with the art of the High Renaissance. Although these figures are clearly grounded in the three-dimensional landscape of this city plaza, most of them, aside maybe from the apostles, have an ethereal quality, as if they are here, but *not* here. The figures are elongated

and loosely painted, almost airy. Although other artists had already begun to paint in this post-Renaissance style called Mannerism, it seems particularly well suited to El Greco's art. While real and convincing, it also is somehow unreal and otherworldly at the same time. This delicate balance invites us into the scene almost as if we were there.

Speaking of otherworldly, look more closely at John's face. His deep understanding of Jesus, his intimate, loving relationship with Him, shows in that face, in those eyes. But what are those eyes seeing that the others can't see? What is he actually looking at?

A few years into our tour, Evelyn was the first to spy what seems to have caught John's discerning eye: an awkwardly stooped figure not fully finished by El Greco. Can you see him too? He's dark, almost a shadow, squeezed by the painter between Jesus' right arm and the backs of the bystanders to his right. Was this figure intended to be a friend of the blind man, helping him to Christ? Possibly. On the other hand, imagine something completely different. Could this figure be an evil spirit, being exorcised from the blind man by Christ? He does seem to be literally rising, reluctantly, out of the blind man.

When Evelyn first broached this interpretation, I realized what El Greco understood about this miracle well beyond the literal interpretation that all artists before and after him would depict: Christ came to heal the blind man—to heal us—first and foremost, *spiritually*. That is the real healing that is happening here. The blind man, an outcast presumed by society to be a dark sinner, is being lifted up, transformed, restored to the perfect human being God created him to be. The physical curing helps, for sure, and additionally it increases our faith. ("Even though you do not believe me, believe the works" [John 10:38].) But the more profound healing is the spiritual, the restoration of dignity to a soul from whom society had taken all dignity away.

And in that process of transformation, the blind man is emboldened. He stands up to the Pharisees. He becomes an evangelist.

El Greco's message to us here is pretty clear, I think. Focus on what is important. Read the words of Jesus with eyes of love. Open your heart to Him. Let Him heal you. And He will lift you up.

Shortly after completing *Christ Healing the Blind*, El Greco moved to Rome, where he met a Spanish ecclesiastic named Luis de Castilla. Soon he found himself in Toledo, where his Byzantine background in Crete and Renaissance colors and brush from Venice would blend with the almost mystic religiosity at the center of Spanish theological thought and learning in that age. What would emerge was art for the ages.

And to see it, we have to do some traveling, too. It's not quite as far as the distance from Italy to Spain, but it might seem like it. The Met is a big place.

A Light Burden

Toledo, Spain, 1580. Toledo, in the north central portion of the country, was the stronghold and capital of Spanish Castile as it struggled, century by century, to unify Spain and drive out the Moors. Although Philip II recently moved the imperial capital from Toledo to nearby Madrid, the city is still an important center of Spanish culture and religiosity.

Sadly, this is also the time when the Spanish Inquisition is working its hardest. In a burst of distorted religious zeal, the Spanish monarchy expelled all practicing Jews in 1492. Jews could remain, however, if they were baptized as Christians. But there's always a suspicion hanging over those converts. Are they secretly still practicing Jews? A little torture will find the truth. In Toledo, the horrors of the Inquisition are always lurking just around the corner.

Still, Toledo's rich Christian spirituality and even sense of mystery seem perfectly suited to the temperament and religious fervor of our young mystic painter from Crete. Another case of spiritual lemonade, perhaps. His neighbors start to call him El Greco—"The Greek"—and the name sticks.

—⫷⫸—

Shortly after his arrival in Toledo, El Greco produced this moving, inspirational image of Christ carrying the Cross. It would prove to be one of several Cross images he would paint during his subsequent long career based in the city.

And we here in the Met have also had a long trek to see it. It has been a long walk to the Lehman Gallery, where *Christ Carrying the Cross* normally hangs. So let's just stop here for a while, take it in, absorb it, and be present with it.

Despite the gruesome subject matter and dark, foreboding storm clouds in the sky behind Christ, there is something about this painting that simply exudes hope and even joy. Jesus' slender, almost feminine hands don't just carry the Cross, they seem to embrace it; in fact, the Lord embraces it with His whole body. The Cross itself does not appear to be the ridiculously heavy tool of torture that it most surely was but looks almost like two sticks of balsa wood that our Lord seems to carry effortlessly. And interestingly, the Cross is thrust upward, toward Heaven and victory, not downward, toward Earth and defeat.

And Christ's eyes. They remind me a little of the eyes of Antonello's *Virgin Annunciate* of Spanish Naples, painted a century earlier. Yes, there is a pensive sorrow here, as Christ contemplates the sins of man, for whom He carries His Cross. But there is also joy, maybe even tears of joy, as He looks upward to His Father in Heaven and contemplates the salvation of God's people, entrusted

El Greco, *Christ Carrying the Cross*, 1580

to Jesus. And in His joy, there is confidence and perseverance, a determination to finish the mission, whatever the costs.

No hint here of regret, anger, or remorse over loss. Only utter acceptance of—no, embracement of—His mission. And utter confidence in its success.

No hate. Only love.

And like the Cross itself, those eyes focus skyward, to God and victory, not downward to Earth and death. The things of this world, even its miseries and tortures, are instantly trivialized in this brief moment captured by El Greco along the road to Calvary.

What does the heart of a missionary look like? It certainly surfaces through time in all its various aspects: sorrow, contrition, saying yes, mission, perseverance, joy, love. And yes, embracing suffering. The mystery for me is that virtually all of these aspects of the missionary heart, of the heart of Jesus, are here in the face of Christ carrying His Cross—painted by a Greek mystic with a creative genius that transcends time and space.

And now I'm going to take you back in time again—all the way back to the distant world of the late twentieth century.

Holy Toledo

Toledo, Spain, April 1999. We're on one of our family trips for the Easter holidays, and Evelyn has brought the boys and me to Toledo, the heart of Catholic Spain. The 1990s were part of my "indifferent agnosticism" period, before my first confession in thirty years, following a near-fatal health emergency that would convert me from Sunday-morning Catholic to a deeper relationship with our Lord. In retrospect, in these little outings, I think Evelyn was trying to plant the seeds that would later sprout when the moment was right.

In those days, I would often arise before dawn and go for a long run. I found this helped me burn off a little energy and slow my

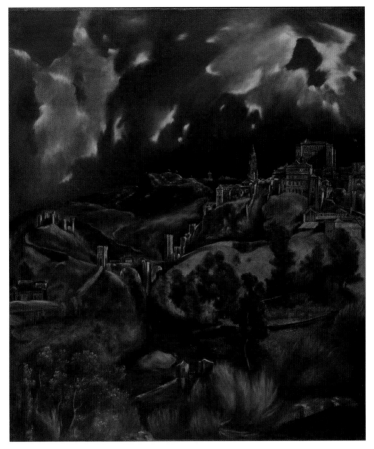

El Greco, *View of Toledo*, 1599–1600

pace a bit for the rest of the day with two small children in tow. When we were traveling, these morning runs often took on historic proportions, inspired by all the history around me and the desire to take it all in in one sweeping, romantic gesture.

Since our hotel, or *parador*, was in the hills outside the city, it seemed natural to set a course to encircle the town, which is

perched on a rocky outcrop at a sharp bend in the Tagus River. My route was up and down the many hills that surround the city. Although I had a map with me, out there in the predawn light, I must say I was growing a tad impatient. No sign of anything like Toledo at all—just darkness.

Then, almost precisely at dawn, I reached the top of a hill above the river, and the sun beamed down directly on this image painted here by El Greco: Toledo. Without even thinking, I instinctively burst out with an oddly coincidental idiom I had learned from my father many years before: "Holy Toledo!"

When we returned to the Met that year, I sought out and found this painting by El Greco of the great city on a hill. Although the forms are distorted and almost transformed, and whole buildings from the city's famous skyline are misplaced or omitted, the overall composition, encased in an eerie, almost spiritual light, creates an image of the town that somehow is, in spirit, very accurate. For me, it is best summarized by that very same idiom I used those many years ago when I first saw the city rising out of the darkness into the dawn: "Holy Toledo!"

The art world would come back to El Greco's impressionistic *View of Toledo* centuries later, not so much for its sense of holiness but for the energy and for the nearly abstract, fluid forms painted here. Again, we'll get there. Patience.

A Doorway through Time Is Opened

When he opened the fifth seal, I saw under the altar the souls of those who had been slain for the word of God and for the witness they had borne; they cried out with a loud voice, "O Sovereign Lord, holy and true, how long before thou wilt judge and avenge our blood on those who dwell upon the earth?" Then they were each given a white robe

and told to rest a little longer, until the number of their
fellow servants and their brethren should be complete, who
were to be killed as they themselves had been. (Rev. 6:9–11)

Toledo, Spain, 1610. El Greco is an old man now. His style has loos-
ened considerably. Here in *The Opening of the Fifth Seal*, elongated
and almost ethereal figures seem to transcend space and time.

El Greco, *The Opening of the Fifth Seal*, 1608–1614

In the foreground, the oversize figure of St. John, as told in Revelation, kneels before the divine image of God in Heaven, looking up toward his Maker with love and rapture. Amazingly, it is the same St. John the painter had imagined forty years before in *Christ Healing the Blind*. To John's left are a grouping of spirits, writhing with Michaelangelo-esque energy as they await the cloaks of sainthood outside the throne of God. Painted with broad swaths of bright blues, reds, and yellows, and set in a three-dimensional yet heavenly space, these figures seem to transcend time. They are both of *this* world and of *another*.

As I am slowly pulled into the scene under the outstretched arms of "the apostle whom Jesus loved," I, too, find myself overwhelmed with a sense of love — not earthly love, but sacrificial, divine love: the love of the martyrs assembled there in the heavens. Do I love like this?

El Greco's surreal canvases, especially this one, would often leave his viewers of later generations baffled and uninterested, especially those who did not share the mystical religiosity of early-1600s Toledo. I will confess that I also found El Greco confusing for many years. But after my spiritual awakening, I suddenly fell in love with him. His ability to transport me from here to Heaven and back again is quite unique among all the great artists I've studied. El Greco is in some ways a kind of perfect synthesis of art and spirituality that is courageous, mystical, and visually appealing, all at the same time.

There is one more El Greco I want to take you to — another one of "Evelyn's paintings."

The Emmanuel Moment, El Greco Style

Toledo, Spain, 1605–1614. In his last years, El Greco painted first this smaller, stand-alone "Emmanuel moment" on canvas, then later a more monumental work as an altarpiece for the Santo

El Greco, *The Adoration of the Shepherds*, 1605–1610

Domingo el Antiguo Chapel in Toledo, meant to hang above his tomb. So it belongs in the category of "last works" from the great masters, two others of which the Met also owns. We'll visit those other two soon enough. For now, let's spend some time here at the scene of mystery, Christ's birth.

El Greco's late style is all in evidence here, with the ever-more-elongated figures that look more like three-dimensional spirits than the flesh-and-blood humans we know those spirits to have dwelled in. In a kind of distant salute to Duccio, El Greco has here painted the figures inside out, with their souls exposed and their bodies hidden within. The swirl of energy and movement encircles one figure at the center, from whom the entire light of the scene seems to emanate, piercing the surrounding darkness: the Christ Child, "God with us."

Within the whirlwind of spiritual energy that seems to encircle the painting, El Greco has painted a little reminder for all of us of why God has come into the world: the pure, unblemished lamb at the foot of the creche. Yes, here before us is the very "Lamb of God," who will be sacrificed for us all and our salvation. El Greco's brush has deliberately focused us on these two sides of Christ, the God-Man come to Earth and the God-Savior fulfilling His Father's will, sacrificing Himself to end death once and for all.

This hope-filled—yes, joyous—last word of El Greco, for me, speaks of an artist who is facing death with confidence and joy, knowing he will pass from here to an eternal resting place with his Father in Heaven. Although his work in his time was not as popular as many other artists' and would go largely unappreciated until the twentieth century, El Greco seems to be going out with no regrets. He has used the talents God has given him, his unmatched artistic genius, to glorify his Creator and to lift our collective gaze upward, to God in Heaven. In the words of St. Paul, "I have fought the good fight, I have finished the race, I have kept the faith" (2 Tim. 4:7).

The Battle of Light and Darkness

Baroque Art through Rococo

In the beginning was the Word, and the Word was with God, and the Word was God. He was in the beginning with God; all things were made through him, and without him was not anything made that was made. In him was life, and the life was the light of men. The light shines in the darkness, and the darkness has not overcome it.

—John 1:1–5

Rome, May 6, 1527. A short ten years following Luther's break with the pope, Christian Europe had already turned on itself. Catholics were determined to uphold the primacy of St. Peter and the legacy of tradition and teachings passed down through him and the apostles to the laity through the bishops of Rome. They opposed with words and soon with swords their fellow "Protestant" brothers who were scandalized by the behavior of some of those same bishops and clergy. While important theological differences, such as on transubstantiation, would also factor into the new Protestant movement as it expanded and fragmented, at its heart was almost a political rebellion against the power and prestige of the papacy itself.

This deep hostility and even hatred erupted in a new level of violence during a fight for control of Italy between Holy Roman

Emperor Charles V of Spain and Francis I of France. After the rout of the French troops which were allied with the papal forces of Rome at Pavia, a mutinous imperial division, composed mostly of Lutheran troops from Germany, set out to take the holy city itself. Rome was defended only by the Swiss Guards, who bought enough time with their blood for Pope Clement to escape. In the carnage that followed, many of the Swiss Guard were killed, along with an estimated twenty-five thousand civilians. Rome itself was wrecked.

And with this one blow, the era of the Renaissance, already shaken by the loss of some of its titans, such as Raphael and da Vinci, ended. In the period that followed, art drifted away from the idealized view of the world in the well-ordered compositions of the Renaissance painters. A darker, scarier, and perhaps more accurate depiction of reality emerged out of the rubble. That style of art produced some of the greatest works of art that Europe had ever produced. Enter the Baroque.

The Light of God Helps Matthew the Evangelist

Milan, Italy, mid-1500s. Rome is a mess, just barely beginning to recover after the sack in 1527. But up north, Milan is thriving under the protection of the king of France. Here, an artist known as Giovanni Girolamo Savoldo is painting in a new and different style.

We know little about Savoldo or his work. One of his few surviving pieces, painted in the early 1530s, hangs in the Met: *Saint Matthew and the Angel.*

One spring, after Caravaggio's great Baroque masterpiece *The Denial of Saint Peter* had gone out on tour, Evelyn and I searched the galleries for a painting that picked up on the themes of light and darkness that Caravaggio popularized in his dramatic works. We'll get to Caravaggio in a minute, but for the moment, let's pause here with Savoldo. Some people think he may have had a

Giovanni Girolamo Savoldo, *Saint Matthew and the Angel*, ca. 1534

substantial artistic influence on the young Caravaggio as he grew up in the streets of Milan.

The subject of this painting was a common one for this era, when the Church was seeking to emphasize biblical stories that substantiated the tradition that the Holy Spirit inspired the Evangelists in writing down the story of Jesus in the Gospels. By extension, we Catholics believe the Holy Spirit continues to inspire Church teaching within the Magisterium, as slowly but surely God reveals to us the depth and richness of the salvation story. Savoldo depicts the Holy Spirit's inspiration to Matthew here—and in a dramatically new way.

Unlike the Renaissance masterpieces of just a few years earlier, with their careful stage lighting, Savoldo's *Saint Matthew and the Angel* is a study of light and darkness. We peer in on him here writing his Gospel, illuminated by the light of a lamp—which surely stands for divine inspiration.

As if to underscore this point, Savoldo paints a heavenly angel, sent by God to inspire and remind Matthew of the Gospel story he had been a part of. In the dark edges of the piece, we can faintly see mysterious figures: a group surrounded by a campfire and, over Matthew's right shoulder, a scene inside what appears to be a basilica. Some historians speculate that the scene on the evangelist's left side is a reference to Matthew's entrance into the Caspian Sea province known as Ethiopia. (This is *not* the same Ethiopia as the one in Africa; confusingly, at least two places are called "Ethiopia" in ancient writings.) According to tradition, St. Matthew evangelized there. The scene on Matthew's right seems to hint at his gruesome martyrdom there; he was killed by the king while celebrating Mass. The king was upset that Matthew would not condone an adulterous affair.

This painting gets very little attention at the Met, surrounded as it is by more famous masterpieces. Certainly, it lacks the emotional charge and intense drama of Caravaggio's far more skilled hand that would come later. Yet this poignant scene that captures both the intimacy of Matthew's relationship with the angel of light inspiring him and the threat of the forces of darkness that loom in the background, grips me. And importantly, it points to a new direction for Western art.

We are no longer in the perfect world of Renaissance Rome seen through the eyes of God. A less tidy, more difficult reality is upon us.

The great battle of light and darkness in art has begun.

St. Peter Has a Trebonianus Gallus Moment

Milan, Italy, 1582. A boy of just eleven years of age is orphaned in Milan when both his parents die young, possibly of the plague. He grows up on the rough streets of the city and falls in with a gang of thugs, fellow "plague orphans." Their motto: "Without hope, without fear."[7]

[7] Ciaran Conliffe, "Caravaggio: The Man without Hope or Fear," HeadStuff, September 27, 2016.

The young man is eventually rescued from the streets by a wealthy Italian prelate, Cardinal Francesco Maria del Monte. Del Monte seems to see through the young artist's rough exterior, sensing a unique genius within. The boy's name is Michelangelo Merisi. He will come to be known simply as "Caravaggio," after the little town east of Milan where he grew up.

Fear and despair will trail him for the rest of his short, violent life. He spends his best years on the run from the law for a variety of barroom brawls and even a murder, interspersed with periods of protection by noble or ecclesiastical patrons, who commission from him paintings for their villas and cathedrals.

Caravaggio was inspired, for sure, by the muscular, monumental figures of Michelangelo, the rich oil paintings of Titian, the early experiments with the play of light and darkness of local Milan artist

Michelangelo Merisi, known as Caravaggio,
The Denial of Saint Peter, 1610

Savoldo, whose work we just visited, and, most importantly, by his own interludes both of light and of darkness within his short life.

Out of all this artistic and personal turmoil came some of the most magnificent, dramatic, and soul-shaking paintings of all time.

The Met owns two of Caravaggio's paintings, which number only thirty or so. One of them, *The Denial of Saint Peter*, was painted just months before his mysterious death at age thirty-eight, on the run, during a boat ride from Naples to Rome.

What's your first impression when you stand before this painting? For me, it is its darkness, maybe even fear.

Only three figures can be seen. St. Peter has just paused in his pursuit of Christ at His trial, to get some warmth from the campfire during the cold night. In the center of the canvas is the accusing servant woman, pointing out St. Peter to the guard on the left. The guard emerges from the shadows, his armor glinting threateningly as it catches a splash of the firelight; his right finger points to St. Peter, referencing the second accusation and denial.

But St. Peter himself dominates the canvas, underscoring the third, final denial with both his own fingers pointing inward. With this third denial of his Lord and master, Peter seems to be swallowed by the darkness that surrounds him.

And worse, we can see that he *realizes* it as it's happening. That creased brow indicates more than a denial: it reveals a realization of the horror of what he has done. It's Peter's Trebonianus Gallus moment. He's cut off, without God. Alone.

What makes this painting so moving to me goes well beyond the vivid telling of the famous Gospel story of Peter's denial. In its emotive power and energy, I sometimes see myself here, in St. Peter's place. I've just sworn allegiance once again to the Lord and assured Him I was on track. In trying to follow Him to His Cross, I get distracted; I see a warm fire, and it's cold outside. "I'll just

comfort myself for a moment," I rationalize, "and get refreshed for the trials ahead!" Then, in an instant, I'm brought low. Out of nowhere comes the moment of fright as I am threatened by the guard and the servant. Without my thinking, my natural instincts for comfort, for self-preservation take over, and suddenly I find myself denying Christ, falling into sin.

That worried look is the same look I get when this happens to me. I feel unworthy of being called a follower of Christ. I've let Him down, betrayed Him. I've got that Trebonianus Gallus look.

The other thought I have here is of the artist himself. He had had moments of great success, for sure. But his life was a mess: too many sudden bursts of rage while drunk at a bar, too many sins to count. Was this painting somehow autobiographical? Was Caravaggio reaching out to us over the ages? "*I'm* St. Peter. I had great talent, and I diminished it in an uncontrolled moment of passion! I turned from God."

We don't know. Within months of finishing this masterwork, the great artist was dead—possibly of a fever, or, as some speculate, possibly murdered in revenge for one of his crimes. But even in the horror of this painting, Caravaggio left us with a little hope. After all, he knows *we* know how the story ended: that Christ not only survived His Cross but defeated it and rose from the dead. And He came back for St. Peter, reconciling him on the misty shores of Galilee soon after, giving him the chance to say the famous three I-love-yous to offset the three denials. And He commissioned Peter to lead His Church.

Even in the darkness, there is a light.

Caravaggio even gives us a glimpse of this light. It is the dimly flickering light of the fire in the background over St. Peter's right arm—the light of Christ. Even in darkness, there is grace. Whether we embrace that grace or not is up to us.

Pilgrimage to the Museum

There's still time to make the right decision. And decisions like this are becoming very important in art.

I Have a Decision to Make

Amsterdam, Netherlands, mid-1600s. Even as Caravaggio was making his dynamic breakthrough to the world of light and darkness, the energy center of Europe had begun to drift westward, to the seafaring countries along the Atlantic coast: Spain, the Netherlands, France, and eventually, England. Now, with transworld travel and trade flourishing across the Atlantic and the Pacific, countries with overseas colonies were beginning to experience an economic boom.

The Dutch have been early winners, with colonies in North America (New Amsterdam) and the East and West Indies. Art, often drawn to where the wealthy patrons were, drifted west as well. In Protestant Amsterdam, the art world was dominated by the rise of a new merchant class of patrons. It was the "Dutch Golden Age."

The style of subjects began to shift from purely religious themes to secular ones that fit the proud mood of the day. Within this milieu arose another giant, whose art has echoed over time ever since. His name was Rembrandt van Rijn.

Rembrandt enjoyed early success and fame in his work. On the surface, it was quiet, serene, introspective; beneath, it overflowed with action and drama. Rembrandt saw humanity, and himself, as fundamentally flawed and broken. His many portrait paintings were realistic to a fault—and certainly not nearly as heroic or perfect as his Renaissance forebears preferred to paint their subjects.

As he aged, he seemed to grow darker and more introspective. A series of mishaps and tragedies followed: overspending on the good life; financial speculation and ruin; the early death of his young wife, Saskia. Scandals ensued. Patrons, frustrated with his increasingly "ugly" images of what he perceived as reality, became harder to find.

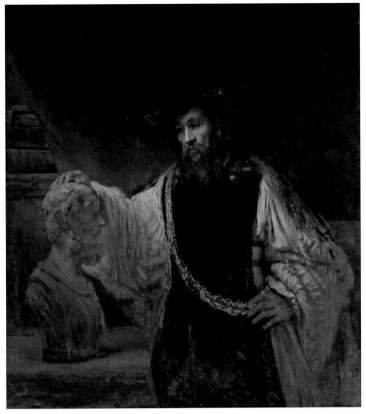

Rembrandt van Rijn, *Aristotle with a Bust of Homer*, 1653

When Rembrandt was still in mid-career, a wealthy patron from Spanish Sicily, Don Antonio Ruffo, commissioned "a painting of a classical philosopher" from the Dutch genius. The Met has that painting, where we pause now. It is perhaps one of Rembrandt's finest works. From the moment it arrived at Don Ruffo's home, its subject has been hotly debated by contemporaries and later by historians. The most compelling description I've found, by which most people today refer to it, is *Aristotle with a Bust of Homer*. My

own secret title is simply "Rembrandt, a Soul in Struggle." We'll get to that in a moment.

On the surface, Rembrandt has painted for Don Ruffo exactly what he asked for. At the center is Aristotle, identifiable by the small image on the medallion hanging from his neck, an image of Alexander the Great. Alexander is inextricably part of the Aristotle story, as Alexander was Aristotle's private pupil and would grow up to conquer the then-known world. But in all the silence of the scene, we sense there is a lot more going on here than meets the eye. Something is stirring.

What's that right hand doing? It's reaching out to a bust—another portrait: a portrait of Homer. Unlike Aristotle, cloaked in the rich finery sent to him by his famous pupil, who is now out looting and pillaging the world with his seemingly invincible army, Homer is clothed simply, almost as a monk. Known for his virtues and simplicity, Homer here stands for classical values of austerity, prudence, self-mastery, temperance, and integrity. He has survived the ages, still a hero to many. And importantly, even now, his forehead—where Aristotle's hand rests—is brightly lit, firmly within the little circle of light flowing from outside the canvas.

Aristotle's other hand, his left, is also reaching for something: the gold chain sent to him by Alexander. It's the ill-gotten wealth of the world, the riches that corrupt, the distractions from the eternal. It glitters in the darkness as it catches the light reflecting off Homer's bust.

Wait. Aristotle is not actually *grasping* the chain; he's fingering it. He's *considering* it.

My eyes are drawn now to the very center of the whole swirling emotion of this piece. The face of Aristotle. It's a window into his mind, his thoughts at this moment, with his right hand on virtue, his left on riches and sin. What to do? What to do?

Evelyn skips back to that hand on the chain. In the light and maybe because of the foreshortening, it seems bigger than the hand on the bust of Homer. "That can't be a mistake, Steve. Rembrandt was too good for that, too careful, too deliberate. That's it! The hand that reaches for the gold seems bigger; the gold's lure is stronger."

I flip back to the right hand. Unlike the left, it's not toying with the bust. It's resting there. No, not really. It's *caressing* the bust. *Considering* it. Grab it, Aristotle! Grab it before it's too late! A storm is coming!

I'm back to the face. It must hold a clue to the outcome of this colossal struggle between good and evil, light and darkness.

I see pensiveness, deep thought, and consideration. That tells me this won't be a spur-of-the-moment, violent, Caravaggio-like burst of passion. It will at least be deliberate. But search this visage as deeply as I can, I cannot find the conviction of Messina's *Virgin Annunciate*. I'm not ready to place a wager on the outcome. It's just not here. Not remotely obvious.

Then I get it.

Rembrandt himself is here, on the canvas. He's showing us his own struggle between giving the world what it wants—and getting that gold chain—and taking the harder road instead, the road he needs to take to save his soul: his path to God.

He's facing a *decision*—an idea we'll come back to again and again. This is not just "a painting of an ancient philosopher" to decorate Don Ruffo's living room.

It's Rembrandt's greatest self-portrait. Not a self-portrait of his earthly visage, which he left for us seventy-four times in ink and oil. This is different, more ambitious. This portrait would make Duccio proud.

This portrait is a window into Rembrandt's inner conflict. This is a portrait of Rembrandt's *soul*.

Or maybe ... it's a portrait of *mine*.

Now we move on—a short hop on the map of Europe, a little backward in time—to a very different painting. But maybe it's about the same thing.

Men of the Flesh, Men of the Spirit

Antwerp, Spanish Netherlands, early 1600s. During the religious wars that followed the Protestant Reformation, the Low Countries on Europe's northwest coast were torn asunder. Eventually, the southern half of them, those closest to the French border, came under Spanish Hapsburg rule following the Treaty of Antwerp, and an extensive period of peace and prosperity ensued.

Peter Paul Rubens had moved with his mother to Antwerp from Westphalia after the death of his Calvinist father and was raised from a young age as Catholic. The Rubens family were highborn and accustomed to moving in noble circles, and as Rubens advanced in his career, he soon found himself executing work for many of the princely houses of Europe.

It was the time of the great Catholic Counter-Reformation, and projecting confidence and vitality in compelling religious themes became the order of the day. Rubens was a leader of this new style in art, a bold synthesis of Michelangelo's muscular figures, Titian's fluidity and color, and Rubens's own dynamism and energy. Rubens's exuberant style bursts with the newly restored confidence of the Catholic Church and particularly the worldwide Spanish Hapsburg Empire. It contrasts starkly with the dark, introspective, and more humble work of his Protestant rival, Rembrandt, painting less than a hundred miles away to the north.

Rubens painted more than a thousand works, and the Met owns several of them. This is one of his most magnificent: *Venus and Adonis*, which stands a full eight feet high and almost commands viewers passing through this gallery to stop before it.

At first glance, you might wonder why a missionary is pausing here. The canvas is dominated by the voluptuous image of Venus, said to be modeled from Rubens's beautiful, young second wife following the death of his first. His skill in rendering the soft, plump flesh of feminine beauty became so well known that *Rubenesque* has become an adjective for describing women with such figures.

"Steve, what are we doing here?" someone asks. "This image seems almost pornographic!"

On the surface, it may well be. But as usual, there's something else going on underneath. In fact, this painting is Rubens's take on the same subject that Rembrandt would take up twenty years later in *Aristotle with a Bust of Homer*. It's another installment of

Peter Paul Rubens, *Venus and Adonis*, mid-1630s

the Decision Series that recurs throughout our journey. My private title for it is "Men of the Flesh, Men of the Spirit."

The Venus and Adonis myth, handed down from ancient Greece, was well known in the world of Antwerp at this time. The version Rubens knew went something like this:

Like all of us, Adonis has a vocation, a calling. His is the hunt. One night, he encounters the alluring goddess of love, Venus—the Roman name for Aphrodite. We visited with her in Athens more than two thousand years ago, and I promised you we'd return to her. Well, here we are: Venus has come to Earth, and, pierced accidentally by Cupid's arrow, has fallen in love with Adonis. An affair is consummated.

Adonis, temporarily distracted in his mission (a little like St. Peter's little detour to the warm fire outside the gates of the Sanhedrin), now faces "the morning after." He is determined to get back on track, to return to the hunt. Venus—the way of the flesh quite literally here—is using all her charms to keep him from it. She has even enlisted her sidekick, Cupid, who gently pulls on Adonis's thigh, trying to draw him back.

Ahead lies the hunt, and danger. Venus has had a premonition that it will end poorly and has implied as much to Adonis, so he senses the road ahead will be difficult. The cross always is.

Behind waits Venus. A much happier outcome, for a moment perhaps—but only for a moment.

Adonis knows Venus, the ways of the flesh, cannot fulfill him. Only his mission can.

What to do? What to do?

Art historians are sometimes critical of this painting, particularly for the lack of detail or emotion in the face of Adonis. In fact, unlike the richness and depth of Rembrandt's Aristotle, this face was painted almost as an afterthought; Rubens probably had

one of the students in his studio finish it for him. Adonis's face is almost a blank.

But study for a moment, please, Adonis's legs, firmly planted on the ground. Though his torso twists to look backward at Venus, the legs don't. They are already advancing toward the hunt. And to underscore the point, Rubens gives us the spear, also planted ahead as Adonis uses it almost as a walking stick, pulling him forward, away from Venus. And his loyal dogs, knowing too well they are already late, are also already on their way out of the scene. They know where they're going, and it isn't to Venus.

And maybe that explains why Rubens spent so much time on those determined legs of Adonis and so little on his face. Adonis's look back to Venus in this interpretation is literally anticlimactic. The decision has already been made.

Rubens has painted for us here a classic, confident "man of the Spirit." He may have fallen, yes, but he has already gotten himself back into the ring. He is now heading out confidently to take up his mission, his cross, again. He is prepared to face death if that's what it takes. Adonis here almost seems to be a study in the great words of St. Paul:

> Do you not know that in a race all the runners compete, but only one receives the prize? So run that you may obtain it. Every athlete exercises self-control in all things. They do it to receive a perishable wreath, but we an imperishable. Well, I do not run aimlessly, I do not box as one beating the air; but I pommel my body and subdue it, lest after preaching to others I myself should be disqualified. (1 Cor. 9:24–27)

Rubens's viewers would also have known the end of the story. Adonis was gored by a wild boar on that hunt and died, leaving Venus to mourn him.

So we've started to see a theme coming out here. In several of our paintings, the subject has a decision to make—the way of the flesh or the way of the cross. I think this is what I had just begun to realize when I started on this long journey through art history. And now I think we're ready to go back to our first Rembrandt with new eyes.

Rembrandt Takes Us for a Slide Down the Slippery Slope

Amsterdam, Dutch Republic, mid-1600s. So here we are, back where it all started for me—the painting that set me off on my long trail through art history. We're back in Protestant Amsterdam again, where Rubens's major artistic competitor, Rembrandt van Rijn, is producing far more dark and introspective works. Rembrandt's clients and viewers, all Bible-reading members of the Dutch Reformed Church, would have been well-schooled in all the biblical stories. So, when he painted this rare nude of the biblical Bathsheba bathing while David looked on from his castle's parapet, they could easily finish the story in their minds. They could see immediately what Rembrandt was up to. They had studied 2 Samuel (see chapter 11).

Let's put ourselves inside their heads and try to see what they could see.

First and foremost, what was David doing out on that parapet that afternoon? The rest of the Jewish army was up north, fighting the Ammonites. David wasn't. He was in the wrong place at the wrong time, as we are at the start of many of our own troubles. That's often the start down the slippery slope, and David is now taking that first tentative step onto its slick surface.

David's wandering eye catches a glimpse of Bathsheba in her garden, at her bath. He takes a second look, then a third. He is attracted for sure—passions rising. So he takes the next step down the slope. He invites Bathsheba over for dinner.

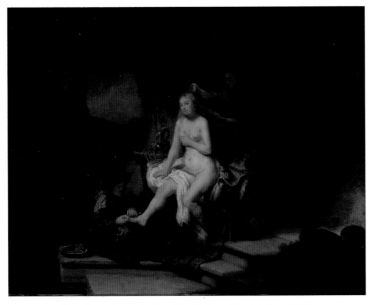

Rembrandt van Rijn, *The Toilet of Bathsheba*, 1643

Wine flows. Passion begets passion. Soon they are in bed. Adultery. Oops.

It gets worse. Bathsheba becomes pregnant. Oh, my!

No, there's more. Bathsheba's husband is a captain in David's army. He's up north, fighting off the invaders—where David should be.

In fact, David is virtually the only eligible male left in Jerusalem who could have impregnated the young woman.

What to do?

Cover it up.

David invites Uriah, the husband, back from the field for dinner at the palace and has Bathsheba dress in her sexiest outfit. When dinner's over, he suggests that Uriah spend the night with her before returning to the front.

Uriah famously refuses. Call to duty. Army at war. No time for dalliances with his wife.

Now, we're in trouble. When Uriah learns of the pregnancy, he'll know David is the father.

David panics. "I have no choice. I'll have to kill him."

He sends Uriah back to the camp with a sealed order for the Israeli general in the field.

"Send Uriah to the front. Make sure he doesn't come back alive."

And with that, David has completed the entire slide down the slippery slope of sin, from being in the wrong place at the wrong time, through adultery, lies, and then murder.

Pretty dark.

To underscore the point, Rembrandt gives us the peacock. His audience knows the peacock. It stands for eternity. And for Christ.

And as David looks twice at Bathsheba, the peacock fades into the shadows. David's eternity is slipping away. And David himself slips into those same dark shadows.

No, this painting is not Bathsheba at her bath, at all. It is David on the slippery slope.

In fact, maybe that beautiful, alluring nude image of Bathsheba is not even Bathsheba.

What is that mysterious light on Bathsheba? Where is it coming from? Could it be the work of the devil, playing with David, shining an alluring light on the very thing the Lord has ordered him not to do? Could this be Rembrandt's hint that what we are seeing here is the image of Bathsheba in David's mind as he contemplates what an evening with her would be like?

That's when I remember the garter.

Do you see it? The mark of the garter on Bathsheba's right leg? Critics at the time went wild about this. "What's that garter doing there? The biblical Bathsheba didn't wear garters! They weren't

invented yet! Wait, is this a real person from here in town? Stark naked?"

The answer, of course, is yes. Rembrandt was too good an artist to make a casual mistake like this. In fact, I think Rembrandt painted the controversial garter with a very deliberate intention, to underscore exactly this point. *This image is not Bathsheba.*

"Yes, it's David's image of Bathsheba in his mind," adds Rembrandt. "But it's also my son's nurse. I'm having an affair with her. And the guy in the tower is not David. It's me."

A year earlier, Rembrandt's long-time wife Saskia van Uylenburgh had died, and Rembrandt's messy affair with his son's nurse would soon become public. After (or perhaps before) confining her to an insane asylum, he would begin another adulterous affair, with his housekeeper. They both would be shunned over the scandal. Was this painting of Bathsheba at her toilet a peek inside Rembrandt's own head, about the slippery slope of sin he knew he was already on but couldn't get off?

Or maybe it was about the end of the story: Psalm 51. Rembrandt's viewers would have known this, too. David wrote Psalm 51 after his fall, to seek the Lord's forgiveness for his sins; and through the psalm, he would deepen his commitment to God as he went on to become Israel's greatest king:

> *Have mercy on me, O God, according to thy*
> *steadfast love;*
> *according to thy abundant mercy blot out*
> *my transgressions.*
> *Wash me thoroughly from my iniquity,*
> *and cleanse me from my sin!*
> *For I know my transgressions,*
> *and my sin is ever before me.*
> *Against thee, thee only, have I sinned,*

> and done that which is evil in thy sight,
> so that thou art justified in thy sentence
> and blameless in thy judgment.
> Behold, I was brought forth in iniquity,
> and in sin did my mother conceive me.
> Behold, thou desirest truth in the inward being;
> therefore teach me wisdom in my secret heart.
> Purge me with hyssop, and I shall be clean;
> wash me, and I shall be whiter than snow.
> Fill me with joy and gladness;
> let the bones which thou hast broken rejoice.
> Hide thy face from my sins,
> and blot out all my iniquities.
> Create in me a clean heart, O God,
> and put a new and right spirit within me.
> Cast me not away from thy presence,
> and take not thy holy Spirit from me.
> Restore to me the joy of thy salvation,
> and uphold me with a willing spirit. (vv. 1–12)

So as dark as "Bathsheba" is, there is hope here too.

And before we move on to another mistaken decision in the battle of light and darkness, another wrong turn, we spend one more minute in silence before Rembrandt's great introspective work, with this last question:

What if this painting is not about Bathsheba, or David, or even Rembrandt? What if it's about *me*?

What Are *You* Looking At?

Isle of Malta, mid-1600s. Malta is flourishing as a center of trade in the Mediterranean. The Knights of St. John—descendants of a

Mattia Preti, known as Il Cavalier Calabrese,
Pilate Washing His Hands, 1663

storied crusader order — rule under the protection of the Kingdom
of Sicily. Their predecessors retreated from Acre in the Holy Land
more than three hundred years earlier and then, from their fortress
at Rhodes, were driven out by the Ottoman forces under Suleiman
the Magnificent. The great Ottoman sultan came for them decades
later in their new redoubt, Malta, but the Knights, outnumbered

as badly as twenty to one by some estimates, somehow hung on until the siege was finally lifted in 1565.

Now the island kingdom is rich—rich enough to be building lavish Baroque churches. Those churches need to be decorated, and their patrons are also eager to show off their wealth in their own estates.

It's a good place for an artist like Mattia Preti, a follower of Caravaggio from the Italian mainland. The Order of St. John has taken him in as a member, and now in Malta they call him "Il Cavalier Calabrese"—"the Knight from Calabria." There's a lot to do for an artist with this kind of talent, and Preti will stay in Malta for the rest of his life.

This scene of the Lord's Passion, taken from the Gospel of Matthew, has rarely been painted over the years. Artistically, Preti's work lacks the drama and intensity of Caravaggio, Rembrandt, and Rubens. But something about this haunting image of Pilate washing his hands drew Fr. Shawn to it many years ago during one of our tours.

Now we come back to it whenever we can. "Its message is about something all of us tend to do," Fr. Shawn says: "rationalize away our mistakes."

Sound familiar?

Fr. Shawn reminds us of the story in the Bible. Pilate has just condemned Jesus to a gruesome death on the Cross. He had found no guilt in Jesus, but the mob continue to demand "Crucify him! Crucify him!" Pilate became even more afraid (see John 19:6–8). He couldn't reason with this crowd.

When Pilate saw that he was gaining nothing, but rather that a riot was beginning, he took water and washed his hands before the crowd, saying, "I am innocent of this righteous man's blood; see to it yourselves." (Matt. 27:24)

He relented. He took the easy route, the route less likely to cause a bad report about him to make it back to the emperor Tiberius in Rome. He saved his career. He sent Jesus to the Cross.

But now, the moment after, the magnitude of the evil he has done is sinking in. An innocent man, a holy man, perhaps even God Himself, has just been led out to slaughter. The little boy to Pilate's right looks on both innocently and wonderingly. "Are you really going to let this happen?" Pilate asks for a tray of water, to attempt to rid himself symbolically of his diabolical role in something almost too big to fathom—the execution of God's Son. He looks out plaintively to us, his witnesses, with that look on his face of a dog that just got caught eating the family dinner off the table. "You understand, don't you? I mean, after all, what was I supposed to do? The crowd had gone crazy. I had to give them what they wanted! Right? Right? *Right?*"

In the distance, to the right of Pilate's knee, we see the image of another man. He's heading to the Cross—to a horrible death. And yet He seems resigned to it, comfortable. He has taken the hard road—the way of the Cross; the will of His Father. It is tough to take, but there is no second guessing. He knows He has done the right thing.

And like the peacock in Rembrandt's *Bathsheba*, what is actually valuable here—eternity, if you will—fades into the background as Pilate's moral struggle engages us.

Pilate has gone down in history as a loser, a guy who couldn't stand up at the key moment and do what was right; a guy who had his shot and whiffed—almost cartoonish in his weakness.

Then I get it. There is a third main character in this drama, and it's not the various attendants surrounding Pilate, watching him wash his hands. It's *me*. *That's* the one whom Pilate is looking at. *I'm* in the crowd, demanding crucifixion.

Or is Pilate making a deal with me? Condone this one for me, and I'll give you a hall pass on your next screwup.

Or maybe he is even more directly pulling me into his predicament. With that piercing, haunting stare straight out of the canvas, he seems to be asking me, "Well, what would *you* have done?"

Interestingly, I think we have another patron painted into his painting here. It's that knight in the foreground. He's dressed not in the first-century garments of the others, but rather in a knight's armor, probably that of a Knight of Malta. His image seems a portrait, with distinctive characteristics, such as the long, thin face and the pointed, well-trimmed beard. It seems—again, in a kind of anti-Perneb gesture—that he has asked Preti to have him stand in for us, the ones who share in Pilate's guilt.

Think about that for a while, and then ask yourself one more question:

When have *I* had that Pontius Pilate look on *my* face?

Too often, when I've done something that I know the Father would not want for me.

And alternatively, how about those decision points where I have just "done it," taken up the cross as offered and carried it for Christ to where He wanted me to go?

Ironically, the latter road, the road less taken, always worked out better.

Speaking of roads, our next stop is to one of the most important roads in the Bible story, the Road to Emmaus.

Christ with Us Now and Always

When he was at table with them, he took the bread and blessed, and broke it, and gave it to them. And their eyes were opened and they recognized him; and he vanished out of their sight.... And they rose that same hour and returned to Jerusalem; and they found

the eleven gathered together and those who were with them. (Luke 24:30–31, 33)

Metropolitan Museum of Art, Spring 2011. By the spring of 2011, our little pilgrimage to the Met had already begun to evolve and mature, and we'd had a dozen or so small groups with us on our "Search for God." It was close to Holy Week, and we had another tour scheduled for the week after. By then it would be Easter, and I desperately wanted to add an Easter painting to the itinerary—if for no other reason than to lighten the mood after studying some of the darker themes of Caravaggio and Rembrandt that seemed to dominate the Baroque part of the tour. After searching for an hour, I finally found this stunner by Diego Velázquez, court painter to the Spanish Hapsburgs.

The Hapsburgs have cropped up earlier in Antwerp, Malta, and Sicily. But Velázquez painted for the crown in the very capital of the empire—indeed, practically the capital of the known world: Madrid.

It was the height of the Counter-Reformation, and Catholic artists were being commissioned to paint biblical scenes that re-inforced and supported the Catholic Magisterium. This painting is about one such controversy, the Real Presence of Christ in the Eucharist—Christ with us.

For his inspiration, Velázquez drew on chapter 24 of Luke's Gospel, the account on the road to Emmaus.

When I first found *The Supper at Emmaus*, my jaw dropped. It still does.

It's the first Easter Sunday. The resurrected Jesus has been walking side by side with two discouraged disciples, one named Cleopas and the other unnamed. (Could that be *me*?) They're heading out of Jerusalem—possibly throwing in the towel; we don't know. From their perspective, the man they had believed

Diego Rodríquez de Silva y Velázquez,
The Supper at Emmaus, 1622–1623

was the Messiah has just met a sudden and horrible end, and it's all over. Sure, "some women of our company … amazed us" (Luke 24:22) with news of His Resurrection, but these two disciples seem skeptical at best.

Slowly, patiently, reassuringly, Jesus unpacks what happened in His Passion, showing the disciples how it was all part of God's plan, all foretold in advance in the Scripture texts (now our Old Testament) with which they were familiar. Their hearts "burn within them as He opens the Scriptures to them (Luke 24:32).

It's the Liturgy of the Word.

When they reach Emmaus, they insist that He stay for supper. He does. Then He enters into the mystery of the Eucharistic celebration: "When he was at table with them, he took the bread and blessed, and broke it, and gave it to them" (Luke 24:30).

In an instant, they recognize Him: resurrected from the dead; present with them — physically present, and at the same time, present in the bread. It's the first Mass following His Passion and death. He has come to celebrate it with them!

Instantly, they are converted from forlorn disciples into joyful missionaries! The Lord now disappears, but they know He is with them. They leave Emmaus and rush back to Jerusalem and the apostles in the Upper Room to proclaim the stunningly good news.

Velázquez has recorded here this magnificent moment of recognition of the risen Christ. Cleopas, astounded, turns to his companion in joy. The latter's arms are outstretched, almost bursting from his body. At the center of the scene sits Jesus, serene, the wounds in His hands suddenly visible and marking His identity.

This is the Easter moment, writ large. Christ with us now and always.

-‹‹‹•›››-

My visit to the Met that day would prove eerily timely. Two weeks later, I found myself on the streets of SoHo, outside Old St. Pat's, trying to convince an out-of-town, long-ago-fallen-away Catholic who was "dying of three forms of cancer" to come back to the Church. He had taken a shortcut through SoHo and bumped into me.

His issue when he left in a huff forty years earlier? He had concluded that "the whole Mass thing was all made up. Jesus isn't really there. We're alone."

At one point in the long conversation that followed, I needed to stall for time; I was getting nowhere. I asked him what he had been up to in New York besides "settling his estate."

"Well, I visited the Met."

"Really? See anything interesting?"

"Well, one thing. A painting about a place called Emmaus. I didn't really understand what was going on, but I seemed drawn to it."

"And," I added, "by some extraordinary coincidence, now, near the end of your life, you've bumped into maybe the only person in New Yok City who just spent two hours reflecting on that painting and can explain to you what it has to do with your decision forty years ago to turn away from Christ."

Thirty minutes later, he came home—to Emmaus.

Fr. Shawn once told Evelyn that in the missionary life, just when the road is hardest and you're beginning to wonder what it's all about, the Holy Spirit will often send you a "small consolation, a sign."

In 2011, the street mission in New York was still in its early, fumbling stages. And the spiritual tour of the Met, though it had had some success, was not even fully put together. Doubts inevitably arose.

This little encounter on the streets of New York early one spring evening changed all that. This was my own Emmaus.

Rembrandt Comes Home

Well, you remember that Evelyn granted me three paintings outside the Met. I have to choose carefully. Which three paintings are so important to art history, and especially to our search for God, that we simply have to look at them, even if we can see only tiny reproductions?

It's a hard choice. But I'm confident that this is one of the three. And by the way, Evelyn is the one who added it to the tour. So blame her.

Amsterdam, Dutch Republic, 1668. We're back now in the great Dutch Republic, nearly twenty years since Rembrandt's struggle between virtue and riches, painted so dramatically in his *Aristotle with a Bust of Homer*. The inner struggle he depicted there did not end well. As mentioned earlier, soon after his wife died in 1642, he fell into an affair with his son's nurse, then with his young housekeeper, Hendrickje Stoffels—after first condemning the nurse to an insane asylum. Both Rembrandt and his lover were shunned by the local Dutch Reformed Church. For this and other vague reasons, the two lived as an unmarried couple. As Rembrandt's paintings grew darker, and some would say uglier, his supply of patrons began drying up. His finances, always on the brink, grew worse. Stoffels died in 1662, leaving him alone. Five years later, he was dead. His bankrupt estate had no funds to bury him; the greatest painter of his generation was laid to rest in a pauper's grave.

Just months before the end, Rembrandt painted the dramatic image of *The Return of the Prodigal Son*. He painted it for himself. There was no commission. It was purchased eventually by Catherine the Great of Russia, and, to this day, it hangs in the State Hermitage Museum in St. Petersburg. Now it's one of the most reprinted images in all of art.

The parable of the prodigal son is one of the stories everyone remembers from the Bible. It's in Luke 15. "There was a man who had two sons," Jesus begins, "and the younger of them said to his father, 'Father, give me the share of property that falls to me.' And he divided his living between them" (vv. 11-12).

Rembrandt van Rijn, *The Return of the Prodigal Son*, ca. 1668,
State Hermitage Museum, image courtesy of Wikimedia Commons

Of course, the younger son goes off and spends everything on wild parties. Finally, when he's homeless and starving, he decides to go back and beg his father to take him in as a hired worker because at least his father's workmen have food and a roof over their heads. "Father, I have sinned against heaven and before you; I am no longer worthy to be called your son" (v. 21).

But the father is so delighted his son has returned that he throws a big party to welcome him back into the family. "Let us eat and make merry; for this my son was dead, and is alive again; he was lost, and is found" (vv. 23-24).

In this painting, Rembrandt shows us that dramatic moment when the father lovingly embraces his begging son. But I think there's another story here, too.

Like Caravaggio's *Denial of Saint Peter*, which we stopped at earlier, this "last painting" may be a cry across time from an artist who was searching for God, but—like many of us—may have taken a wrong turn. And now, near the end, he was regretting it.

The emotional power of this work is, in many art historians' minds, unmatched in the history of art. In the forefront of the canvas kneels the younger son, who has wasted his father's estate in a life of promiscuity and dissipation and has now crawled home, almost shoeless, contrite. He has committed virtually the entire list of mortal sins in Jewish law, the "whole left side of the menu." In the process, he has wasted all the funds he had taken from his father on things of the secular world. Instead of buying him happiness, it has bought him misery. Now he returns with nothing to offer but a contrite heart. He kneels in humility and prayer before the father. He's hoping against hope for a job in the fields. He believes he is unforgivable.

Standing above him—no, crouching with him—Rembrandt places the father. Surprisingly, perhaps, the father not only forgives

the prodigal but also embraces him warmly. He restores him to his place in the household. He gives him back his dignity, the dignity that the son believes has long been lost. Now, a joyful, welcoming light flows out of the father himself, enveloping the son, bringing him home out of the darkness. It is "the light that comes from an inner fire that never dies: the fire of love."[8]

Evelyn's eye is drawn to those two hands of the father. Art historians have long debated Rembrandt's "mistake" here. The father's two hands are different: his left hand strong and masculine, his right hand slender and feminine.

Some believe this is Rembrandt's reference to the two hands of God: justice for sure, but also mercy, which prevails here in the loving way the father's arms—indeed, his entire body—embrace the prodigal son.

In this last testament, Rembrandt is both seeking forgiveness and hoping for mercy. The great artist has been brought to his knees. He's seeking the forgiveness of the Father, pleading with him over time and space for mercy, not justice. For love, not disdain. Forgiveness, not revenge.

There's more, as usual. Who is that mysterious figure standing to the right? It's the older son! Well dressed in the fine clothes and jewels that led to his younger brother's ruin, he stands apart, looking on diffidently "with clasped hands"[9] as this scene of mercy and forgiveness unfolds. Though technically still a part of the overall composition, he seems strangely distant, aloof. He has stayed at his father's side loyally and obediently all these years while the prodigal was out partying away the estate. What a contrast here to

[8] Henri J. M. Nouwen, *The Return of the Prodigal Son* (New York: Doubleday, 1992), 94.

[9] Nouwen, *The Return of the Prodigal Son*, 67.

the forgiving attitude of the father! While the father is warm and generous in his love, the older son seems judgmental, condemning, maybe even jealous that at this late hour, the younger son is being forgiven. If *he* were running things, which he hopes he'll soon be, this miscreant would never have been allowed back on the estate!

What's wrong here? The older brother has followed all the rules. But the father is not embracing him. He's embracing the prodigal. And later, when the celebratory party begins, the older brother won't even be part of it.

For all his loyalty, the older son fails one simple test. He doesn't let the father love him. He's too proud for that. He won't drop to his knees to ask the old man for love, for mercy. And as a result, he can't love him back. And he certainly can't love his brother.

And just as we settle in here, coolly evaluating the older son's failures, it's time to ask a key question.

When have I been the older son—too proud to ask the Father to forgive me, to love me?

Bad recipe if I want to be a missionary.

Transformation: Mary Prepares for a Journey

Lorraine valley, mid-1600s. Politically, the Lorraine valley has constantly shifted back and forth between Germany and France. Spiritually, it's a deeply Catholic area. Georges de La Tour grew up in this fervently Catholic religious culture. He joined a Franciscan-led religious revival early in his career, and most of his few surviving paintings follow an important religious theme. One of these, *The Penitent Magdalen*, hangs at the Met.

On any given evening, a small crowd of all shapes and sizes, and probably of a variety of religious and nonreligious backgrounds, can usually be found here, contemplating this strange, quiet painting, which draws us in with an invisible but powerful magnetic force.

Georges de La Tour, *The Penitent Magdalen*, 1640

Entire books have been written on this mysterious image, debating about what's going on in the subject's head as she sits calmly, meditatively. As missionaries, we can enter the scene.

It's evening. Mary sits alone, illuminated by the light of a single candle. It seems she has just returned from her first encounter with Jesus. He has driven out her demons and forgiven her, and, maybe for the first time in her life, someone loves her. Jesus has told her that she matters. She has decided to change, to take a new course in life. She's still dressed in her "work clothes": notice the red skirt and the unveiled long hair, both common fashion for "women of the night" in La Tour's day. Yet, somehow, we sense she's moving on; the pearls of her past have been tossed to the side. She's determined to fix things, to follow Christ.

On her lap rests a symbol of her mortality, a skull. It no longer threatens her; her arms rest serenely on it. She has put her hope in Jesus. He has given her the water that lasts forever. She's looking to the eternal. She's heading out.

But the journey will not be easy. She senses that. The old habits that attracted her are still with her; those pearls are just an arm's length away, tempting her to return to old sins. The skull may also refer to Golgotha, the place of the skull, where she will follow Jesus with His Cross to His death there. She, too, will have crosses to bear. The journey to Heaven will not be easy.

Instinctively, she turns to her left, where her silver-gilded mirror rests. Until now, it has been one of her favorite possessions, in which she could admire the reflection of her external beauty. But as she turns, she gasps. She no longer sees just herself. There is a second candle there, walking side by side with hers. It's Jesus, the light that will guide her home.

As rich as all this is, there's more, and that's partly what draws so many into this masterwork.

We are in this painting. Each of us.

You see, La Tour doesn't show us all of Mary's face. This was an artistic device of the day, meant to invite us into the scene, to put *our* faces in place of Mary's. Let's spend a moment doing this.

Yes, we've met Christ. We've experienced His mercy and His love. He has "converted" us. We've promised to follow Him. But conversion is not a single moment in time. It's a journey. There will be joys and sorrows. There will be spiritual high points, then low points. Old temptations will crop up, drawing us back to our old habits. The pearls of yesteryear are just an arm's length away. From time to time, we may reach out and grab them briefly. We may stumble, even fall.

One moment, we'll be Perneb. Another, the owner of the Upper Room, serving Jesus. At times, we'll be the emperor Constantine, looking forward confidently with eyes of faith. Then we'll take a wrong turn and find ourselves in Pilate's shoes, regretting a big mistake. But if we stay focused on the prize, we'll get up the next day and take up our cross and follow Him. That's the message of *The Penitent Magdalen*. The candle remains lit.

Transformation is a lifelong commitment and a daily struggle—a journey, not a destination.

Most evenings, Evelyn's prayer card for *The Penitent Magdalen* is one of the most popular of all the cards in our after-tour discussion over dinner. The prayer we include on the back is from Psalm 139. We think of this as "Mary's prayer":

> LORD, *you have probed me, you know me:*
> *you know when I sit and stand;*
> *you understand my thoughts from afar.*
> *You sift through my travels and my rest;*
> *with all my ways you are familiar.*

Even before a word is on my tongue,
 LORD, you know it all.
Behind and before you encircle me
 and rest your hand upon me.
Such knowledge is too wonderful for me,
 far too lofty for me to reach.
Where can I go from your spirit?
 From your presence, where can I flee?
If I ascend to the heavens, you are there;
 if I lie down in Sheol, there you are.
If I take the wings of dawn
 and dwell beyond the sea,
Even there your hand guides me,
 your right hand holds me fast.
If I say, "Surely darkness shall hide me,
 and night shall be my light"—
Darkness is not dark for you,
 and night shines as the day.
Darkness and light are but one.
 (vv. 1–12, NABRE)

True Love at Last

Bologna, Italy, early 1600s. Northern Italy's economic boom of the late Middle Ages is fading as the global trading powers rise on Europe's western shores. But there's still considerable wealth and artistic tradition.

In Bologna, Guido Reni is the leading light of a classical school of artists—the Bolognese School, as art historians call it. Much of Reni's work blends the very beautiful, idealized images of the High Renaissance, the stage-like settings and stylized figure paintings of Mannerism, and the use of light and darkness of

Caravaggio and the Baroque: a synthesis of two hundred years of artistic tradition.

Late in his career, Reni's habit for gambling left his finances in considerable disarray, despite his fame and success throughout Europe. Although many of his late paintings seem rushed and incomplete as he hurried to complete yet more revenue-producing commissions, he fortunately spent sufficient time with *Charity* to create an image of Christian love that calls to all of us across time and space. We're standing before that painting now.

As Counter-Reformation painters were called to assert the Catholic Faith more boldly, they addressed not only key aspects of the Faith—such as the Sacraments of Reconciliation (e.g., *The Penitent Magdalen*) and the Eucharist (*The Supper at Emmaus*)—but also more abstract ideas, such as the Christian virtues. Of these, the highest is charity. In a Catholic context, charity represents pure *agape* love, the kind of love that is self-sacrificing, the love of Christ on the Cross. Love was the Christian virtue that stood out as singularly new and different in the ancient Christian communities of the Roman Empire. In some ways, it was the virtue that conquered the empire. So what better virtue to celebrate within the Counter-Reformation than this?

On the surface, Reni's *Charity* seems simply a beautiful image of an ideal mother tending to her three small babies. One feeds at her breast, one is napping, and the other is engaging. The mother is pretty tied up but seems to be managing okay.

Take another look.

The mother is giving her children everything she has—even her last drop of blood.

The feeding baby seems to be the last of the three to be fed. He is sucking away greedily at her breast, siphoning from it the last of her milk. As he does so, his cheeks become rosy as new life flows into him from her. At the same time, her exposed chest

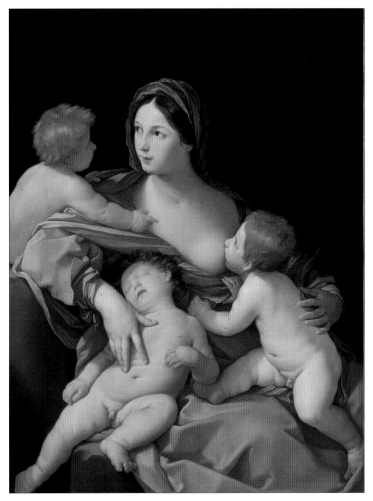

Guido Reni, *Charity*, ca. 1630

turns dead pale, as she gives her last to the little boy to preserve him. Though his cheeks are rosy, the rest of his body looks weak and pale; the nourishing life force of the mother is only just now entering him around those lips.

On the mother's lap rests a now fully fed and satiated second child. He's so full that he has fallen asleep, his content, languid body resting peacefully, in full, fleshy color. None of the paleness of his brother to his left.

To the mother's right is her third, fully restored child. He must have been the first to feed and then rest. His body is painted in even rosier tones than the resting boy; he's clearly animated and very engaged. Alive and kicking!

What's amazing about this ideal mother is that even as these three children drain her last, she is still fully engaged and attentive to each. With her left arm, she is gently cradling the feeding child, holding him to her breast. With her right hand, she's caressing the sleeping boy, making sure he rests peacefully and is not disturbed by the action going on around him. And with her fully attentive eyes, she playfully engages the wakeful child, encouraging him, teaching him. She's all in.

Then, focus on her cheeks. Even while the feeding drains her body of its last strength, her cheeks are beginning to glow again with the same rosiness of life that appears on the cheeks of the boy who is feeding. New life.

Where is that coming from?

From the love of the restored child.

By giving her all, completely, totally, without reservation, she is restored to a new life, new energy.

That is the mystery of Christian love. When we give everything we have, though at the end we may be completely exhausted, we somehow come away with more than we started with. We receive new life. Ask any street missionary after eight grueling hours evangelizing on the streets of New York.

Stand in front of this beautiful image of love for a moment and reflect. When in my life have I been all in, as this mother is here?

When I reflect privately on my own moments like this, I seem to feel my own cheeks growing rosier. I feel restored.

Funny how love works.

Dignity Restored

Madrid, Hapsburg Spain, 1600s. We are back now to the center of it all, Hapsburg Spain and the court of Philip IV. The great Spanish Empire is already being attacked on all sides. By century's end, it would fall into a gradual decline. But like Athens before it, it's brightest before the fall. The so-called Spanish Golden Age has arrived, and its leading light is Diego Rodríquez da Silva y Velázquez—commonly known simply as Velázquez.

We encountered him earlier, in his dynamic Counter-Reformation painting of the first Mass after the Resurrection, *The Supper at Emmaus.* Now we will look at a later, more mature work. Like Reni's *Charity,* it highlights another of the great Christian virtues, the dignity of every person.

Velázquez's career was built around his role as the official court painter of Philip IV and his family. He was accustomed to painting the great nobility of Spain and, indeed, of the world. In 1649, he set out for northern Italy, to collect paintings of the great masters for Philip. Unsurprisingly, once he was there, it wasn't long before the pope himself requested that he come to Rome to paint his portrait.

Velasquez had brought with him for the journey his personal servant, Juan de Pareja. Pareja was ethnically a *mestizo*, partly of Moorish descent. In Hapsburg Spain, that meant lower class—servant material. In fact, he was his slave.

Velázquez seems to have developed a close relationship with Pareja over the years and had begun to teach his servant the art of painting. For some unknown reason, prior to painting the pope's

Diego Rodríquez de Silva y Velázquez, *Juan de Pareja*, 1650

portrait, Velázquez decided to paint Pareja's. The result became a masterpiece, not just in Catholic Spain, but across the ages. Today, it's one of the most popular paintings in our museum here in New York.

The Met's catalogue quotes one of Velázquez's biographers: "[Velázquez's *Juan de Pareja*] received such universal acclaim that in the opinion of all the painters of different nations everything else seemed like painting but this alone like truth."

What "truth" is the biographer thinking of here?

For sheer technical skill, Velázquez's *Juan de Pareja* already qualifies as a masterpiece. Pareja stands alone against a blank wall, looking out on us. His portrait seems completely lifelike: the black curly hair, the bushy eyebrows, that noble, Middle Eastern nose, that neatly trimmed beard, and the worn clothing of a servant (notice the frayed collar of his cloak and the hole in his sleeve that opens at his right elbow). Velázquez has captured even Pareja's handsome ethnic roots; he almost looks like an older brother of the young man from North Africa we saw on that Egyptian tomb nearly two thousand years ago!

But what made this painting so important in 1640, and what draws visitors from around the world to it today, is not simply its technical virtuosity. It is the inner dignity of Juan de Pareja, the dignity that asserts itself through the tattered clothes. His bearing. His royal pose, reaching for his royal scabbard that he actually doesn't have and, more importantly, doesn't need.

And then there are his eyes.

Pareja's eyes speak everything, as they look out on us serenely, confidently—not plaintively or arrogantly but full of pride in who he is. His eyes seem to say, "Though a slave, I am a beloved son of God. I know my worth. It is as great as a king, or as a pope. I am *Juan de Pareja*. I am not a victim. My life matters. And I don't hate you. I love you."

This painting is a reminder from Velázquez to the princes and popes he painted for, to the people of Europe, that all of us, as children of God, possess inalienable dignity. This painting is as Catholic as you can get. And you don't need to be Catholic to

sense this reality. It's there. In those magnificent eyes speaking softly to us over space and time. Eternal.

I often wonder how many people of all stripes and colors, but particularly of royal Europe, were "converted" by this single painting. How many are still being converted today?

The first conversion may have been Velázquez himself. Shortly after executing this portrait of Juan de Pareja, he freed him. His former servant moved on to become a great artist in his own right.

–≺≺≺◆≫≫–

Papal nuncio's residence, New York City, 2015. When the Holy Father visited New York City in 2015, Evelyn and I had the privilege of meeting him briefly at the papal nuncio's residence on the Upper East Side. (I never learned by whom this meeting was arranged, but frankly, I didn't ask too many questions.) By then, we were very engaged in our mission to the Met, and I wanted to give a little piece of it back to the Holy Father. After careful consideration, the prayer card we chose for this purpose was the *Juan de Pareja.* We thought it spoke most to one of the greatest themes of his papacy. This is the prayer on the back of the card that we gave to His Holiness:

> As a body is one though it has many parts, and all the parts of the body, though many, are one body, so also Christ. For in one Spirit we were all baptized into one body, whether Jews or Greeks, slaves or free persons, and we were all given to drink of one Spirit. (1 Cor. 12:12–13, NABRE)

Beneath the Veil

Naples, Italy, 1750s. The cultural influence of Naples is ebbing, but its port is still a great source of wealth, and the city still holds sway as an important cultural center of the Baroque and, more broadly,

of Catholic religious art. So before we set our sails to the western winds that will steer art into the modern age, we need to pause one last time to catch our breath, or maybe to lose our breath, before a sculpture of God Himself, created by an Italian artist of Hapsburg Naples. It marks the third in a series of veiled sculptures in our pilgrimage. And beneath that veil, it comes as close as any work we've visited yet to answering the question "Where is God?"

Okay, let's get this little issue over with right off the bat. The *Veiled Christ* is not in the Met; it's in the city it was carved in: Naples. And no, I'm not counting it in my three-painting limit! Little loophole, here: it's not a painting. (Evelyn didn't say anything about a sculpture limit!)

Evelyn and I first visited the "*Cristo Velato*" (its Italian name) on a trip to Naples with Liz Lev, whose book *How Catholic Art Saved the Faith* is a must-read for anyone interested in Counter-Reformation art. We had known for years about this famous marble carving. Even so, when we first stood before it, we, like most first-time visitors, could hardly believe the veil over the body of the dead Christ was marble. It seems so light, so transparent, as it clings to the Lord's body, seen in repose not long after His gruesome death on the Cross.

Giuseppe Sanmartino's *Veiled Christ* is perhaps the ultimate stone carving of a veil covering a human form. We've already visited with two earlier virtuoso performances, one by an unknown Egyptian artist around 1500 BC, which depicted the beautiful Egyptian pharaoh Hatshepsut on a divine throne. The second, carved more than a thousand years later, was executed by the classical Athenian sculptor Kallimachos, portraying the Greek goddess of love, Aphrodite, the perfect female form, standing before us alluringly, beneath her thin (marble) cloak. Following the Renaissance and the rediscovery of classical technique, artists from Donatello to Michelangelo to Bernini produced works of great beauty and emotive power in marble. Bernini, born in Naples, though he worked

primarily in Rome, is perhaps the best known of the Renaissance and Baroque sculptors, and his works such as *Apollo and Daphne* and *Saint Teresa in Ecstasy* have awed visitors to Rome ever since.

Sanmartino's artistic legacy extends back to Bernini, though the former died a full century before the *Veiled Christ* was sculpted. And while he was clearly inspired by the great sculptors before him, especially Bernini, here, in the *Veiled Christ*, the art of sculpting has shifted to an entirely new level. Indeed, the veil here that covers Christ is so entirely transparent that we can see fully the body beneath it. Incredibly, Sanmartino would have had to carve the veil first, as he broke his way through the marble, and carved the body beneath only at the last stage. Of course, to the naked eye, it seems entirely probable that he had done precisely the opposite: carved the body, then simply covered it with a veil of marble.

But let's move for a moment beyond the sheer technical brilliance of this statue. We didn't jet all the way over here from the Met simply to admire a technical skill. We came to find God.

We stand before a life-size image of a dead man, lying on a bed of stone. We know from the sculpture's title alone that the lifeless man is Jesus and that we are presumably in the Lord's tomb. Probably, it's the night after His Passion and not long before His triumphant Resurrection from the dead.

Beneath the delicately carved burial cloak, we can see His image clearly, including the wounds in His head made by the crown of thorns and those in His hands and feet, made by the nails by which He hung on the Cross. These instruments of torture are visible beneath the veil as well, pulled off and left at His feet by the women who prepared His body for burial. Though He clearly died an agonizing death, here in repose He looks at peace—exhausted from the effort of giving His all to fulfill His Father's will, yet at peace.

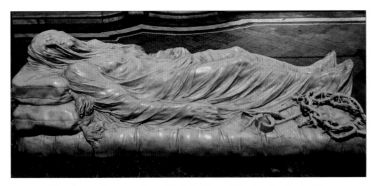

Giuseppe Sanmartino, *Veiled Christ*, Naples, Italy, 1753

As we stand before this riveting image of our Lord in death, His countenance of peaceful confidence reminds us that this is not the end. In death, He almost seems to be comforting us with the promise of His Resurrection, through the veil, to everlasting life. Soon He will complete His mission. He is about to conquer death itself.

Then I am pulled back to the veil and to the role veils play in our search for God.

God is a mystery, one we can never fully contemplate. We can search for Him in this life but never fully find Him. We can see Him, but not fully. It is as if there is always a veil of some kind in our way. Or as St. Paul put it, "at present, we see indistinctly, as in a mirror" (1 Cor. 13:12).

What is the veil between us? What is the barrier between me and Him?

That's it! There are many veils. And each of us has our own veil separating us from God.

For Hatshepsut, who is depicted partially veiled by her shendyt-kilt, is not the veil her own pride? Indeed, beneath the veil was, well, Hatshepsut, in all her beauty, for sure, but nevertheless Hatshepsut herself, placing herself on the divine throne.

For Kallimachos and the Greeks, seeking their god through the great virtues, hoping to become gods themselves, beneath the veil of Aphrodite is love. But the image of love here, seen through Aphrodite's veil, is not the love that Christ would later preach in the Beatitudes. Rather, Aphrodite's love is what the Greeks called *eros*—human love, or passion, if you will. And that, too, can become a barrier to God rather than a passage to Him.

But here, in this tomb, beneath the veil is something quite different. Beneath the veil is the image of God Himself, who has given His all to find us and to help us find Him. Beneath the veil is a personal God, a God who yearns for us, a God who won't quit on us—to the point of taking on human form and subjecting Himself to the most hideous of deaths. Beneath the veil is complete and total self-sacrifice. *Agape*. Love. The pure love that is the path to God.

The love described in 1 Corinthians 13:4–13.

Love is patient and kind; love is not jealous or boastful; it is not arrogant or rude. Love does not insist on its own way; it is not irritable or resentful; it does not rejoice at wrong, but rejoices in the right. Love bears all things, believes all things, hopes all things, endures all things.

Love never ends; as for prophecies, they will pass away; as for tongues, they will cease; as for knowledge, it will pass away. For our knowledge is imperfect and our prophecy is imperfect; but when the perfect comes, the imperfect will pass away. When I was a child, I spoke like a child, I thought like a child, I reasoned like a child; when I became a man, I gave up childish ways. For now we see in a mirror dimly, but then face to face. Now I know in part; then I shall understand fully, even as I

have been fully understood. So faith, hope, love abide, these three; but the greatest of these is love.

This is the path to God. Love.

Do I love like this?

Embarking in a Different Direction

Paris, France, ancien régime period. As Europe roared into the 1700s, the two great nation-states of England and France came to dominate the scene. Though the former had settled into a more modern version of representative rule, with a people's Parliament checking the sole power of the monarchy, the latter was playing out the last stages of absolute monarchy—the "ancien régime," or "old government"—before it would all come crashing down in the violence of the French Revolution and the Reign of Terror at the end of the century.

Both worldwide empires brought enormous wealth home to their capitals, and in both cultures, a wealthy upper middle class emerged and dominated the scene. Art, always drawn toward its patrons, began to devolve into sophisticated interior decoration for the many palaces and country estates of its benefactors. A lighter, less high-minded form of art evolved, which art historians call Rococo. Art, and the increasingly secular, worldly society it serviced, was embarking in a new direction.

The Met has a rich collection of Rococo works, though not as rich as the more intimate Frick Museum, a few blocks down Fifth Avenue. Still, a beautiful example of high Rococo art can be found here, in Jean-Baptiste Joseph Pater's masterpiece of the era, *The Fair at Bezons.* Pater's piece celebrates an annual fair outside Paris where virtually the whole city headed in early September, a kind of "end of summer" public party. Citizens of all stripes and status were welcome there.

By this point in our tour, we're all eager to move on to the more dramatic happenings of the nineteenth century that we know are

Jean-Baptiste Joseph Pater, *The Fair at Bezons*, 1733

waiting for us. This painting isn't going to delay us long. Delicately executed, with light pastel colors, both the subject matter and painting style share a lively, if somewhat shallow, attitude. In the little vignettes that dot the landscape, one can almost imagine the animated conversations and gleeful partying that is in the air.

Absent from the scene is any sense of the eternal, of the future. No deep thought here. The figures, and even the viewers, are simply caught up in the present moment, enjoying it for what it is.

For me, this painting is like a glass of iced Perrier on a hot summer afternoon. Refreshing for a moment but forgotten a few minutes later out in the summer's heat.

As I stand here in front of this worldly image, I wonder how similar it might have been to that wonderful party that the occupants of Fannius Synistor's villa bedroom in Pompeii had enjoyed the night before Vesuvius exploded with all its fury.

We all have moments like this in our lives. In fact, we all need moments like this, to let the air out, to decompress, I suppose.

But what happens when these moments become more than moments? When all we have to live for is the next party?

Inevitably, the "hangover" awaits us. The next artist, Antoine Watteau, painted it.

The Morning After

Paris, France, early 1700s. Amid the light, fanciful culture of the *ancien régime*, a deeper thinker arose, challenging his viewers to this day. In his plaintive *Mezzetin*, before which we now stand, he seems literally to be addressing the hangover that must have followed the fair at Bezons. Ironically, Watteau was Pater's sometime mentor; he painted the *Mezzetin* a decade earlier than Pater painted *The Fair at Bezons*. But Watteau could already see where all this was headed.

Though Watteau died young and relatively unknown, his art continues to speak to visitors. Two of his greatest masterpieces—*The Embarkation for Cythera* and *Pierrot* or "Clown"—have been viewed in his hometown at the Louvre by millions. He painted *Mezzetin*, or "Musician," in his waning years, his health already in decline

Antoine Watteau, *Mezzetin*, 1718–1720

from what some suspect was tuberculosis. Like Caravaggio's *Denial* and Rembrandt's *Prodigal Son*, it's an artist's last legacy to us.

On the surface, *Mezzetin* seems to be as light and airy as the other lovely scenes of his fellow Rococo artists. The musician sits dreamily in a bucolic, imaginary garden somewhere outside Paris, enjoying the evening air as he strums his guitar after entertaining visitors to the garden. Watteau has rendered the stage character Mezzetin exquisitely, delicately drawing in oil his fine silk costume, those rosette buttons on his shoes, and his shimmering purple cloak. He captures Mezzetin here at the end of a long day, resting. Another day, another dollar.

Yet, it feels as if there's more to this. As we stand in front of the small image hanging innocently in a remote gallery, we are somehow drawn to it, mesmerized. We are not sure what is mesmerizing us—what is even riveting us to it.

There's something about the mood here that pulls us inside Mezzetin's mind, into his deepest thoughts. And it's an irony.

Mezzetin is a musician. Musicians are supposed to be happy. After all, they get to *do what they love* for money! But this Mezzetin seems quite a bit less than happy. He looks worn out, forlorn, even melancholic.

The sun has set; evening is coming. The only other semblance of humanity present here, the statue in the garden, seems to have turned her back on him, moving on. His beard has that five o'clock shadow. His wig is ruffled; his face, pensive, even sad. There must have been a party going on—perhaps it still is, just a few steps away. But our Mezzetin is alone, even if he's in a crowd.

His right hand has just made one last flick of the guitar's strings, as if say "That's it. It's over." Or maybe, "It is finished" (John 19:30).

We don't know what is supposed to be going on in Mezzetin's head here; some say this is a painting about a lost love, a broken heart. It may well be. But I think it is more than that.

I think it's a painting about a lost life. Watteau's life, perhaps. Or maybe mine.

Late in his life, Watteau painted not just one image like this but several. Two others that come to mind are the Louvre's *Pierrot* and the National Gallery's *The Italian Comedians*. Watteau almost seemed obsessed by the topic.

The common theme is an artist not enlivened and fulfilled by his work, as he *should* be, but rather, saddened and worn. All the artists Watteau pictures—the clown, the musician, the comic actor—have engaged their talents for the sake of light, comedic entertainment rather than something richer, deeper, more spiritual, perhaps: like Watteau himself, who, with his fellow Rococo artists, had deployed his skills for a quick buck as interior decorators.

There are times when I come to the Met just to stand alone in front of *Mezzetin*. How am I using *my* talents, Lord? For You, for the eternal? Or for a passing fancy, a nice party, a good time?

Then I turn to this quote from Lamentations:

> My soul is bereft of peace,
> I have forgotten what happiness is;
> so I say, "Gone is my glory,
> and my expectation from the LORD."
> Remember my affliction and my bitterness,
> the wormwood and the gall!
> My soul continually thinks of it
> and is bowed down within me. (3:17–20)

It's the morning after. Hangover's here.

Time to embark for the nineteenth century, as art takes one more dramatic step away from its heretofore higher purpose.

10

The End of the Soul and the Death of God

Realism to Impressionism

God is dead. God remains dead. And we have killed him.

—Friedrich Nietzsche, *The Gay Science*, 1882

Paris, France, mid-1800s. By the middle of the nineteenth century, Europe was an even less spiritual place than the one toward which Watteau's *Mezzetin* looked with trepidation and regret for the wrong turn taken. The Age of Enlightenment had arrived.

Harking back to the first "enlightenment" in the Garden of Eden, when man first considered the proposition of replacing God with himself, European culture was fast evolving in the same direction. New discoveries in the sciences, political revolutions upending the old order, the Industrial Revolution underway, and the urbanization of society all conspired to leave men wondering if there was a God at all. And if not, what was man's purpose in life—if any?

The arts, which had fallen from the *Mezzetin* toward propaganda machines for increasingly powerful national governments, were caught up in the malaise, searching for a new direction, new meaning.

Enter Édouard Manet.

Pilgrimage to the Museum

The Anti-Duccio Moment in Art Arrives

Manet's leap forward for art was to assert that its centuries of seeking to render on canvas the inner thoughts of man, to paint his soul, were pointless. *Man doesn't have a soul.* There is only now. This moment. There is no eternity. So don't bother trying to paint it.

Stylistically, Manet's assertion opened the possibility of a new direction as well. He abandoned the painstaking traditional methods of painting canvases using multiple layers of oil paint and opted instead for more easily applied and rapidly finished coatings that left his images less three-dimensional, less deep, almost flat. His color palette similarly grew simpler; his backgrounds, blank.

To the modern eye, none of this seems strange at all, but in its day, it was revolutionary. Many of Manet's most forward-looking pieces, most famously the Musée d'Orsay's *Luncheon on the Grass*, were rejected for exhibition at the annual Paris establishment art shows, called the Salon. The Met has one of these rejected Manets, *Young Man in the Costume of a Majo*. We stand before it now.

A *majo* was sort of a Spanish fashionista. The young *majos* dressed in elaborate costumes with an exaggerated Spanish flair, similar to the toreadors of the Spanish bullrings. It was an early version of the culture wars, a deliberate rejection of the French-centric fashion sported by Spain's upper classes.

So look at this painting. What's the fuss all about?

Many of our visitors have the same reaction they had to Duccio's *Madonna and Child*, which we stopped at nearly six hundred years ago. *What's the big deal?* "Nice-looking young *majo*, if you ask me. I love that cummerbund he's wearing."

This is where I take my opportunity to ask a few questions.

First, what's going on inside this guy's head?

Second, where is he?

And third, what is his purpose in life?

Édouard Manet, *Young Man in the Costume of a Majo*, 1863

The short answers to the quiz are:

Nothing.

Nowhere.

None, other than posing for this picture.

Look carefully at that face. It's a blank face. No depth, casually painted. This, in fact, is what led to its rejection from the Salon that year, according to the Met: "Critics complained ... the Majo lacked psychological characterization, the artist having rendered his face and hands with no more attention than the details of his costume."

Look back in your mind now at Duccio's masterpiece. Consider the depth of emotion, of thought, he painted into the faces of Mary and Jesus.

Consider also the backdrop of Manet's painting. It's a blank. We are standing nowhere in particular here, other than perhaps the artist's studio.

And consider the title, if you haven't yet gotten the point. This is not a figure meant to transport our minds to the heroism of a young *majo* out in the bullrings of Spain, pursuing his mission in life, as Adonis did in Rubens's painting of his morning after with Venus. Manet wants none of that. This is simply a model, posing for Manet in "the costume of a *majo*," so that he can paint an image of the various textures and colors of his costume, as it appeared that day in his studio in Paris in 1863. In fact, the model is Manet's younger brother. And the costume is just something he had lying around the studio: you can see the same costume in Manet's painting *Mlle. Victorine in the Costume of a Matador*, painted the previous year. It's right here at the Met, too.

This is the *anti-Duccio moment* in art. From here, artists would no longer feel compelled to use their considerable talents to transport us to a spiritual realm ruled by God, to communicate great virtues, to explore our inner thoughts, to understand our souls.

From here, artists would apply their skills simply to demonstrating their dexterity in using those skills—for self-promotion, if you will. And maybe, providing us with a *moment* as we stand before their work, admiring it. But only that—a moment.

I am not making a talent judgment here, nor am I blaming artists for this turn of events. Artists, like all of us, reflect the culture and understanding of the time. They were not alone in slipping toward atheism, toward a belief that we are on our own and need henceforth to make our own decisions, using our own moral compass. We are all guilty as charged.

Within this context, art would go on to produce works of genius, for sure. We are about to visit some of those. But the backdrop, the purpose, was now essentially godless—whether we or they want to admit it. Manet was simply the first one to acknowledge this and to paint the outcome.

From here, with the search for God, and the soul of man, abandoned, it would not be long before another artist would paint God's tomb—a pretty tomb, to be sure, and certainly one that admirably demonstrated the artist's skill in communicating to us the time of day that his moment was made—but the death of God, nonetheless. And with God dead, there would be no need to search for Him through art.

We'll be arriving at God's tomb in a moment. But first, let's revisit that first "enlightenment," in the Garden of Eden.

Driven out of the Garden

Then the LORD God formed the man out of the dust of the ground and blew into his nostrils the breath of life, and the man became a living being....

Then the LORD God said: See! The man has become like one of us, knowing good and evil! Now, what if he also reaches out

his hand to take fruit from the tree of life, and eats of it and lives forever? The LORD *God therefore banished him from the garden of Eden, to till the ground from which he had been taken. (Gen. 2:7; 3:22–23)*

Paris, France, 1880s. With the great industrial age well advanced, France's shift toward a humanist secularism, even atheism, was well underway. Even as the culture slid uncomfortably down this slippery slope, most of society, I would guess, did not even realize this was happening. Christianity remained the dominant religion of Europe, followed by its older relative, Judaism. Artists themselves were similarly conflicted. One such artist must have been Auguste Rodin.

Auguste Rodin, *Adam* and *Eve*, modeled 1881, cast 1910

Unlike Manet, Rodin came from a working-class background. He began his career as a decorative-arts craftsman, though at one point he attempted to join a Catholic religious congregation called the Order of the Blessed Sacrament. When that effort failed, he eventually found his way back to the decorative arts and, in particular, to sculpture.

After multiple attempts, he finally received a commission for an elaborate project that was to adorn a new museum planned for Paris. The project was called *The Gates of Hell*, based on Dante's *Inferno*. Over the years, Rodin would work intermittently on the many sculptural groups for the project. Though the museum was never built, the castings from the molds for *The Gates* became world famous. The Met has three of them, including a casting of the famed *Thinker*. We pause now before two others, *Adam* and *Eve*.

In one of these bigger-than-life images, Rodin captures a half-awake Adam literally coming to life as an invisible God molds him from the very mud he is being drawn out of. The energy and forcefulness of this monumental figure was clearly inspired by Michelangelo, whom Rodin admired deeply; the young artist references the Renaissance master here in that right index finger of Adam, coming to life just as it does on the Sistine Chapel ceiling. But even as it evokes Michelangelo, Rodin's *Adam* also distinguishes itself from it, declaring its position within the new modern art movement underway. Adam has none of the stylized, polished figuring of Michelangelo's David or his idealism. Rodin's work is very tactile, impressionistic—almost as if it were molded with hands, not a chisel and sanding tools. Adam is very present here—now.

Look now to the right side of the grouping, to Eve. Rodin presents Eve here not at the moment of her birth, but of her expulsion from Eden. Her sin: disobedience, attempting to make herself God. Perneb's sin. My sin. The sin of pride.

As she leaves Paradise and enters the modern world, the very life force we sense entering Adam at his creation is now draining from her. She slouches down as her energy runs out. It's almost as if Rodin is portraying the death of her soul.

Between the two massive figures of Adam and Eve, the Met has placed on a pedestal the much smaller, and more famous, image of *The Thinker*. *The Thinker* was originally planned as a central piece to sit above the portal of the front door of the gates of Hell, looking down on the Inferno below. There are as many interpretations of what is going on, or not going on, in *The Thinker*'s head as there are essays on it. The one that most fits for me—perhaps the one Rodin had in mind, given where the figure was to be placed—is that this is Adam himself, looking down on the chaos that ensued

Auguste Rodin, *The Thinker*, modeled 1881, cast 1910

because of his one big mistake, his Original Sin: trying to make himself God.

Is this Rodin's betrayal of his own misgivings about where this culture of "Enlightenment" could be heading next? We don't know. But it is interesting that the Met has placed *The Thinker* at the very entrance of the Modern Wing.

Wait, I See Something

Paris, France, 1879. Another young French painter of the 1870s, also of the realist and naturalist movement, was Jules Bastien-Lepage. Like Manet, Lepage believed in painting what he saw, almost photographically, not something idealized or standing for something more. Nevertheless, he is more like Rodin in his ability to recognize something lurking within that was at least mysterious, if not outright religious. Some say that Lepage was influenced by Velázquez. Lepage's paintings, like Velázquez's *Juan de Pareja*, focused on everyday working people, painted in a way that recognized and celebrated their individual dignity. In this sense, though I've never found much material hinting at Lepage's religious beliefs, his paintings are very "Catholic."

His depiction of Joan of Arc, painted just five years before Lepage died of tuberculosis at age thirty-six, is perhaps his most famous work. Despite its links to French nationalism (Joan of Arc was still a French national hero for her valiant courage in facing back the occupational forces of England in the fourteenth century), the painting won no awards at the Paris Salon of 1880, when it was first exhibited. It was scooped up that year by a wealthy New York businessman who brought it back to the Met. It hangs right next to us here, across from the Rodin sculptures.

Stylistically, Lepage paints a simple, uneducated French country girl, barefoot, in a densely wooded backyard in Lorraine. The painting

Jules Bastien-Lepage, *Joan of Arc*, 1879

is so precise, some visitors initially wonder if it is a photograph. Yet even as we admire Lepage's simple, unadorned, and skillful rendering, there's something more that draws us into this young woman's head.

And as still as everything seems, beneath the surface, a storm is brewing.

The young woman herself seems transfixed by something; she's staring out into the heavens, not blankly but with great concentration and deliberation; closer to the *Virgin Annunciate* than the *Boy in the Costume of a Majo.*

Something is out there, for sure.

And something is in here as well.

We scan deeper into the forest behind her, looking for clues. The chair near the loom that she has been working at has been knocked over, almost as if she was startled out of it by the sudden appearance of something. And above the loom hover three semi-transparent, three-dimensional figures. These are presumably the visionary figures who appeared to Joan to charge her with rushing to the aid of the beleaguered French army.

The largest of the three, armored himself, is said to be St. Michael the Archangel, a great fighter in the battle of light and darkness if there ever was one. The other two, both women, are Sts. Margaret and Catherine, who, like Joan, took vows of chastity and had both died young and bravely for the Faith. St. Michael is calling Joan to battle, and Sts. Margaret and Catherine will attend to her through the trials that will result in her martyrdom at age nineteen. After successfully leading the French forces to victory at Orléans and then seeing the new French king, Charles, crowned at Reims Cathedral, she would be captured by British forces and burned at the stake.

According to the Met's guidebook, Lepage's *Joan of Arc* was rejected by the French Salon for almost the opposite of the reason Manet's boy was rejected fifteen years earlier: this time, they didn't like the inclusion of the saints, which they found disruptive of the naturalist spirit of the painting. To me, this alone says a lot about where the culture was heading: the world of the spirits was increasingly considered one to be avoided, not talked about, even denied. In this sense, the Salon's attitude had already grown thoroughly modern, for better or worse.

Interestingly, though by now we are hurrying our little group along toward the Impressionists of the next two decades, I invariably see a few of us lingering behind, meditating for a moment more on Joan.

In that look of serene anticipation as she gazes up toward the God who has called her to mission, we sense the same relentless perseverance, courage, and determination we feel in La Tour's *Penitent Magdalen* or Rubens's *Adonis* after their calling by God.

Have *I* ever been called in this way, unexpectedly? Asked to change my plans, toss my loom aside and head out into the deep, in a different, unplanned direction that seemed uncertain, risky, a long shot, at best?

What did I do? What *would* I do?

God's Tomb

Rouen, France, 1894. More than five hundred years after Joan of Arc triumphantly delivered the young crown prince Charles to Reims Cathedral to be crowned king of France before God and men, a young French artist, Claude Monet, would usher in a new movement in art that would leave a legacy of some of the most visually appealing paintings ever created. The movement was called Impressionism, and it carried over from realism the idea that art existed for no higher purpose than what the artist chose. It evolved from realism by emphasizing the importance of painting the *moment* quickly, with no underlayering or levels of application that often made the production of a single work a matter of weeks, sometimes months, even years. In Impressionism, artists attempted to capture only the moment, leaving us with a fleeting, beautiful impression of what they had seen in a particular time and place. This seemed to fit well with the spiritual milieu around them, which, while still nominally humanist Christian, was increasingly sliding toward secularism, agnosticism, and eventually atheism.

German philosopher Friedrich Nietzsche captured the mood in 1882 with his famous statement "God is dead."

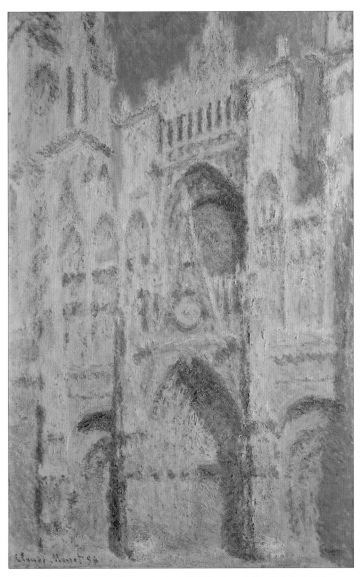

Claude Monet, *Rouen Cathedral: The Portal (Sunlight)*, 1894

Pilgrimage to the Museum

Ten years later, in a series of more than thirty images of the great Rouen Cathedral at various moments of the day and night, Monet painted God's tomb. We're standing before one of those famous images here at the Met.

This bold assertion often provokes a response from our visitors, sometimes even Evelyn herself. After all, at least Monet has painted something very religious here—and has painted it very beautifully, to boot. Art critics note that, in Monet's day, the Rouen series was celebrated by the entire nation, and it accompanied a temporary revival of Catholicism at time when things had begun to slip away.

All this is, no doubt, true.

On the surface—which is probably how the painting is meant to be read—what we have here is quite beautiful. Monet has somehow captured the moment the bright overhead sun is shimmering off the surface of the stone. We sense the midday heat in the wavy light that reflects off the cathedral's stone façade. The light has bleached the dark-gray stones almost pure white, set off brilliantly against that azure sky in the background. For a moment, we are all transported to the scene, staring out on the cathedral from Monet's apartment, just across the street from it.

At the same time, there is something dark going on here. As beautiful as the cathedral's façade is, the great gothic church's entire soaring architecture, and the façade with it, had a purpose in its time: to draw us inside, to the shimmering light of the stained-glass windows in its high, thin walls, within which, in the Sacrifice of the Mass, Heaven itself literally comes to Earth. Think back to those beautiful backlit stained-glass panels from Saint-Germain-des-Prés. These enchanting images of God on Earth can truly be "seen" only from within, both literally and figuratively.

But here, in this beautiful impressionistic moment, there is no time for that; the one stained-glass window in the painting, the

great rose window over the portal, is so gray that it almost blends as stone with the surfaces around it. We're *outside* this cathedral; God is inside.

But it's worse than this. What's going on here? What's happening in this moment?

Nothing. Nothing is happening.

The cathedral's great doors are closed. No people are to be seen anywhere. Even the very sculpture apses, which house a large number of gothic sculptures of the great saints of the Faith, are empty in Monet's "impression."

I don't know that Monet deliberately set about painting God's tomb here. I doubt it. But whatever religious revival may have been going on in France by the time of the Rouen series, it is pretty well accepted in history circles that Monet had shifted early in life from his Catholic roots to a convicted atheism. And in the very purpose of his Rouen project—to demonstrate his skill in conveying the changing textures and shades of light on stone at all times of the day, using one of the great symbols of the Catholic Faith in France to do it—there is something of our old friend Perneb at work.

Nietzsche not only had declared God dead, by the way. He even told us how God had died: "We have killed Him."

It was inevitable that art would at some point imagine both of these sentiments. Monet was just the messenger who did so.

As Evelyn likes to add about now, if just to lighten the mood, God would have the last laugh. The Rouen series is still celebrated as a lasting tribute of modern art to a great symbol of the Catholic Faith. And both the cathedral itself and the bright sun and azure sky within which it shines project a lasting beauty off the hurried canvas. Tourists of all faiths seem drawn to this masterwork by a French atheist. As the psalmist wrote many centuries ago:

The heavens are telling the glory of God, and the firmament proclaims his handiwork. (19:1)

Sorry, Friedrich. It's just not that easy to kill God.

God as Dark Energy Force

Then I looked, and lo, a white cloud, and seated on the cloud one like a son of man, with a golden crown on his head, and a sharp sickle in his hand. And another angel came out of the temple, calling with a loud voice to him who sat upon the cloud, "Put in your sickle, and reap, for the hour to reap has come, for the harvest of the earth is fully ripe." So he who sat upon the cloud swung his sickle on the earth, and the earth was reaped. (Rev. 14:14–16)

Saint-Rémy-de-Provence, Southern France, 1889. By the late 1880s, the pursuit of art for the artist's sake that Manet's revolution had launched was already leading post-Impressionist artists out into unique stylistic conventions. One of the most original directions undertaken, though highly unpopular in his time, was Vincent van Gogh's. His highly tactile images, painted hastily with large scrapes of viscous oil paints and broad brushstrokes, have since become some of the most prized and instantly recognizable paintings of all time.

Van Gogh's descent into madness—which led to his cutting off his ear in late 1888 and to his suicide at age thirty-seven two years later—is the stuff of legend. Of all the artists we encounter on our journey through the Met, van Gogh is the one for whom it seems least necessary to fill in a background; most visitors have all at least heard of this.

One detail, interestingly, is less frequently discussed, though I think it's incredibly important in understanding van Gogh's art and life. He was deeply religious. In fact, not only was van Gogh the

Vincent van Gogh, *The Starry Night*, 1889, Museum of Modern Art,
image courtesy of Wikimedia Commons

son and grandson of Dutch Reformed ministers, but by the time
of his young adulthood, he himself became a Christian missionary
and held a ministerial post in the Dutch Reformed Church. He
was dismissed from it for somewhat fuzzy reasons in 1879, just a
decade before his death. This incident seems to have driven him
toward painting as a way of finding God.

Van Gogh's difficulties with forming personal relationships,
with the storied exception of his younger brother Theo, are well
documented. I wonder at times whether that same difficulty ex-
tended to his relationship with his God. Some of his richest paint-
ings seem to suggest this struggle. Though not "dead," God seems
to have been for van Gogh a scary, impersonal, and somewhat
dark energy force.

The sense of foreboding, that something bad is about to happen, to drop from the sky, screams off the surface of another of van Gogh's most famous late works, *The Starry Night*, which hangs down the street at the Museum of Modern Art. (You don't have to look at this picture if you don't want to, because I'm not counting it as one of my three paintings outside the Met. It's so famous that you can probably see it in your head anyway. If you do look at it, don't tell Evelyn.) The dark, threatening nature of the Faith that van Gogh felt comes through at times in his many letters; we see it, for instance, in this excerpt from a letter to Theo, detailing his initial impression of Arles when he temporarily settled there in 1888: "The Zouaves, the brothels, the adorable little Arlésienne going to her First Communion, the priest in his surplice, who looks like a dangerous rhinoceros, the people drinking absinthe, all seem to me creatures from another world."[10] Through van Gogh's eyes, a peaceful scene of a First Communion reception in the idyllic French countryside seems transformed into something scary, almost out of a nightmare.

In *Wheat Field with Cypresses*, van Gogh turns to another image that apparently haunted him from his religious years: the final harvest, the separation of the wheat from the chaff. Yes, in his painting, we see great beauty and color: the yellow wheat blows here and there in the breeze; the dark-green cypresses sway gently, standing tall, reaching toward the heavens; the billowy white clouds drift in the midday sky above.

Yet there is something threatening here. There is a force at work in that breeze, which blows incessantly and without a clear direction or source. All below seem vulnerable to it. Despite the great beauty of the field, it is almost as if we can sense the sharpness of

[10] Robert Hughes, *Nothing if Not Critical: Selected Essays on Art and Artists* (New York: Penguin, 1992), 143.

Vincent van Gogh, *Wheat Field with Cypresses*, 1889

the scythe's blade about to descend from the clouds, cutting the blades of grass down even as they are out enjoying the midday sun.

A year later—alone, friendless, and penniless—van Gogh would cut himself down with a bullet to his chest.

And my hunch is that, in van Gogh's mind, the Creator he believed was "out there" would not have cared in the least.

Now we're going just a few steps away to a painting that *looks* very different but, to me, says a lot of the same things.

Getting Lonely Out Here

Paris, France, 1888. Often hanging near *Wheat Field with Cypresses* is George Seurat's *Circus Sideshow.* Seurat's career was even shorter than van Gogh's. Stylistically, Seurat took a different road from

Georges Seurat, *Circus Sideshow*, 1887–1888

van Gogh, inventing a style of painting with tiny dots of color that, when taken in as a whole, created an image of haunting beauty—a technique called "pointillism." Very much reflecting the rising popularity of science as the ultimate source of all knowledge and even of creation itself—following the work of Charles Darwin—Seurat pursued the use of science and chemistry as a method of creating art. Using careful analysis of color, he understood that by placing complementary colors adjacent to each other but still separate, he could create the illusion of a color that joined the two. One of his most important works of pointillism hangs before us now.

Seurat may not have been mad, but he shared this with van Gogh, his contemporary: his paintings often pointed to an underlying sense of loneliness and despair. I don't think this was an accident. Rather, it was the natural conclusion in a world where God no longer existed, especially when the Christian God, a highly personal one in the form of Jesus, was viewed as a crutch of the

past that could now be abandoned for the firmer footings of scientific knowledge.

What the world would slowly figure out is that without Christ at the center, the brotherhood in Him that we all shared would also disintegrate. We would be left alone.

Whether consciously or subconsciously, Seurat seems to have grasped this. Virtually all of his paintings project a sense of isolation, even within a context teeming with people.

In *Circus Sideshow*, Seurat seems to be calling on his inner Watteau. Here we have a group of performers, presumably all working together to produce light, happy entertainment. Ironically, each member of the band, seen through a marvelous patina of hazy twilight, appears neither united with his fellow band members nor happy. No one in the audience seems happy either.

Despite the joyful subject matter, there is a melancholy in the air. The characters almost seem to be groping blindly in the dusk, looking for each other, but lost. They're together, but each one is alone.

My mind at this point somehow inevitably harks back two thousand years to classical Greece, before God had fully revealed Himself but well after the initial search for Him had begun. In his famous Allegory of the Cave in the *Republic*, Plato wrote:

"Imagine human beings living in an underground den which is open towards the light; they have been there from childhood, and can only see into the den. At a distance there is a fire, and between the fire and the prisoners a raised way, and a low wall is built along the way, like the screen over which marionette players show their puppets. Behind the wall appear moving figures, who hold in their hands various works of art, and among them images of men and animals, wood and stone, and some of the passers-by

are talking and others silent." "A strange parable," [my student said], "and strange captives." "They are ourselves," I replied; "and they see only the shadows of the images which the fire throws on the wall of the den."[11]

Increasingly, with God no more, it seemed to the most sensitive eyes that we were left with very little purpose or meaning in life. Like the captives in Plato's cave, or the hazy figures in *Circus Sideshow*, we were all left simply chasing shadows.

Just a year after van Gogh's premature death in 1890, Seurat would pass into the distant eternal at age forty-two.

In less than a decade, as the second millennium would enter its final climactic century, an artistic genius for the ages would begin his rise, almost single-handedly birthing several new and very modern forms of painting in succession. His name was Pablo Picasso.

Early on, he painted his own contribution to the circus of a life without God.

Life Is but a Passing Shadow

Paris, France, turn of the twentieth century. By the early twentieth century, Paris's art scene had developed a bohemian, revolutionary spirit that captured in some ways the broad uncertain mood of Europe on the eve of the two great wars that would devastate the continent. The certainty and common conviction in the world order, with God at its head, was coming apart. Chaos loomed. Art patrons such as Gertrude Stein led a cultural movement ever restless, seeking new directions.

The Spanish artist Pablo Picasso was drawn to Paris at a young age, and he brought with him a rich heritage of deep artistic

[11] Bk. 7, trans. Benjamin Jowett.

Pablo Picasso, *The Actor*, 1904–1905

sensitivity and the skills to capture that sensitivity with canvas and brush. But unlike the great painter-mystic El Greco, whose work is said to have influenced Picasso throughout his career, Picasso evidenced no belief, or even interest, in God. His world was entirely rooted in the here and now, and—judging by his long string of romantic dalliances and affairs—satisfying his own appetites and passions seems to have been his primary interest. Yet just beneath the surface of many of Picasso's early works lies the bitter irony of a life without God.

Early in his career, painting still in a naturalistic style during his so-called Rose Period, the young artist painted his own version of Watteau's *Mezzetin* and Seurat's *Circus Sideshow*. We now stand before this: a giant canvas that is bigger than life, or perhaps more accurately, bigger than death.

The Met's catalogue for *The Actor* points to the early influence of El Greco in the thin, elongated, almost surreal image of the main character and the broad forms and shapes that form the image. On the surface, at least, the influence seems clear. Yet there is something missing. Unlike El Greco's great works, where the figures often share a common focus on *something*—usually God or Christ—that gives them purpose, Picasso's actor seems utterly alone on the stage. Ironically, though he is engaging with his audience, he does so diffidently, arrogantly, uncaringly. As if he is saying, "I'm doing this for my sake, not yours. I couldn't care less about your entertainment. This is about *me!*"

At the same time, the irony is that "me" doesn't seem terribly happy himself. Isn't this always the case? When we focus on "me," engaging in pursuits solely designed to satisfy our passions, rather than on "you," any happiness we achieve is fleeting. This is the opposite of the great love of Christ, of Christianity, the self-sacrificing love that we witnessed in Fra Angelico's *Crucifixion* so many years

earlier. That love lasts. It may require a more difficult road, but it lasts. It leads to lasting joy, not fleeting happiness.

What was it that Shakespeare said?

> *Life's but a walking shadow, a poor player*
> *That struts and frets his hour upon the stage*
> *And then is heard no more: it is a tale*
> *Told by an idiot, full of sound and fury,*
> *Signifying nothing.*[12]

The Met owns another post-Christian image by Picasso, from his earlier, related Blue Period, and the museum sometimes displays it in place of *The Actor*. This painting also hearkens back to an El Greco—one that we visited with earlier, *Christ Healing the Blind*. We'll pause briefly at this Picasso now.

Blind, Again

Paris, France, 1903. Although still nominally Catholic, with many of the faithful still practicing Christianity, by the early twentieth century the avant-garde of the culture and the art world seemed to be rapidly abandoning any thought of God or the hereafter. Pablo Picasso, the young genius who would paint some of the great classics of the modern movement in the decades ahead, seemed to summarize the sentiment at play in this simple statement in a letter:

All I have ever made was made for the present and in the hope that it will always remain in the present.[13]

The slippery slope down which artists were sliding (or climbing, depending on your perspective) was summarized in some way by

[12] *Macbeth*, act 5, scene 5.
[13] "Picasso Speaks: A Statement by the Artist," *The Arts*, May, 1923.

Pablo Picasso, *The Blind Man's Meal*, 1903

this image from Picasso's melancholic Blue Period. It is a troubling image of a gaunt blind man struggling to find the wine and bread that make his meal lying right before him. The allusion to the Catholic Faith, and particularly the Sacrament of the Eucharist which we contemplated so ecstatically with Velázquez centuries before, seems pretty clear. Picasso, though presumably atheist, certainly was raised in very Catholic Spain and must have been familiar with the sacraments. The Met's catalogue celebrates the relationship in this way:

This work is a remarkable restatement of the Christian sacra-
ment – the ritual of tasting bread and wine to evoke the flesh and
blood of Christ – in contemporary terms. Lit with the mystical light
of El Greco, the composition derives its strength from its sparse
setting and restricted palette.

My own take is a bit different. Perhaps *The Blind Man's Meal*
is at once Picasso's taunt of his Christian past and his warning
of the post-Christian future. In the Gospels and in El Greco's
magical *Christ Healing the Blind*, where we paused earlier, it is the
blind man who can see Christ. He sees Him with the eyes of faith.
And Christ sees the blind man. He stops for him. He heals him.
Christ is his light.

Here, in Picasso's world, the blind man is alone, the sacrament
devoid of meaning. With God presumably dead, the beauty and
majesty of the Eucharistic sacrament is empty, without purpose or
effect. God is no longer with us. We are, indeed, very much alone.

Every man for himself.

We are back now in the godless world of Trebonianus Gallus.

As I stand sadly before *The Blind Man's Meal*, I reflect on the
times in my life when I've turned away from God, pretended He
wasn't there, gone my own way. How often those wrong turns
ended up, spiritually at least, in a moment like this: fumbling,
alone, in the dark.

Years later, the French philosopher Albert Camus summed up
for us what Manet and the Impressionists had already acknowl-
edged. Regrettably, this quote from his 1932 essay "Intuitions" is
still today a very popular search on Google:

You will never be happy if you continue to search for what hap-
piness consists of. You will never live if you are looking for the
meaning of life.

Pilgrimage to the Museum

As a curative, reflect for a moment on a particularly memorable Eucharistic Communion in your life—perhaps at an Easter Mass, or a special wedding, or just after a really good Confession.

How did that go? Did you see Christ?

If you're like most of the Catholics I meet on these tours, you'll probably answer, "Yes, I did."

Searching for God in a World of Chaos

Abstract Expressionism and Modern Art

"Yes, now's the moment; I'm looking at this thing on the mantlepiece, and I understand that I am in hell."

—Jean-Paul Sartre, *No Exit*, 1944

Paris, France, 1905. Paris at the turn of the century is the center of the art world, with virtually all the great artists of the Impressionist and early modern era assembled there. Rummaging in a dusty art gallery, a leading art patron and collector, Ignacio Zuloaga, comes upon El Greco's *The Opening of the Fifth Seal.* He buys it immediately and shows it to his friend, the young painter Pablo Picasso.

At the time, Picasso was in the middle of his Rose Period, painting large, rounded, and oversize, but ultimately natural figures, often with a rose palette and a contemplative message. *The Actor*, whom we've just visited, is a good representative of Picasso's style at this time.

Then suddenly, two years later, Picasso produced this painting, *Les Demoiselles d'Avignon*, and changed the direction of art forever. This painting hangs today in one of New York's other great museums, the Museum of Modern Art. With it, Cubism was born,

and we were brought to the threshold of fully abstract art, which would be devoid of any physical representation at all.

Things Start to Come Apart

Because Picasso is said to have painted *Les Demoiselles* from left to right, some art historians have pointed out that the viewer can watch Picasso invent Cubism as he paints. Although all the images are fragmented and largely two-dimensional, the woman on the far left is the most recognizable figure of a three-dimensional woman. Her slim figure and rounded curves are of one piece,

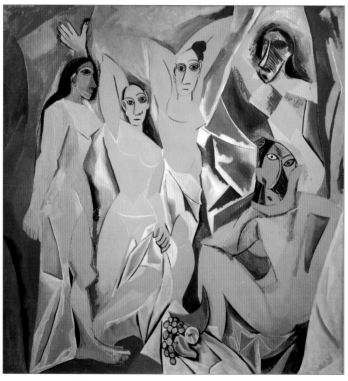

Pablo Picasso, *Les Demoiselles d'Avignon*, 1907

more or less. But as the painting progresses from left to right, the figures become increasingly fractionalized and pieced together with perspectives chosen by the artist from different angles. Eventually, the pieces that form the whole appear to be no longer from the same individual, but composites of images of every man, or no man. The two faces on the far right are actually African masks, presumably discovered by Picasso at a new African art museum that had recently opened in Paris.

We've now moved materially further from anything art had seen since the two-dimensional images we began with in ancient Egypt. Yet even in the tomb of Perneb, the flat images point toward an abstract spiritual realm in the heavens. And the image of Perneb on the walls presumably bore some resemblance to the wealthy official while he was alive on Earth.

Here, the images are not portraits at all.

They have been deconstructed.

And now, they are simply figments of the artist's mind—his creations.

And they are not even images of a single, created, unique human being. With the Creator now dead, the artist has declared himself the new creator. And he has creatively, imaginatively, using techniques of mathematics and mosaics, stitched together his own images of these women of the night, casually hawking their wares as if manning a fruit stand.

Haunting. Picasso's discovery of El Greco's *The Opening of the Fifth Seal* in 1905 and his creation of *Les Demoiselles* two years later were probably not unrelated events. In the minds of many historians, the images of El Greco's martyrs, particularly the pose of the three martyrs in the center of El Greco's canvas, were most certainly borrowed by Picasso in the form and pose of the three prostitutes on the left. If so, there is more than irony here.

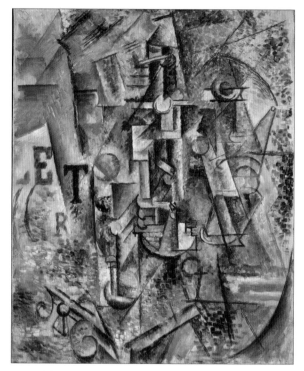

Pablo Picasso, *Still Life with a Bottle of Rum*, 1911

El Greco's martyrs, however "modern" he envisioned them, are imagined in a spiritual realm, in Heaven, receiving their reward of eternal life from the God they love and who loves them—an image, if you will, of perfect, unselfish, divine love.

With a stroke of the brush, Picasso has converted this divine image into one very different, where God doesn't even figure into the equation. Here, self-sacrificing *agape* love is out the window.

This is a world where love can be had for a few coins, if only for a night. It's the banal, shallow love that we are left with: profane love; *eros*, in the Greek.

Not really love at all.

Before we jump too quickly to condemn Picasso here, pause and think: How often in my life have *I* taken something divine and twisted it into something profane? Alternatively, when did I run with God, love like Him?

And try this: Which of these loves felt *right*?

Just to the left of *The Blind Man's Meal* is a good example of Cubism in full bloom, also by Picasso but sometimes thought to be by his collaborator in Cubism, Georges Braque. We won't discuss it in detail here, but all the elements that were birthed in *Les Demoiselles* are readily apparent: figures broken into so many pieces from so many angles they are unrecognizable—virtually abstract.

Things were beginning to come apart—in more ways than one.

Almost hesitantly, we exit the Picasso galleries toward an uncertain future. And suddenly, as we do, we are arrested in our tracks by Jackson Pollock's colossal canvas of chaos in motion, *Autumn Rhythm*.

Clearly, Toto, we're not in Kansas anymore.

Nothing but Chaos

In the beginning God created the heavens and the earth. The earth was without form and void, and darkness was upon the face of the deep; and the Spirit of God was moving over the face of the waters. And God said, "Let there be light"; and there was light. And God saw that the light was good; and God separated the light from the darkness. God called the light Day, and the darkness he called Night. And there was evening and there was morning, one day. (Gen. 1:1–5)

New York, after World War II. By the late 1940s, two devastating global wars had left millions dead and virtually all the major economies of the world wrecked. One combatant remained standing:

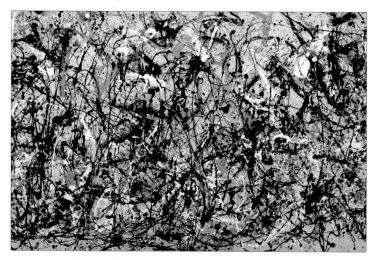

Jackson Pollock, *Autumn Rhythm (Number 30)*, 1950

the United States. New York took the lead as the world's financier, and art followed. The city and the nearby Hudson Valley became the new center of the modern-art movement, and one artist above the others led the charge toward abstract expressionism that Picasso had initiated years earlier. His name was Jackson Pollock. He divorced art once and for all from any need to reference the world around us in its natural form.

Thoughts of God, or declarations about Him, seem unimportant here, not even interesting. What we have instead, purportedly, is the bodily energy of the artist himself, the creator, flung at the canvas with abandon as he walks around it, dripping liquid paint as he goes.

By this point, we've been on a long journey. It doesn't surprise me when people don't have the energy to engage with this painting. I see you over there looking at your phone screen. You're probably as indifferent to this painting as the artist was to you.

"Well, even I could have done this," says someone way in the back of the group.

Really? Is *Autumn Rhythm* nothing more than splatters of paint?

Look more carefully. Notice how the different lines of paint seem to swirl in some unified way, even though, in the end, they don't come together to form anything recognizable.

And look more carefully at the palette here. It's not as random as it seems. The blacks and the whites seem to be almost in some kind of dance with one another, touching here, overlapping there, and then separating again. Is this somehow a battle of light and darkness playing out in Pollock's mind? And what of those little splashes of green within the chaos? They serve to break the monotony of the black and white, but are they also signs of life, peeking through?

Have I made any converts?

Maybe not, but at least we can agree that maybe this work is more complex than it seems.

None of us can know what was going on in Pollock's mind as he painted this and his other famous abstract works using his now signature "drip technique." He does seem to have been quite troubled, and his struggles with alcoholism are well documented. He died young at forty-four in a single car accident with a mistress in the car with him and while "driving under the influence of alcohol," which in 1956 generally implied more than today's strict one-drink limit.

But what I see here is chaos. The chaos that breaks out when I've let my faith in God fade and He is no longer a part of my life, when I even forget that He is there. Yes, through the haze, I may sense some form of underlying order, some central energy point that is creating the rhythm of autumn, but little more.

This is the definition of loneliness and chaos. Enough to drive anyone to drink.

Michelangelo, *The Creation of the Sun, Moon, and Planets,*
1511, Sistine Chapel, image courtesy of Wikimedia Commons

Am I seeing too much here? It's easy to pull up another image of chaos on my phone, one painted many years ago by Michelangelo. It's his small panel called *The Creation of the Son, Moon, and Planets* on the Sistine Chapel ceiling. In the swirl of energy of the entire scene, and particularly the mad swirling ball near God's extended right arm, there is something of the chaos of Pollock's *Autumn Rhythm.*

What is different entirely about Michelangelo's masterpiece? What makes this panel high up in the ceiling far more approachable than the mental gymnastics required to engage with *Autumn Rhythm?* It must be that robust image of God, moving hither and thither within the chaos. God brings order to the abyss. He creates the world from it. He creates *us.*

God is the *energy force* many of the artists of the modern era were seeking but couldn't see.

And that is why, with eyes of faith, we can see God, even in Pollock's godless canvases. We can imagine Him moving frantically within and around them, trying to restore order despite our efforts to destroy it.

Alone in the World

New York, mid-twentieth century. Even as Pollock led a movement of artists away from representational art, others sought to use more easily understood natural forms to express the same loneliness and isolation brought on by the increasingly secular, godless culture around them. One of these artists, though his work is often displayed deeper into the modern galleries, seems immediately recognizable by most of our group: Edward Hopper. Said to be an introverted and conservative man of a strict Dutch Baptist upbringing, his art seemed more inspired by the works of Rembrandt and Manet than by those of Picasso. Regarding the latter, Hopper once responded to an art critic's inquiry about the influence on him of the most famous artist of the day, "Who is Picasso?"

The Met helped put Hopper on the cultural map when it purchased one of his paintings for its collections in 1931. The museum today owns several Hoppers but often exhibits only one of them at

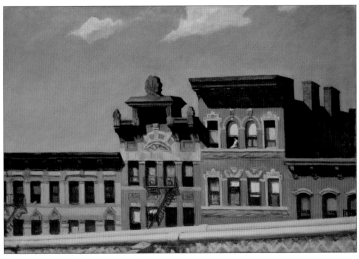

Edward Hopper, *From Williamsburg Bridge*, 1928

a time. Of these, one of the most poignant is his haunting 1928 image, *From Williamsburg Bridge*. Like many of Hopper's urban scenes, this one presents the irony embedded in city life as it was evolving in twentieth-century America.

Hopper transports us to the walkway along the Williamsburg Bridge, where we stare out over the bridge's suspension cable toward the crowded apartment buildings alongside it as the bridge begins its ascent from Brooklyn across the East River.

The painting's irony evokes the same feeling we get as we view Monet's Rouen Cathedral from his apartment window. As busy as this scene should be and, in fact, must be—with automobile traffic whizzing across the bridge in the lane behind us, and hundreds of human beings presumably moving about within the apartment complex we are seeing here—we can see only one living being in the entire canvas. A lone woman sits on her sill, perched on an upper floor of the building, staring out at the busy yet quiet abyss below her. Encircled by people we can't see—and whom she doesn't feel—she is alone in her thoughts, isolated.

What is she doing on that window? What is she contemplating here?

We'll never know. That's the mystery of it.

Hopper's lonely images of urban life echo for us the together-but-alone motif we first saw in Watteau's *Mezzetin* and then more deeply in Seurat's *Circus Sideshow*. Isn't this just the inevitable outcome when our center, our Creator, is presumed dead? Without Him to unite us, in Him, it's now every man for himself, a kind of dog-eat-dog existence that has its moments perhaps, but ultimately ends like this.

Hopper does not seem to be exercising a judgment here or even trying to make a statement. He's simply painting what he feels, what we *all* feel in a world in which we are increasingly isolated from our Maker and, by inference, from one another.

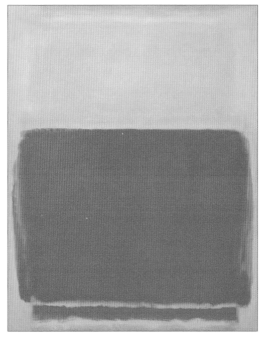

Mark Rothko, *No. 3*, 1953

A few years later, French existentialist Jean-Paul Sartre would summarize the sentiment here in his 1944 play *No Exit*:

> If you are lonely when you're alone, you are in bad company.... Hell is other people.[14]

People of faith know better than this. We are not alone. We are all brothers and sisters in Christ. We're alone only when we make ourselves alone. We are our own "bad company."

For a missionary, Sartre has it backward.

Thank you, Hopper.

[14] Jean-Paul Sartre, *No Exit* (New York: Vintage International, 1989), 45.

Pilgrimage to the Museum

Something Is Out There

New York, 1950s. Marcus Rothkowitz, a Latvian Jew, emigrated to New York from Russia through Ellis Island in 1913. (He anglicized his name to Mark Rothko during World War II.) Raised in an Orthodox Jewish setting, he would spend much of his later life as an artist seeking to find God, or at least his own spirituality, through abstract art. His last major art project, to which he dedicated the final six years of his life, was designing and executing the murals for a Roman Catholic chapel in Houston, Texas, now called the Rothko Chapel. (It would be converted after his death to a nondenominational Christian worship space.) His artistic signature—simple rectangular canvases in which one or more blocks of color float and radiate—was a more organized take on the abstract expressionism developed by Jackson Pollock. The one we're looking at is simply titled *No. 3.*

Like *Autumn Rhythm*, *No. 3* draws mixed reviews from our group. "It's so simple. I could have done that!"

But the longer we stand there, the quieter we all become. There is something going on here that's hard to define.

Rothko himself famously refused to give us much help in understanding what precisely is going on, though he hoped, it seemed, that viewers would feel an energy that transcended time and space emitting from the painting. Call that God if you will; I don't know. But in the isolation and separation that the world had inflicted on itself in denying God's very existence, Rothko seems to be pushing back.

He sees something.

Something is out there.

Oops, I Wish I Hadn't Done That

New York, 1940s. As most theologians point out, once we lose belief in God, it's a short leap to the belief that there is no moral absolute, no Absolute Good. After all, Absolute Good is the very nature of God.

From here, it's logical to conclude there must be no Absolute Bad either, since the Bad is just the opposite of the Good. Evil is no longer something we all agree to or concur about; it becomes a moral relative, in the eye of the beholder.

Given our natural instincts, it's not very long before, without God, we begin the descent down the slippery slope captured so dramatically by Rembrandt in the painting we began this adventure with, *The Toilet of Bathsheba*. As we gradually numb our consciences, one small sin at a time, the next-worst thing becomes tolerable. An accidental glance begets lust; lust begets adultery; adultery begets an illegitimate child; the cover-up begets lies; lies beget murder. All become tolerable. Anything goes.

Paul Cadmus perhaps sensed this in his own life and work, known for its celebration of male eroticism and the gay lifestyle. In 1949, he painted seven panels as part of a single composition called *The Seven Deadly Sins*. The modern galleries are often uncrowded relative to the some of their busier sixteenth- and seventeenth-century cousins, but here we find a crowd of onlookers huddled around this seven-panel series as we approach it.

In his "magic realism" style, Cadmus has portrayed all seven of the classic sins that lead to spiritual death. The images are almost too horrible to look at it, but look at them we must—starting at the left:

- Lust, depicted in the form of a naked woman who boldly displays her enlarged genitals to the viewer and sits trapped within a suffocating plastic tent of her own making
- Pride, shown through an androgynous figure who is so puffed up from toe to head that it seems about to explode in its own narcissism
- Envy, seen as a grotesquely malformed being so trapped in its jealousy of others that it has grown roots and webs

Paul Cadmus, *Anger* and *Gluttony* from *The Seven Deadly Sins*, 1949

melding it to the floor, even as its bulging eyes still stare outward, seeking others' joy

* Anger, a boiling red devil of a being, arrows and blood spewing out of its body as it destroys itself while trying to do the same to those around it
* Avarice, an emaciated wraith that appears starved by its own greed, which can never be satisfied by the things of this world
* Sloth, unable to connect with anyone or anything because its sheer unwillingness to act, for good or bad, has left it forever alone in some dark, dank place of its own design

- Gluttony, still pushing more foods of the world down its cavernous mouth, even as its bloated body is spilling the food just inhaled out through the hole in its stomach, which can't be satisfied

These are horrible images, to be sure. That's what makes them the seven deadly sins! Cadmus did not have much to say about this, but the Met's catalogue quotes him writing, "I don't appear [here] as myself, but I am all of the Deadly Sins in a way, as you all are, too."

There is a deep truth, to be sure, in this statement. Though none of us wants to admit it, we've all been tempted to commit or have committed one or more of these sins in our lives. As Rembrandt reminded us, even King David fell prey to them.

Or in the words from Virgil's *Aeneid*, "Easy is the descent into hell."[15]

What is sad, though, is that Cadmus—like many out there in the secular culture today—seemed to believe there was no way back.

After all, David and Rembrandt both had the promise of Psalm 51, the mercy of God that could forgive them, restore them, and help them get back on track. Even at the very bottom of the slippery slope, they never lost faith, never gave up. They came back. They had their Penitent Magdalen moment. They returned home.

Or more correctly put, Jesus brought them home.

I'm quite certain He tried to bring Cadmus home too. He certainly must have knocked on his door. He was probably knocking as the artist painted these horrible images of the sin within himself.

[15] *The Aeneid of Virgil*, bk. 6, line 126, trans. J. W. Mackail (London: Macmillan, 1920), 123.

We just don't know if Cadmus opened the door, if he had his prodigal son moment. That's between him and his Maker.

More relevant is this question: Will *I* open the door? Will I let God love *me?*

12

Christ Comes out of Storage

Surrealism

*Love is patient and kind; love is not jealous or boastful; it is
not arrogant or rude. Love does not insist on its own way; it
is not irritable or resentful; it does not rejoice at wrong, but
rejoices in the right. Love bears all things, believes all things,
hopes all things, endures all things. Love never ends.*

—1 Corinthians 13:4–8

Metropolitan Museum, Spring, 2016. Evelyn and I have been wander-
ing through the Met separately for the last two hours. Customarily,
upon our return to New York from our winter lodgings, one of our
first stops is the Met. We like to cover the galleries from our own
perspectives, see where our favorite pieces have been moved—if at
all—and discover if anything new has emerged from the museum's
cavernous underbelly, where most of its encyclopedic collection
lies. We "divide and conquer" to save time.

I dial Evelyn's cell phone number. I know she's in a remote
gallery somewhere but not sure where.

"Are you ready, sweetie?"

"Yes, your timing is impeccable!"

"Okay, I'll meet you at the Dalí."

"So you found it too!"

We meet a few minutes later, standing before this enormous, bigger-than-life canvas, hanging in its new spot, a gallery within the Modern Wing dedicated to the human body. The Dalí had been missing for two full years. It disappeared unexpectedly—at least, *we* didn't expect it—in 2014. We found it missing when we had a full tour group in tow, including the papal nuncio and two culinary luminaries from Manhattan who had signed up for the tour with us several months earlier. (Try as I might, I never was able to get a good explanation from the Met's chain of command as to why the Dalí had been put in storage. So you'll have to draw your own conclusions on this mystery.)

Everything Back Where It Belongs

The Dalí is customarily the last painting of our tour. Its image of pure love, the love of the Cross, seems the perfect antidote to the dark themes of the 1800s and 1900s, the spiritual chaos that we've spent the past hour slogging through. And importantly, this painting of pure, Christian love was painted by a modern, highly respected, even famous, surrealist: Salvador Dalí.

For two years, we struggled on without the Dalí on display, using instead an iPad to show it as we stood in a remote, quiet corner of the Modern Wing, bringing our search for God to its dramatic conclusion. So the painting's return to the galleries was a very big event for us.

Salvador Dalí, like many of the modern artists we've been viewing, started his career as a confirmed atheist, raised by a Catholic mother and a nonbelieving father. His mother died when he was a teen, and by the time of his early career, he was a self-proclaimed atheist. Like other artists of the era, he was heavily influenced by the writings of Fredrich Nietzsche. For Dalí, God was dead.

Salvador Dalí, *Crucifixion (Corpus Hypercubus)*, 1954

Pilgrimage to the Museum

Dalí's reconversion to a devout Catholicism, in midcareer, remains highly controversial and has been explained by many in a variety of ways. I won't pretend to weigh in here. Something brought Dalí back, for sure. Or more likely, *many* things brought him back. The still-strong influence, perhaps, of his long-dead mother? The devout Catholic who became his muse and then his wife, Gala? The great masterpieces of Catholic art that surrounded him in Madrid, Barcelona, and Paris, as he moved around and among these great centers of the Faith? His trips to New York, and then to Rome, during and after the war years? Or maybe his visit with the pope in the late 1940s?

God yearns for each of us. There are so many ways in which He reaches out—as He must have reached out to Dalí. I'm sure there's a very good story in this, and someday we might know it. But by the time Dalí painted *Crucifixion* (*Corpus Hypercubus*), commonly called "Christ on the Hypercube," in 1954, the great Spanish painter of the modern era—perhaps just behind Picasso in fame—was as Catholic, perhaps, as El Greco. And like his predecessor, he seems to have been something of a Catholic mystic.

In this enormous devotional painting, Dalí has reimagined the Crucifixion in its religious significance, rather than in the more traditional, torturous way in which the death of our Lord on the Cross was always shown during the Renaissance and Baroque periods, when it was a favored subject of artists across Europe. Rather than display the tortured, defeated, dead body of Christ, Dali has portrayed Him in His already resurrected form: fully sculpted, unharmed, full of life and vibrancy. With those powerful outstretched arms and fully extended legs, He holds Himself to the Cross; there are no signs of nails holding Him there. And at the very same time that He is extending Himself before the Cross, He is in the process of resurrecting, taking His Cross with Him to Heaven.

Dalí's interpretation makes sense within the context of the secular world he presented it to. Think back on Fra Angelico's dramatic *Crucifixion*, which we visited in Florence six hundred years earlier. As horrific as the scene on Calvary is depicted, the artist's medieval audience was sufficiently schooled in the Faith to see easily the paradox of the Cross for what it was. They understood that the Cross stood for Christ's triumph over death, not for death itself. Dalí's audience is different; even most Catholics today struggle with the Cross, much less secular non-Christians. So Dalí spells it out for us. In his surreal depiction, the Crucifixion scene is painted literally within the triumph of the Resurrection.

The mystery of the hypercube also fascinates us. Some researchers suggest that, just prior to attempting *Corpus Hypercubus*, Dalí had begun to study the intersection of mathematics and religion, which led him to wonder if the God he had been searching for existed in a fourth dimension of reality. Believers in this idea, not inconsistent with Catholics' more mysterious explanations of God, suggest that a being in the fourth dimension—God—could have created men and then came down to the third dimension to save man from himself when things went off track. God's fourth-dimensional reality might have allowed Him to perform many of the mysteries and miracles that Christ did. The hypercube depicted here as a cross is called in this literature a tesseract, a four-dimensional object in a three-dimensional space.

Like all things concerning God, we don't know if this explanation of where and how He exists is correct. But given Dalí's position here at the end of our long search for God through art and time, and the struggle of the last two centuries between religion and science that led to the dark paintings of Picasso and Pollock and to the loneliness of Hopper and Seurat, "Christ on the Hypercube"

offers some hope: religion and science working together, if you will. The atheist turned devout Catholic.

Importantly, though—by all the Gospel accounts—the Crucifixion did not occur like this, Dalí has shown in a single painting all the key elements of the Catholic Faith:

- the Cross, without which there would have been no sacrifice to defeat the forces of Evil
- the Resurrection, without which there would be no triumph of the Good
- and the bedrock of our faith: Love

This painting, in a very real, graphic way, is pure love—love as we last saw it back in the 1500s in Reni's *Charity*, in El Greco's *Christ Carrying the Cross*, and in Sanmartino's *Veiled Christ*. This is the perfect, self-sacrificing love of Christ in all its glory.

It is the triumph of Love over Hate, of Life over Death, of Light over Darkness.

And yes, of God over the secular atheism among us—even within Dalí's own soul.

And there's more here: the old motif of the big person and the little person, first used by Perneb 4,500 years earlier, when he tried to get to Heaven by making himself a god.

Down there in the corner of Dalí's painting, plenty large enough to see but smaller than Christ on the Hypercube and certainly lacking the drama of His powerful victory over death, stands a lone woman, adoring the rising Lord.

It's Gala, Dalí's wife. He has painted her into the painting, and as with the patron of Lorenzo Monaco's *Intercession of Christ and the Virgin*, he gets it right.

"He is God, I am not."

An unlockable mystery.

Everything is back in its place.

Epilogue

Paul, standing in the middle of the Areopagus, said: "Men of
Athens, I perceive that in every way you are very religious. For as
I passed along, and observed the objects of your worship, I found
also an altar with this inscription, 'To an unknown god.' What
therefore you worship as unknown, this I proclaim to you."

—Acts 17:22-23

Naples, Italy, April, 2021. It has been a fruitful Lent and Easter
for me, for sure. Distracted, like everyone else, by the disruptions
of the Coronavirus lockdowns, my plans to commit to words the
story of our pilgrimage to the museum had been delayed for the
better part of a year. But as things calmed down in late February,
my Lenten project became *Pilgrimage to the Museum.*

And like most other spiritual projects, I've gotten more from
it than I gave.

I've spent years studying and meditating on these masterpieces
at the Met. But the very process of writing the stories down brought
fresh insights—some simple and obvious, others more profound—and
set me off in new, unexpected directions.

Let me leave you with one of those thoughts.

Pilgrimage to the Museum

Though the history of art can be viewed, for sure, as a missionary's search for God, or even as "Man's Search for God," in a deeper way, isn't it more realistic to call it "God's Search for Man"?

After all, who put it into Perneb's head even to dream of finding his route to eternity—even if he, as all of us often do, took a wrong turn in getting there?

And who gave Polykleitos that image of the perfect God-man that became the Diadoumenos?

Wasn't God there, knocking on the door of Trebonianus Gallus, waiting to break through, to ease the pain of his wrinkled brow, even as he did for Constantine just a century later?

Who inspired St. Vincent to take up his own cross in the third century, eventually to be remembered forever in the heavenly stained glass of the Saint-Germain-des-Prés Abbey Chapel?

Wasn't God there, speaking to Duccio through the gentle hand of the Christ Child as He comforted Mary?

And wasn't He there, in that wind, as His angel disrupted the young Mary in prayer in Messina's *Virgin Annunciate*?

Surely He was present in the eyes of El Greco as he painted St. John looking up to the clouds in *The Opening of the Fifth Seal* and in the fire that still called to St. Peter, and Caravaggio, through the pain of his denial: "Peter, I still love you. Come home."

He *had* to be with Rembrandt as he struggled with virtue and vice in *Aristotle with a Bust of Homer*, and He was surely there welcoming him home as the prodigal son in the great artist's final painting.

He was there with Mary Magdalen in the second candle and with the forlorn Watteau in the *Mezzetin*, calling to them across time and space, "Don't give up. There is still time to let me love you. Just give me a chance."

Wasn't He there as Sanmartino carved his image in the veiled Christ? How else could a mere human have captured so entirely His peaceful confidence, and love, in death itself?

Could He have been there as *The Thinker*, looking down on Rodin's *Gates of Hell*, opened by our Original Sin?

And surely He was there in Monet's beautiful attempt to paint His tomb, in the shimmering sun and the azure sky.

Picasso couldn't see Him, but *we* could, reaching out to the poor blind man, ready to heal him if he would just ask Him to.

He seemed gone entirely in that lonely woman near the Williamsburg Bridge, looking out, sad and alone, but still, we could sense His presence in those white clouds above her.

And Dalí may have lost Him, at one point, as we all do, but he found Him again, on the Hypercube.

He was there all along. He's there now. Waiting for us.

We just need to open the door. To lift the veil.

For as I passed along, and observed the objects of your worship, I found also an altar with this inscription, "To an unknown god." What therefore you worship as unknown, this I proclaim to you. The God who made the world and everything in it, being Lord of heaven and earth, does not live in shrines made by man, nor is he served by human hands, as though he needed anything, since he himself gives to all men life and breath and everything. And he made from one every nation of men to live on all the face of the earth, having determined allotted periods and the boundaries of their habitation, that they should seek God, in the hope that they might feel after him and find him. Yet he is not far from each one of us, for "In him we live and move and have our being"; as even some of your poets have said, "For we are indeed his offspring." (Acts 17:23–28)

Acknowledgments

From my many learned art-history and history professors at Princeton, who taught me how to unlock the mysteries of art—and, more broadly, of the past—to the humble, holy guides to the spiritual life whom I've been graced to meet and work with, the full list of contributors to the mysteries touched upon in *Pilgrimage to the Museum* is too long to include here. I'll try to highlight those who most directly affected the narrative.

First and foremost are my two fellow authors. Though I'm the writer of the group, their ideas, insights, and editorial suggestions are interwoven so tightly with my own that it would frankly be impossible to separate them one from the other.

Evelyn, of course, has been with me from long before the beginning of this project, when many a date in our courting years would be to one of New York's great museums; even then, we were entranced with the mysteries of art. It has been a beautiful journey—one we are still on together. Evelyn is responsible for important segments of the research behind the narrative, along with the narrative itself, for many of the seminal pieces that form pivot points in the text—the icon paintings of the Greeks and the Italians of the 1100s and 1200s, Lorenzo Monaco's *The Intercession of Christ and the Virgin*, Reni's *Charity*, Rembrandt's *The Return of*

221

the *Prodigal Son*, La Tour's *The Penitent Magdalen*, and several others. More broadly, her rich spirituality and faith in God have been an anchor for me on this entire mysterious journey. And, of course, she has been the first and toughest editor of these pages, literally one page at a time, as I began the process of committing the tour narrative to ink nearly two years ago.

Fr. Shawn Aaron, LC, has been an integral member of our tour team since Evelyn assigned him this role shortly after my leap into the unknown the day I returned from *The Toilet of Bathsheba*. Fr. Shawn has devoted many a long night on the tour with us as we've brought one small group after another on our pursuit of God through space and time. His quiet support and reflections on the art on any given evening have been incorporated so seamlessly into the narrative that, again, I'd struggle mightily to identify which strand of thought was his or mine or Evelyn's. I'll also say it here (though I've never admitted this to him in person): I've always appreciated his somewhat mischievous interruptions to my monologues *en route*. They've deepened my understanding and enriched the narrative. And I've now come to cherish the moments when I spy him out of the corner of my eye, wandering off to some other painting in the gallery we find ourselves in; these spontaneous wanderings have usually paid off with suggestions of a new painting or sculpture that could be added to the narrative. Beyond the substance of the tour itself, Fr. Shawn has proven an insightful editor of the text; his many suggestions and theological corrections were, frankly, invaluable.

Father Shawn is not the only priest to accompany us on our little tours, and whenever he was not available, we made sure we had another spiritual guide with us to keep us on track theologically. Other priests who have attended and contributed to the tour include Fr. Roger Landry, papal nuncio Archbishop Bernardito Auza,

Msgr. Donald Sakano, Fr. Charles Sikorsky, LC, and especially Fr. Michael Sliney, LC, who has logged nearly as many hours with us in the museum and dinners that followed as Fr. Shawn has. All of these very holy, God-centered men have been enormous influences on our spiritual journey that led to this book. And Msgr. Sakano, our dear friend from many mission nights in SoHo, also fully edited the text for theological soundness.

Every summer my investment company hires four or five interns who want to learn more about what working on Wall Street is like. Several of them helped with the tour in their free time over the summers, and three in particular stand out. Maisie Divine, a gifted art-history major from my alma mater, spent most of a summer many years ago reorganizing the tour and suggesting a number of museum classics to be added to it. The basic outline she created, though it has evolved considerably since, gave the tour the underlying chronological structure on which much of the rest was eventually hung. John Matthew Hopkins created the history timeline that is woven throughout the narrative. John's careful overlay of key historical events helped me puzzle through the impact that some of the turning points in world history might have had on the artists and their work. Gianna Spinelli Sgroi did some of the early background research on the spiritual lives of many of the artists, leading us to new breakthroughs and theories about their intent, secret or otherwise.

Thanks also to Mary Soressi, my trusty assistant. She has been an energetic supporter of *Pilgrimage* and of the tour for more than a decade. Every painting and sculpture that is included in the tour has its own meditation card associated with it, which we use in the wrap-up sessions over dinner (discussed below). Mary and her little laminating machine produced every one of these cards—hundreds of them over the years.

Pilgrimage to the Museum

I want to thank, as always, the editorial staff of Sophia Institute Press, especially my editors Chris Bailey and Nora Malone, for their tireless devotion to and faith in this project. Without their support and confirmation, I'm not sure I'd have gotten to the finish line. Their many suggestions and adjustments made *Pilgrimage* a tighter, more compelling read. I also thank two friends who patiently edited earlier versions of the manuscript, Carolyn Dion Cervoni and Maureen Lally-Green. Their many corrections and suggestions kept *Pilgrimage* safely on its journey.

Finally, I want to acknowledge the many reflections and insights over the years that the hundreds of people we've taken through the Met have offered us. Our custom, following our grueling three-and-a-half-hour, high-speed chase through the museum, is always to unpack everyone's reflections over dinner and wine at a local New York eatery. Our guests, their hearts maybe opened a bit more than usual by the flow of images of the eternal that they've just encountered, always provide us with new insights that are often incorporated our next time out. Moreover, their moving, joyful reflections well into the night continually remind us of just how mysterious is the power of art to open the human soul to the face of God.

Bibliography

First, a caveat. This bibliography is composed largely of works I've read or consulted over the last forty-plus years that have influenced or at least provided the background to our interpretations of the artwork in *Pilgrimage*. I've tried to find or remember all of them, but it is certainly possible that I've forgotten about some of them. The bibliography is also meant to reference the sources of the more unique and little-known historical facts that we drew upon in the narrative; for more generally accepted and understood history, such as what is available in sources like Wikipedia or a college textbook, I've not cited specific sources. I have omitted almost entirely any of the spiritual readings and books that in some way influenced us, unless they specifically were focused on one or more of the works of art we were highlighting. Finally, in addition to the sources cited below, the Met's own gallery guides and synopses, along with their regularly published bulletins, were used extensively in our studies over the years for the tour and ultimately, for this book.

"Bathsheba at Her Bath (Rembrandt)." Wikipedia. Last edited December 28, 2021.

Beckett, Wendy. *Sister Wendy's 1000 Masterpieces*. New York: DK Publications, 1999.

Pilgrimage to the Museum

"Biography of Jules Bastien-Lepage." The Art Story. https://www.theartstory. org/artist/bastien-lepage-jules/life-and-legacy/.

Black, Jeremy. *The Seventy Great Battles in History*. London: Thames and Hudson, 2005.

Campbell, Thomas P. *The Metropolitan Museum of Art: Masterpiece Paintings*. New York: Rizzoli Electa, 2016.

Conliffe, Ciaran. "Caravaggio: The Man without Hope or Fear." HeadStuff, September 27, 2016. https://headstuff.org/culture/history/caravaggio -the-man-without-hope-or-fear/.

Dante. *Inferno*.

Dass, N. "Yes, There Were Christians in Pompeii." *Postil Magazine*, March 1, 2018. https://www.thepostil.com/yes-there-were-christians-in-pompeii/.

de Montebello, Philippe, and Martin Gayford. *Rendez-vous with Art*. New York: Thames and Hudson, 2014.

Edwards, Cliff. *Van Gogh and God: A Creative Spiritual Quest*. Chicago: Loyola Press, 2002.

Elsen, Albert Edward. *Rodin's Thinker and the Dilemmas of Modern Public Sculpture*. New Haven, CT: Yale University Press, 1986.

Evans, Helen C. "Age of Transition: Byzantine Culture in the Islamic World," Metropolitan Museum of Art Bulletin, 2015.

Evens, Revd. Jonathan. "Salvador Dalí: The Enigma of Faith." Artlyst, April 19, 2020. https://www.artlyst.com/features/salvador-dali-enigma-faith -revd-jonathan-evens/.

Ferguson, Niall. *Civilization: The West and the Rest*. New York: Penguin Press, 2011.

Frazer, Margaret English. "The Djumati Enamels: A Twelfth-Century Litany of Saints." *Metropolitan Museum of Art Bulletin* (1970).

Frazer, Margaret English; Kurt Weitzmann; and Metropolitan Museum of Art. *Age of Spirituality: Late Antique and Early Christian Art*. New York: The Museum, 1977.

Gerry, Kathryn B. "Panels from a Window Showing the Life and Martyrdom of St. Vincent of Saragossa." The Walters Museum. https://projects. mcah.columbia.edu/treasuresofheaven/relics/Panels-from-a-Window- Showing-the-Life-and-Martyrdom-of-St-Vincent-of-Saragossa.php.

Graham-Dixon, Andrew. *Caravaggio: A Life Sacred and Profane*. New York: W. W. Norton and Company. 2012.

Hajar, Rachel. "Aristotle with the Bust of Homer." *Heart Views* 5 (2005).

Hamilton, R. *Ancient Egypt: Kingdom of the Pharoahs*. Bath, UK: Parragon Chartist House, 2013.

Harkness, Edward S. *The Tomb of Perneb*. New York: Metropolitan Museum of Art, 1916.

Hodge, Susie. *The Short Story of Art*. London: Laurence King Publishing, 2017.

Homer. *Iliad*. Translated by Robert Fagles. New York: Penguin, 1990.

Hughes, Robert. *Nothing if Not Critical: Selected Essays on Art and Artists*. New York: Penguin, 1992.

Janson, H. W. *History of Art*. Prentice Hall, 2015.

Jones, Christopher P. "Joan of Arc by Jules Bastien-Lepage." *Thinksheet*, August 30, 2020. https://medium.com/thinksheet/how-to-read-paintings -joan-of-arc-by-jules-bastien-lepage-7961aab8e0ce.

Jones, Jonathan. "Aristotle with the Bust of Homer." *Guardian* (2002).

Jonker, Menno. "Rembrandt's Philosopher: Aristotle in the Eye of the Beholder." *Journal of Historians of Netherlandish Art* (2017). https://jhna. org/articles/rembrandt-philosopher-aristotle-eye-beholder/.

King, Ross. *Michelangelo and the Pope's Ceiling*. New York: Bloomsbury, 2003.

Lev, Elizabeth. *How Catholic Art Saved the Faith*. Manchester, NH: Sophia Institute Press, 2018.

Lipsey, Roger. *The Spiritual in Twentieth-Century Art*. Mineola, NY: Dover Publications, 2004.

Long, John. "The Shroud of Turin's Earlier History, Part One—To Edessa." Associates for Biblical Research, March 14, 2013. https://biblearchaeology.org/the-shroud-of-turin-list/2284-the-shroud-of-turins-earlier-history-part-one-to-edessa

Longenecker, Bruce W. *The Crosses of Pompeii*. Philadelphia: Fortress Press, 2016.

Macdonald, Fiona. "The Painter Who Entered the Fourth Dimension." BBC, May 11, 2016, https://www.bbc.com/culture/article/20160511-the -painter-who-entered-the-fourth-dimension.

Matar, Hisham. *A Month in Siena*. New York: Random House, 2019.

Maus, Cynthia Pearl. *Christ and the Fine Arts*. New York: Harper and Row, 1938.

Murphy, Bernadette. *Van Gogh's Ear*. New York: Farrar, Straus and Giroux, 2016.

Nouwen, Henri J. M. *The Return of the Prodigal Son*. New York: Doubleday, 1992.

Oakley, Howard. "Work in Progress: Rembrandt's Bathsheba." The Eclectic Light Company, 2019.

Picasso, Pablo. "Picasso Speaks: A Statement by the Artist." Interview with Marius de Zayas. *Arts* (May 1923).

Plato. *The Republic*. Translated by Benjamin Jowett. In *The Dialogues of Plato*. Vol. 3. Oxford: Oxford University Press, 1892.

——. *Symposium*. Translated by Michael Joyce. London: J. M. Dent and Sons, 1935.

Reston, James. *Defenders of the Faith: Christianity and Islam Battle for the Soul of Europe, 1520–1536*. New York: Penguin Books, 2010.

Rosen, Aaron. "Leap of Faith — How Mark Rothko Reimagined Religious Art for the Modern Age." *Apollo*, August 29, 2020. https://www.apollo-magazine.com/rothko-chapel-houston-modernism-religion/

Rodin, Auguste. *The Cathedral Is Dying*. New York: David Swirner Books, 2020.

Sartre, Jean-Paul. *No Exit and Three Other Plays*. New York: Vintage, 1989.

Shepard, Mary. "The Relics Window of St. Vincent of Saragossa at Saint-Germain de Prés." *Gesta* 37, no. 2 (1998). https://www.journals.uchicago.edu/doi/10.2307/767268.

Spivey, Nigel. *The Classical World: The Foundations of the West and the Enduring Legacy of Antiquity*. New York, London: Pegasus Books, 2016.

Shorto, Russell. "The Woman Who Made van Gogh." *New York Times Magazine*, April 14, 2021.

van de Wetering, Ernst. "Rembrandt." Encyclopedia Britannica, 2021.

Vcherashnyaia, Anna. "Three women in Rembrandt's life: a goddess, a mistress, and a maid." ArtSmarts.

Virgil. *The Aeneid of Virgil*. Translated by J. W. Mackail. London: Macmillan, 1920.

Vodret, Rossella. *Caravaggio, The Complete Works*. Milan: Silvana Editoriale, 2010.

Weigel, George. *The Cube and the Cathedral*, New York: Basic Books, 2005.

Wethey, Harold. "El Greco and His School." *Encyclopedia Britannica*.

Wilson, Elaine L. *Transcending Time: The Magnetism of Mary Magdalene*. Self-published, CreateSpace Independent Publishing Platform, 2016.

About the Authors

Stephen Auth has had a long career on Wall Street, first with Prudential Investments in the 1980s and 1990s, and since 2000 with Federated Hermes, where he serves as executive vice president and a chief investment officer of Federated Global Equities. Steve is a frequent guest on Fox Business News, CNBC, and Bloomberg TV, a member of The Economic Club of New York and The New York Society of Security Analysts, and a chartered financial analyst (CFA). He earned his undergraduate degree at Princeton University, where he graduated summa cum laude, and his graduate degree at Harvard Business School, where he was a Baker Scholar. He has twice been profiled in *Barron's*.

Steve is a member of the Regnum Christi movement and sits on the national board of the Lumen Institute, which he helped found in New York. He has participated in missions in Mexico, and with his wife, Evelyn, has led the New York City street mission for fourteen years. Steve and Evelyn are involved in a number of other apostolic activities, including the spiritual tour of the Metropolitan Museum of Art called "Man's Search for God: A History of Art through the Prism of Faith," on which this book is based. Steve also serves on the board of the National Office of the Pontifical Mission Societies in the United States. His previous publications

include *The Missionary of Wall Street* (Sophia Institute Press, 2019) and *The Ten Years' War* (Garland Press, 1989).

Evelyn Moreno Auth has been Steve's lifelong partner in marriage and, with him, raised their two wonderful sons, Richard and Michael. Evelyn has also been a leader in the Regnum Christi Movement since 2002. In addition to her work with Steve leading the SoHo street mission and the spiritual tour of the Met, she serves on the boards of Divine Mercy University and Catholic World Mission. Evelyn earned her undergraduate degree from University of the East, Philippines.

Fr. Shawn Aaron, LC, is an integral member of the Auth's tour team who has contributed invaluable edits, reflections on art, and theological insights to this book. He currently serves as North American Territorial Director for the Legionaries of Christ and board member for Divine Mercy University and the Lumen Institute in Manhattan.

Sophia Institute

Sophia Institute is a nonprofit institution that seeks to nurture the spiritual, moral, and cultural life of souls and to spread the gospel of Christ in conformity with the authentic teachings of the Roman Catholic Church.

Sophia Institute Press fulfills this mission by offering translations, reprints, and new publications that afford readers a rich source of the enduring wisdom of mankind.

Sophia Institute also operates the popular online resource CatholicExchange.com. *Catholic Exchange* provides world news from a Catholic perspective as well as daily devotionals and articles that will help readers to grow in holiness and live a life consistent with the teachings of the Church.

In 2013, Sophia Institute launched Sophia Institute for Teachers to renew and rebuild Catholic culture through service to Catholic education. With the goal of nurturing the spiritual, moral, and cultural life of souls, and an abiding respect for the role and work of teachers, we strive to provide materials and programs that are at once enlightening to the mind and ennobling to the heart; faithful and complete, as well as useful and practical.

Sophia Institute gratefully recognizes the Solidarity Association for preserving and encouraging the growth of our apostolate over the course of many years. Without their generous and timely support, this book would not be in your hands.

www.SophiaInstitute.com
www.CatholicExchange.com
www.SophiaInstituteforTeachers.org

Sophia Institute Press is a registered trademark of Sophia Institute.
Sophia Institute is a tax-exempt institution as defined by the
Internal Revenue Code, Section 501(c)(3). Tax ID 22-2548708.